KING SIZE
TOWEL
ORIGAMI

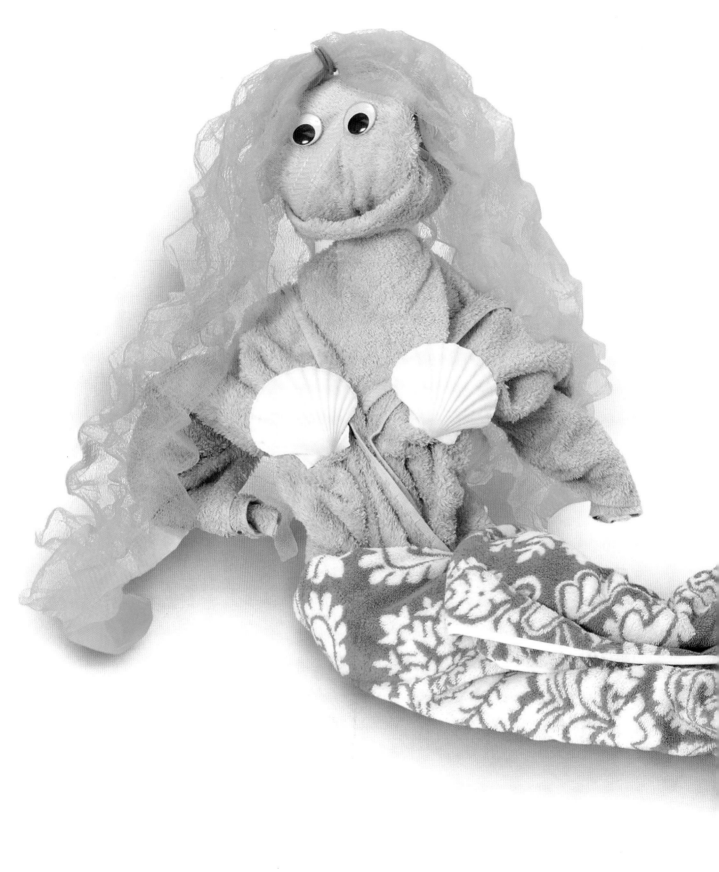

KING SIZE
TOWEL
ORIGAMI

50 FANTASTIC FOLDING PROJECTS FOR YOUR BATH TOWELS, BATHROBES, AND BEACH TOWELS

ALISON JENKINS

METRO BOOKS
NEW YORK

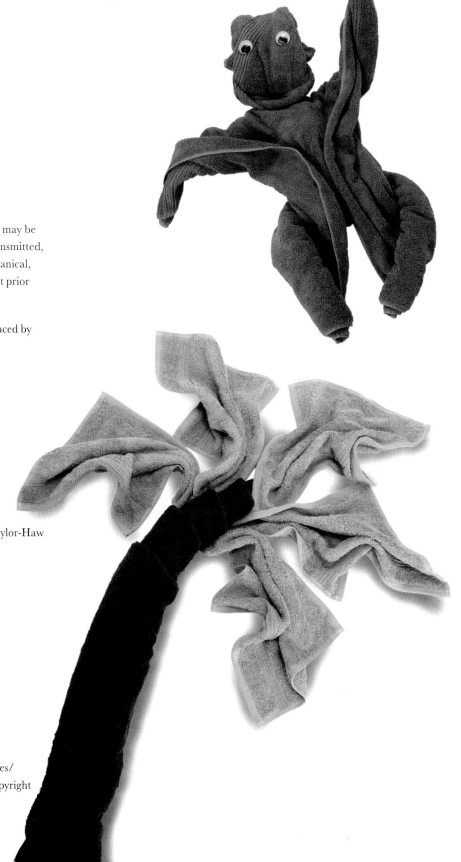

This book was conceived, designed, and produced by

Ivy Press
210 High Street
Lewes, East Sussex
BN7 2NS, UK
www.ivy-group.co.uk

Creative Director: Peter Bridgewater
Publisher: Jason Hook
Editorial Director: Tom Kitch
Senior Designer: Kate Haynes
Designer: Joanna Clinch
Photographers: Andrew Perris and Calvey Taylor-Haw

Metro Books
122 Fifth Avenue
New York, NY 10011

ISBN: 978-1-4351-2313-7

Printed in China

Color origination by Ivy Press Reprographics

10 9 8 7 6 5 4 3 2 1

Picture acknowledgment
The publisher would like to thank Getty Images/
George Marks for permission to reproduce copyright
material on page 6.

CONTENTS

SENSATIONAL GIANT TOWEL FOLDING COLLECTION TAKES CITY BY STORM *story by Alison Jenkins*

PANIC GRIPPED THE WORLD'S GREAT CITIES again yesterday as the incredible towel-folding phenomenon continued to blanket the globe. The New York Stock Exchange nosedived into the deep end as the scarcity of cotton hit store prices worldwide. The bubble burst in the early afternoon as city traders sold up early to dash home for a bath before indulging in the bathroom origami addiction that has put stocks and shares in the shade. One observer stated that the effect was worse than the credit crunch, and was being referred to as the "Wall Street Splash."

Hollywood moviemakers got in on the act, plugging the latest King Kong remake with a helicopter drop of the finest towel origami replicas of their simian superhero. Rumors, though, that the entire cast were to be replaced with computer-generated towel models were dismissed as a load of old fluff.

RIOTING TOWEL-FOLDING SHOPPERS
Store owners in downtown Chicago closed early, barring their doors to the baying mobs who had waited through the night to lay their hands on the latest step-by-step towel-folding projects.

In shopping malls from London to Paris, from Mumbai to Mombasa, the eagerly anticipated release of the latest bible of towel origami wonders brought scenes of chaos. Millions waited outside stores overnight for a chance to snap up a first edition of the King Kong-sized *King Size Towel Origami* book, the world's first supersize collection of towel models. But as disorderly lines of impatient shoppers slowly changed into baying mobs, stampedes and riots ensued. Police in New York City had to eventually refrain from making arrests, as a spokesperson explained to the media: "The mob just got too crazy, so we had to throw in the towel."

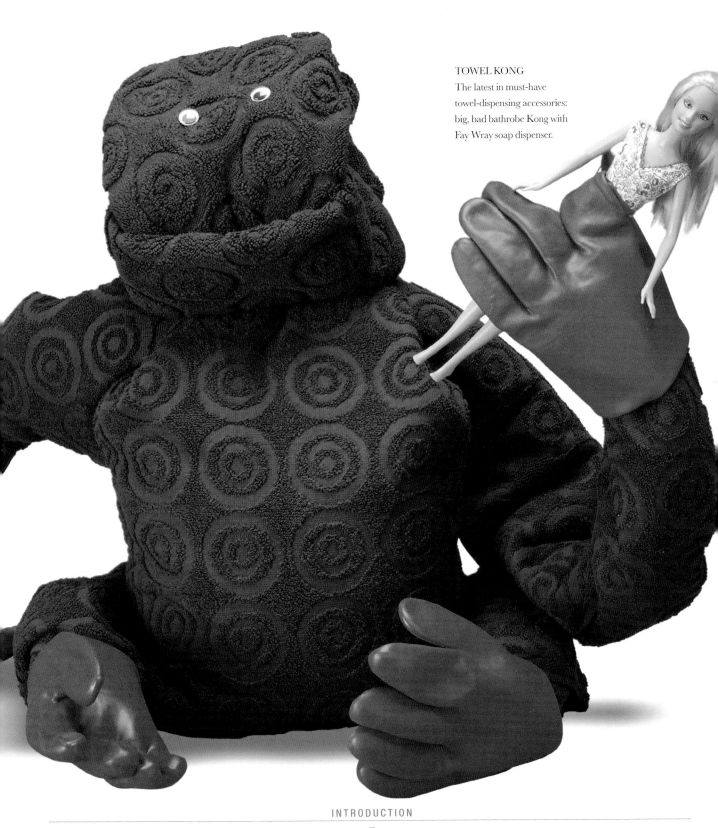

TOWEL KONG
The latest in must-have towel-dispensing accessories: big, bad bathrobe Kong with Fay Wray soap dispenser.

TOWEL BASICS & TIPS

The first step in making a towel origami model is to lay out a towel flat on your work surface—the floor, the bed, or wherever you feel most comfortable. This towel is laid out either horizontally or vertically and is then folded or rolled (or a combination of both techniques) to achieve the desired size and shape. Each set of instructions indicates in the first step which way you need to orient the towel.

BASIC MATERIALS

You need a pile of your fluffiest towels (see below for recommended sizes), plus a little time and patience. We have suggested suitably colored towels for the models, but colors can, of course, vary. You could even let your imagination run wild and go for something completely different, if the mood strikes you. It can help to wash and starch towels to give them extra stiffness, but some of the models need a helping hand to stay upright, so you may need to make use of a few supports in the form of toilet rolls, shampoo bottles, and so on.

TOWEL SIZES

Towels can vary quite a lot in size, but the ones used for our models conform roughly to the dimensions given below. Don't worry if your own towels are slightly smaller or larger—it won't matter too much, but of course larger towels are most suitable for king-sized projects.

- face cloth: 13 x 13 inches (33 x 33 cm)
- hand towel: 20 x 40 inches (50 x 100 cm)
- bath towel: 27 x 51 inches (68 x 130 cm)
- bath sheet: 35 x 68 inches (89 x 172 cm)

FIXING KIT

In order to make sure that your models don't collapse before your guests have had a chance to enjoy them, you'll have to "fix" them… very securely! You'll need to have a fixing kit on hand while you create your models, plus a few other bits and pieces, as listed below:

- Safety pins, for securing overlaps and body parts
- Double-sided adhesive tape, for positioning eyes (normally these are plastic eyes, but buttons can be used instead) and other features
- Clothespins, for holding thick layers in place and for support
- Pencil, paper and sharp scissors, for making templates and for cutting out shapes

BASIC FOLDS

Many of the king-sized projects begin with a towel laid out horizontally, then folded in half widthways to make a square; or with a towel laid out vertically, then folded lengthways to make a long, narrow band. Where the model requires you to fold the towel into thirds or make a fold of a certain depth, first indicate the fold position in the pile with the tip of your finger; you can then use that line as a folding guide.

TOWEL LAID OUT HORIZONTALLY

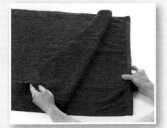

Fold in half widthways.

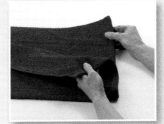

Fold in half lengthways.

TOWEL LAID OUT VERTICALLY

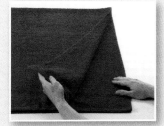

Fold in half widthways.

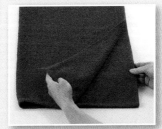

Fold in half lengthways.

FOLDING INTO THIRDS

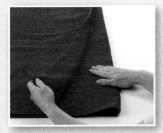

Divide into three horizontally.

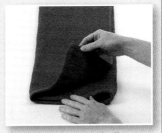

Divide into three vertically.

BASIC ROLLS

The rolling technique can be performed in one of two ways: parallel or diagonal. Parallel rolls are made by rolling the towel in from both long or short ends to meet at the center, running in line with the edge. Diagonal rolls are made from one corner of the towel or folded shape, or along a diagonal fold made in a previous step, obliquely across the towel to the other side (or from both sides to meet at the center).

PARALLEL ROLL

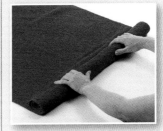

Roll one edge toward the center.

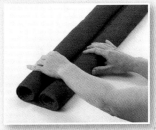

Roll the other edge toward the center.

DIAGONAL ROLL

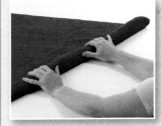

Roll from lower corner.

CREASING

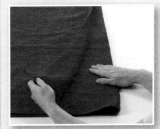

Make a visible crease.

RATINGS

All of the projects have been assigned difficulty ratings:

easy

moderate

challenging

BODY SHAPE 1

This useful body shape looks a bit like a plucked chicken. It forms the basis for Billy Bathtowel, Beach Betty, the angel, octopus, turtle, and many others.

BODY SHAPE 2

This shape can be manipulated to sit in an upright position, and has been used for Marilyn, King Kong, the werewolf, devil, grizzly bear, and leopard.

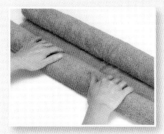

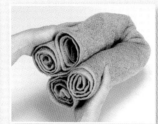

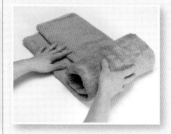

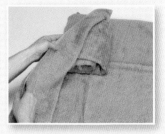

1 Lay the towel out horizontally, then mark the center by drawing your finger through the pile vertically down the middle of the towel. Roll both short sides toward the center point.

2 Grasp the rolled-up shape at both ends and flip it over to the other side. Then bend the shape in half so that all four rolled ends meet, as shown.

1 You need an extra towel for padding. Lay this towel out horizontally, then fold it into three, widthways. Now roll the shape up loosely, beginning at the lower short edge, to form a cylindrical pad.

2 Lay the towel out vertically, then place the rolled pad in the center, about 4 inches (10 cm) down from the upper short edge. Bring the left-hand long edge over the cylindrical pad.

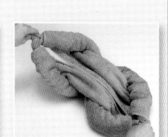

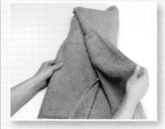

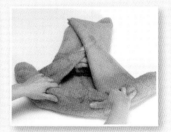

3 Now stretch your arms wide to pull out the rolls and form a slim body shape with four "limbs." The shape can be pinned together at the center if necessary, then manipulated to suit the requirements of the model in question.

4 Holding the rolled shape with one hand, locate the corners of the towel that lie inside each of the rolled ends. Pull these corners out a little, and grasp them in both hands, as shown.

3 Pick up the right-hand long edge and bring it toward the center, overlapping the left-hand side. Use safety pins at this point to secure the overlap.

4 Now open out the lower short edge of the towel and roll it up toward the wrapped pad. If necessary, secure the roll to the base of the pad at the center.

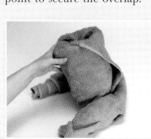

5 Slip your hand underneath the padded body shape and sit it upright. Tighten the roll made in step 4, tucking the loose top end of the towel into the padding. Arrange the ends to resemble "legs" around the body's base.

BODY SHAPE 3

This is used to create an arched legs shape. It has been used for the elephant, but is a useful body shape to know for an assortment of animals you can create for yourself.

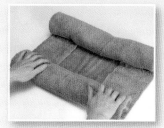
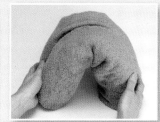

① Lay the towel out horizontally. Make a fold of approximately 4 inches (10 cm) along both lower and upper edges. Now roll each of the short sides toward the center point.

② Grasp the roll at both ends and bend it over to form an arch. The rolls can be secured with safety pins, if necessary. To increase its stability, open out the folds at the base of each leg.

HEAD SHAPE 1

This involves a tight diagonal roll to form a neat triangular shape; variations on the shape and size of the towel will result in a shorter or longer head.

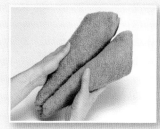
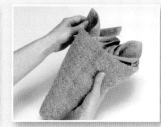

① Lay the towel out horizontally. Now fold it into three widthways (see page 9). Grasp the lower left-hand corner and roll it tightly in a diagonal fashion toward the center point. Do the same with the upper left-hand corner.

② If the design requires it, flip the shape over to the other side so that the "face" is uninterrupted by folds. Pull out the corners that lie inside the rolls at the top to form ears, if necessary.

HEAD SHAPE 2

Used for Elvis, Marilyn, the vampire, zombie, and several others, this head shape is compact and features a large mouth that can become a wide smile or sneer as necessary.

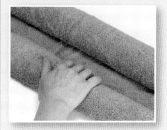
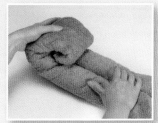

① Lay the towel out horizontally. Then fold it in half by bringing the left-hand short edge over to meet the right-hand edge. Roll the upper edge of the resulting square shape in tightly to the center point, then repeat with the lower edge to make a parallel roll.

② Now roll the shape into a tight ball, beginning at the left-hand corner.

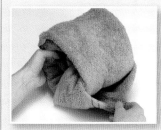

③ Holding the rolled ball firmly in one hand, grasp the outer layer of the open end of the towel in the other hand and peel it right back over the rolled ball. Secure the overlap with a safety pin.

SAFETY NOTE

If you have used safety pins, do make sure that you remove them all before using the towels for bathing; an open safety pin can easily scratch the skin.

PEOPLE &
CREATURES

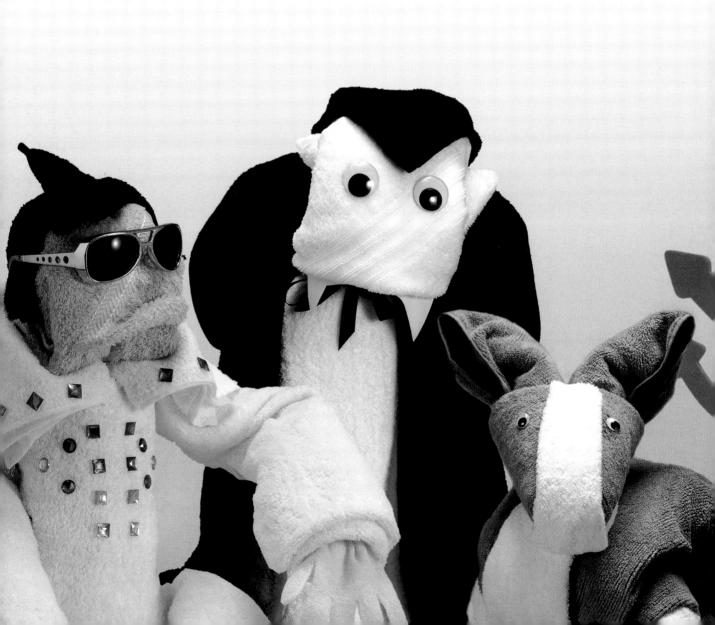

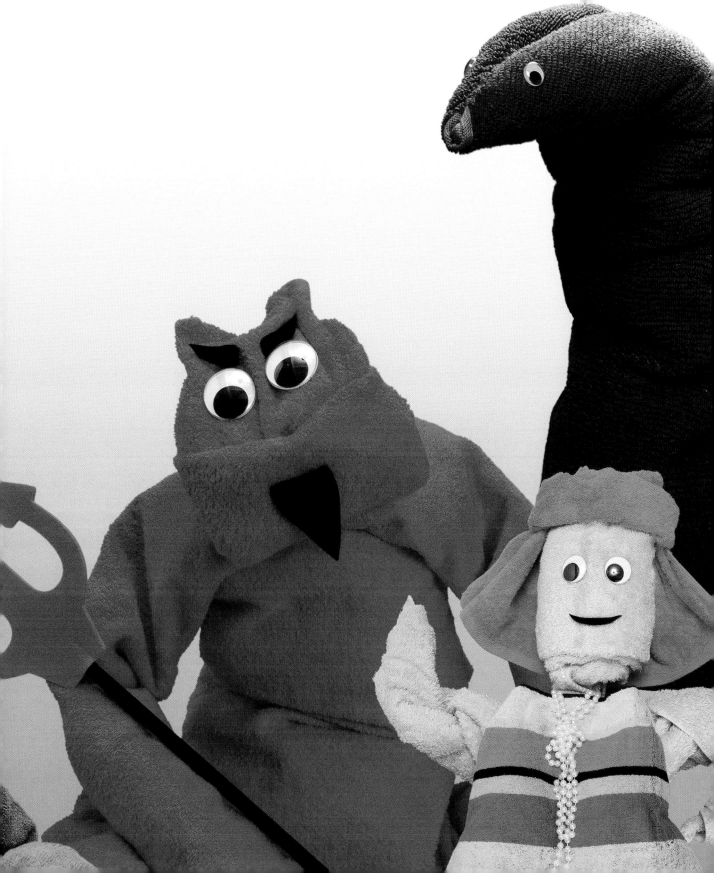

BILLY BATHTOWEL

YOU WILL NEED

1 beige bath sheet for body

1 beige bath towel for head

1 brown face cloth for hat

2 plastic eyes

strip of black paper for mouth

red neckerchief

fixing kit (see page 8)

This cheeky chap is a simple fellow to make. Once you have mastered the art of the four-limbed body shape, the head shape is easy. Billy, dressed in a sailor costume hat and neckerchief, is a fun starter project for the towel origami novice. Have fun with accessories when the basic model is complete; perhaps add sunglasses to his face.

TOP TIP

It's fun to dress up Billy, so use your imagination and accessorize him in any way you choose; you could even use differently colored towels for the neckerchief and hat.

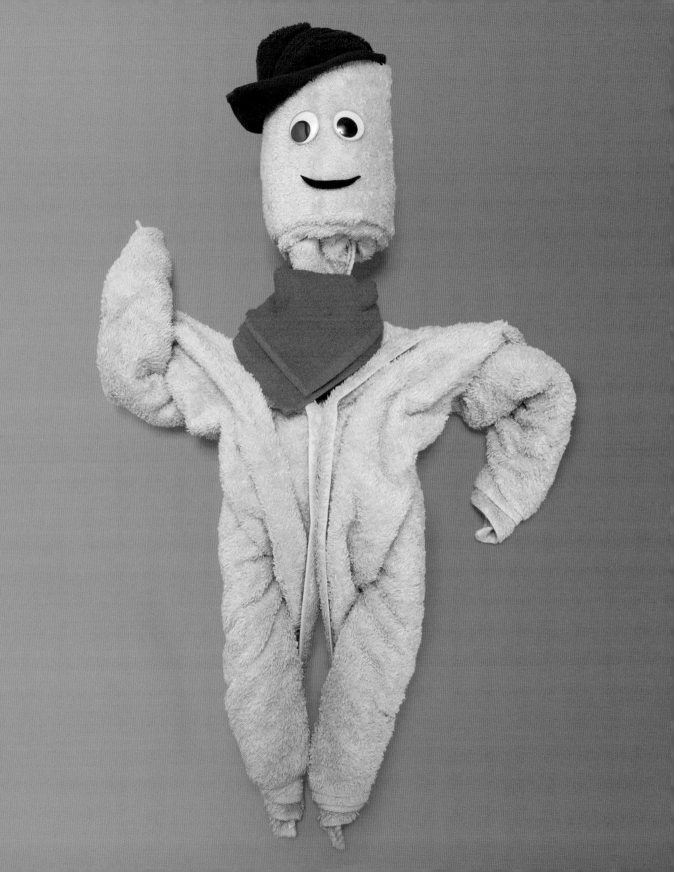

BILLY
BATHTOWEL

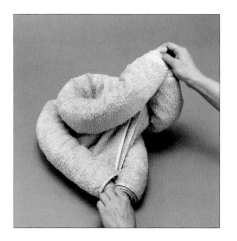

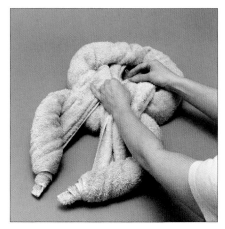

1 For Billy's body, take the beige bath sheet and roll it to form the basic four-limbed body shape 1 (see page 10).

2 Stretch the rolled shapes to create the arms and legs. Use a few safety pins to secure the folds that run along the torso. This will ensure that Billy doesn't fall apart.

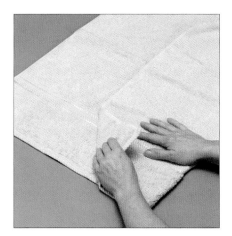

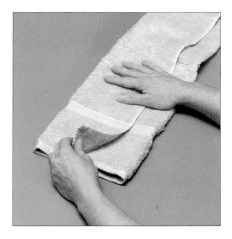

3 Use the beige bath towel to form head shape 2 (see page 11). Lay it out horizontally. Divide the towel into three, horizontally, by running your fingertip though the pile to make faint lines. Make the first fold from the lower edge.

4 Fold the bath towel along the upper guidelines to form a long thick band. Press the fold flat using the palm of your hand.

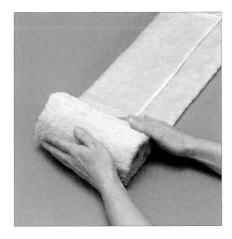

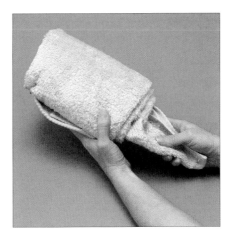

5 To make the head, roll up the band beginning at one short end. Secure the overlap at the back of the head using a few large safety pins.

6 Take the head in one hand and place the other hand up inside the roll at the neck end. Pull out the folded edge from inside the rolled shape. This will form the neck, making a neat join between the body and the head.

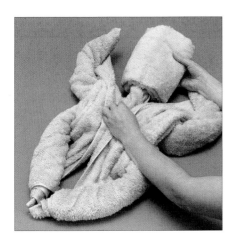

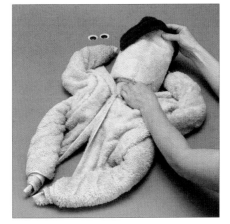

7 Tuck the neck inside the folds between Billy's shoulders to position the head. Use safety pins to hold the neck and head in place if necessary.

8 Take one corner of the brown face cloth. Tuck this corner down inside the roll at the top of the head then arrange to form a sailor's hat. Add two twinkly eyes with double-sided adhesive tape and a mouth to complete the model. Ahoy! Tie a red neckerchief around Billy's neck to complement his sailor's hat.

BEACH BETTY

YOU WILL NEED

1 beige bath sheet for body

1 beige bath towel for head

1 red/orange hand towel for hair

1 red/orange elastic hair band

1 stripy hand towel for dress

1 necklace

2 plastic eyes

strip of paper for mouth

This femme fatale follows the same construction method as her sailor friend, Billy Bathtowel, but her hair and clothing make her an individual. Here, she is wearing a classic, horizontally striped beach dress, but you could go for a spotted, patterned, or floral design. You could also really go to town with Betty's hairstyles, jewelry, and accessories.

TOP TIP

Try dressing up Betty in a glamorous dress to go to the beach ball. With a little imagination, you could really have a lot of fun with this model.

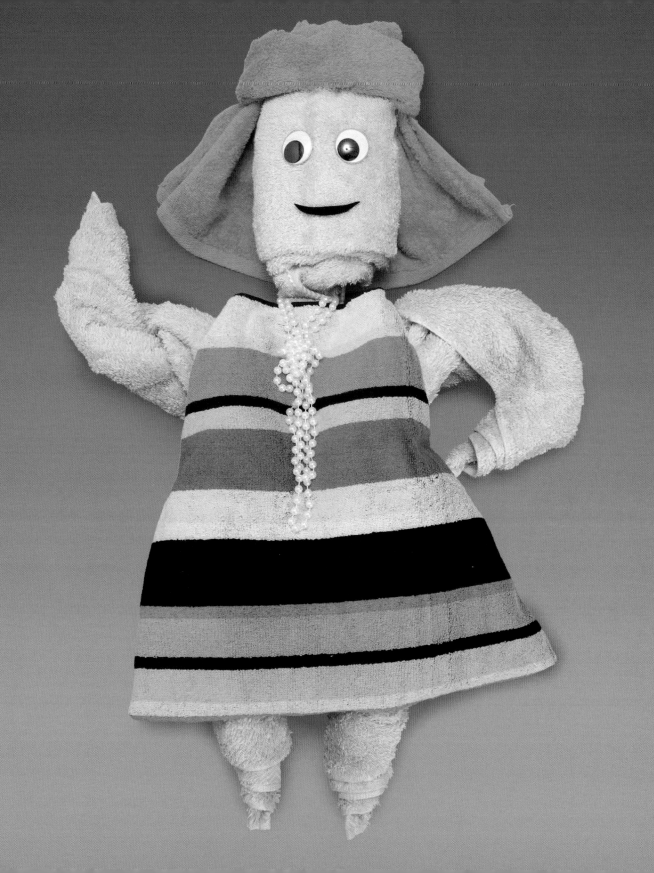

BEACH BETTY

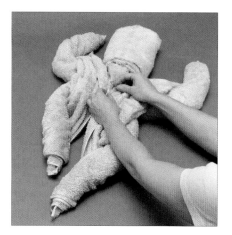

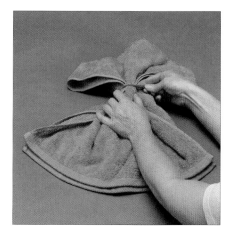

1 For Betty's body, take the beige bath sheet and roll to form the basic four-limbed body shape 1 (see page 10). Use a few safety pins to hold the folds and rolls secure, as before. Take the beige bath towel and roll it to form head shape 2 (see page 11).

2 For her hair, take the red/orange hand towel and lay it out vertically. Fold the towel in half by bringing the short edges together. Take the elastic hair band and wrap it around the towel about 7 inches (18cm) from the top fold.

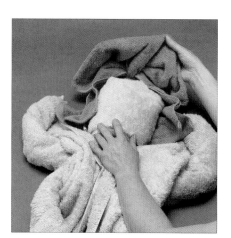

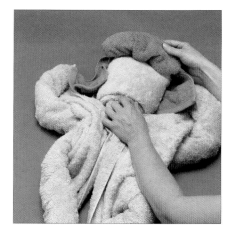

3 Place the towelling hair on the top of Betty's head. Use a few safety pins to secure it in place if the towel is a bit wobbly.

4 Now arrange her hairstyle. Roll up the front fold flat to achieve a simple "bob," or, if you wish, you could experiment a little with her hair for different styles.

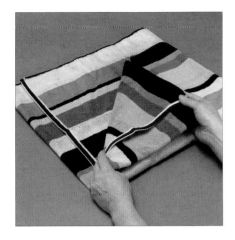

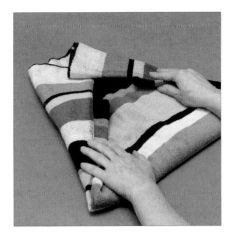

5 For the beach dress, take the striped hand towel and lay it out vertically. Fold the towel in half by bringing the short edges together at the center. Form a square shape by tucking in one edge, if necessary.

6 Tuck both top corners under to form a long, gently sloping trapezium shape. This creates a trendy A-line beach dress.

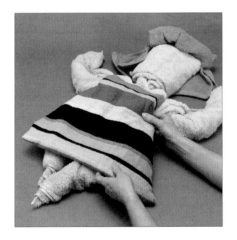

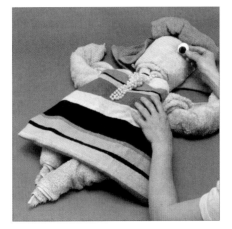

7 Place the dress onto Betty's body. Tuck the top edges under her chin and arrange the folded edges at the top corners neatly to form the armholes.

8 If Betty looks a little underdressed, give her some beads or earrings. Finally, use double-sided adhesive tape to attach two eyes and a cute smile to Betty's face.

ELVIS

YOU WILL NEED

1 white bath sheet for body

1 white bath sheet for trousers

1 white bath towel for arms

1 pair of white body exfoliating gloves

1 white hand towel for collar

1 beige hand towel for head

1 black face cloth for hair

sunglasses

plastic spangles

fixing kit (see page 8)

Ladies and gentlemen… Elvis is in the bathroom. The white jumpsuit, rhinestones and characteristic quiff may certainly suggest this model's identity, but it's the sunglasses that really say "Elvis." It's worth researching Elvis and having a look through your local second-hand clothing stores to get just the right style or accessories for your model.

TOP TIP

Elvis was also famous for his black leather jacket and jeans in his younger days. You could easily create this style using different-colored towels.

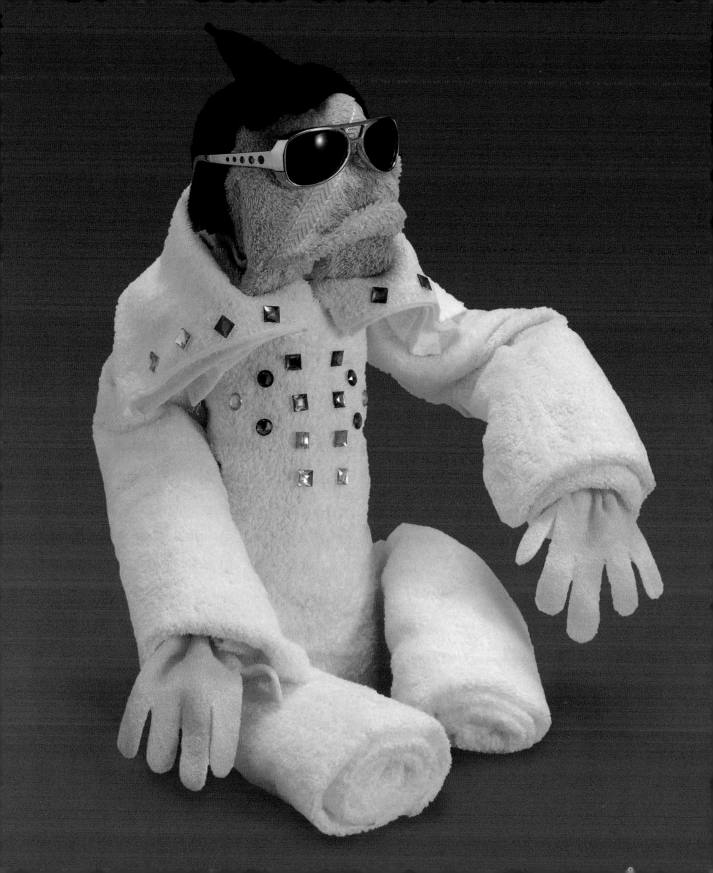

ELVIS

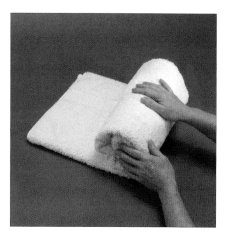

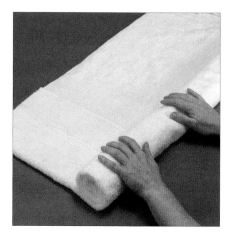

1 For Elvis's body, take one white bath sheet and fold it in half by bringing the short edges together. Fold in half again in the same way. Roll up the folded towel to make a cylindrical shape. Secure the overlap at the back using a few large safety pins.

2 To make Elvis's flared trousers, lay another white bath sheet out horizontally, then make an 8-inch (20-cm) fold at each short end. Roll up the towel from one long edge to form a sausage that is slightly flared at each end.

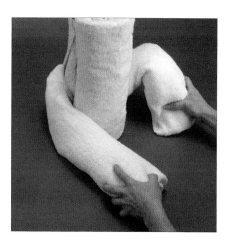

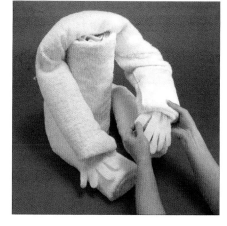

3 Set the body shape on one end on your work surface then arrange the legs around the back and to the side to form a relaxed sitting pose.

4 To create Elvis's arms, roll the white bath towel in the same way as for step 2. Drape the resulting sausage shape over the shoulders of the body. Use a few safety pins to secure the arms to the body roll if necessary. For the hands, insert a glove into the end of each of the arm rolls.

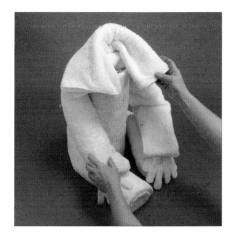

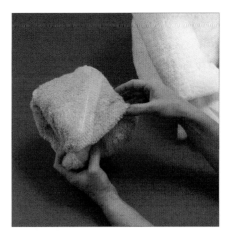

5 To form the characteristic large collar, fold the white hand towel in half by bringing the short edges together, then fold in half again in the same way. Wrap the towel around the shoulders.

6 Use the beige bath towel to form head shape 2 (see page 11). Pin the corners securely at the back of the head. If you turn the shape so the fold is at the bottom, you can curl up the top lip in true Elvis style.

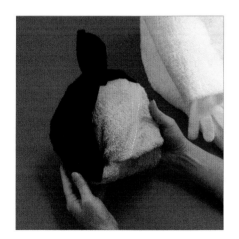

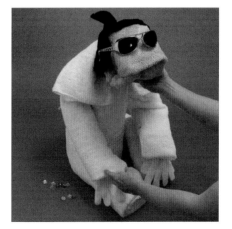

7 Place the black face cloth onto the head with one corner falling over the face, and the diagonally opposing corner falling at the back of the head. Tuck the remaining corners into the sides of the rolled shape to resemble sideburns. Curl the front corner into an Elvis-style quiff.

8 Place the head carefully onto the shoulders and put on the characteristic sunglasses. Decorate your model with plastic spangles (or shiny paper cut-out shapes).

MARILYN

YOU WILL NEED

1 beige bath sheet for upper body

1 white bath towel for padding

1 beige bath sheet for lower body

1 white bath towel for padding

1 beige bath towel for head

1 beige net body exfoliator for hair

2 white face cloths for bodice

1 white bath towel for dress

2 plastic eyes

fixing kit (see page 8)

Marilyn Monroe has to be one of the world's most renowned Hollywood film icons. Here, we have dressed her in the famous white dress featured in *The Seven Year Itch* (1955), but another idea would be to use baby pink colored towels to create that fabulous full-length pink satin evening gown made famous in another of her film classics, *Gentlemen Prefer Blondes* (1953).

TOP TIP

Try suspending the hem of Marilyn's dress so it really looks like it does in the famous scene where it is billowing in the blast from the subway.

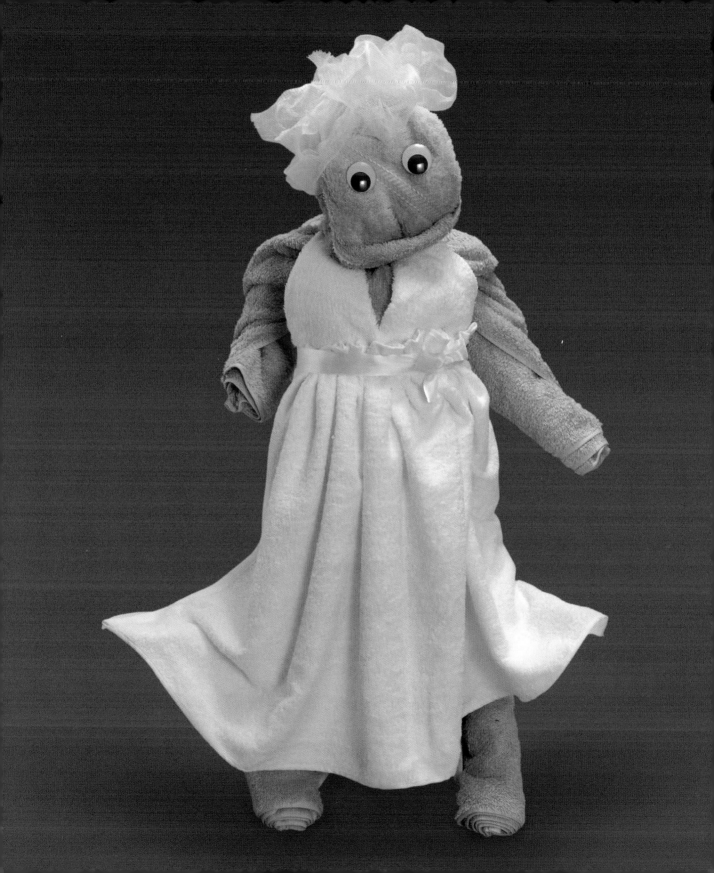

MARILYN

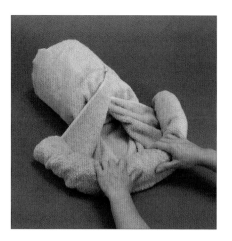

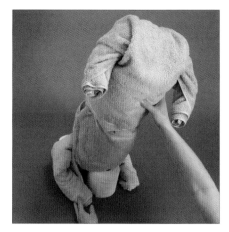

1 For Marilyn's lower body, take one beige bath sheet and one white bath towel and assemble body shape 2 (see page 10). Make the upper parts of the body shape in the same way.

2 Fit the lower body shape on two toilet rolls, with the legs at the lower end. Balance the upper body on top, with the arms at the upper end.

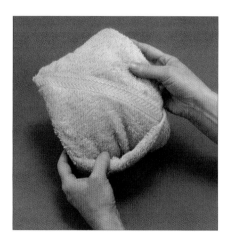

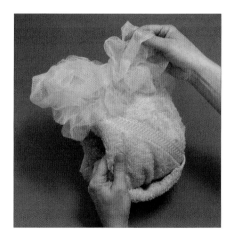

3 Take the beige bath towel and roll it to form head shape 2 (see page 11). Secure the overlap at the back of the head and then squeeze in the sides to form a pleasing shape. The lips can be formed from the fold of the towel.

4 Use the beige net body exfoliator to create Marilyn's famous blonde hair. Simply unravel the long net strip and pin it on the top of Marilyn's head.

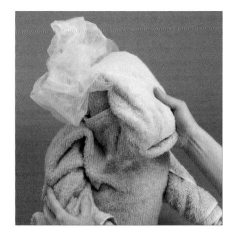

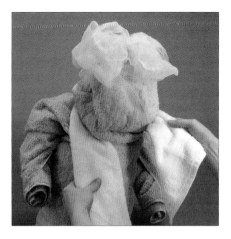

5 Place the head onto the shoulders. You may need a few safety pins to hold the shape securely in position.

6 To make the halter-necked bodice of the famous dress, take the two white face cloths and fold each in half diagonally. Pin the corners together at the top then drape the bodice around Marilyn's neck, bringing the loose corners down toward the waistline.

7 Hand stitch a gathering thread across one long edge of the remaining white bath towel to form the full skirt. Gather up the thread tightly.

8 Using a wide white satin ribbon, tie the gathered edge of the skirt to the model around the waistline. Then complete the model of Marilyn by adding two eyes attached to the face with double-sided adhesive tape.

VAMPIRE

YOU WILL NEED

2 white bath sheets for body

1 white hand towel for neck

1 white bath towel for head

1 black face cloth for hair

1 red bath towel for cape

1 black bath towel for cape

2 plastic eyes

black satin ribbon

white card for fangs

fixing kit (see page 8)

Are you keen on Halloween? Perhaps you like to trick or treat? If you have overnight guests for your Halloween party, then give then a spooky surprise when the "bathing hour" arrives, with a ghoulish vampire model. Popular in fiction and in Hollywood, the vampire is a creature who never dies if allowed to feed on human blood. To ease the fears of your visitors, you could hide lots of fragrant bathtime goodies under the vampire's flowing cloak as a surprise for your guests to find.

TOP TIP

You could accessorize your Prince of Darkness with a few plastic bats— and don't forget to supply your guests with a bulb or two of garlic to help ward off the vampire.

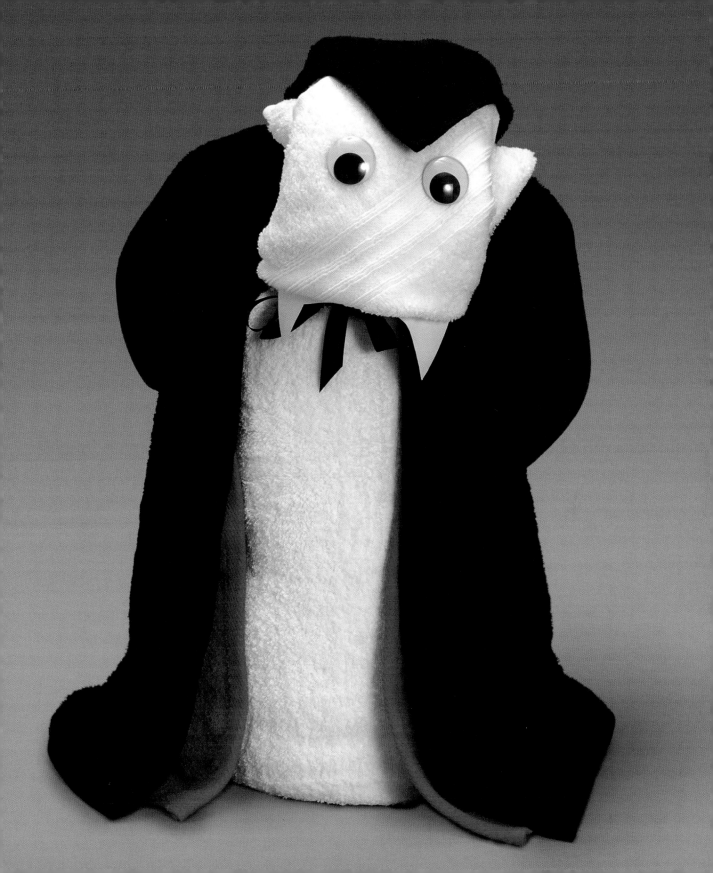

VAMPIRE

1 For the vampire's body, fold each of the white bath sheets in half by bringing the short edges together. Place one sheet on top of the other then fold in half again. Roll into a thick cylindrical shape and secure the overlap with safety pins.

2 For the neck, take the white hand towel and fold it in half by bringing the short edges together. Then fold it in half again in the same way. Roll to a cylindrical shape then secure the overlap with safety pins.

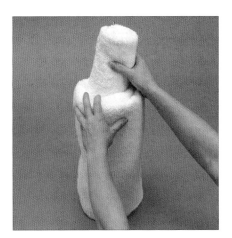

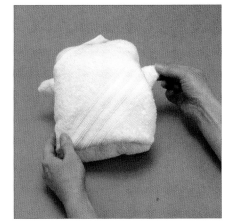

3 Insert the rolled-up hand towel into the top of the body roll to act as a neck and support for the head.

4 Take the white bath towel and roll it to form head shape 2 (see page 11). Secure the overlapping corners at the back of the head. Manipulate the shape and mouth into a vampire-like sneer. Tease out the corners at the sides to form small ears.

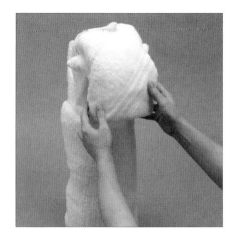

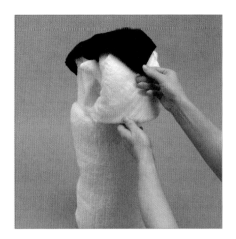

5 Place the head carefully onto the neck. The head should balance quite steadily, but if your vampire's head seems loose then secure it with a few safety pins.

6 Use the black face cloth to create the pointed hairline characteristic of your classic vampire. Simply drape one corner of the face cloth over the vampire's forehead, then tuck and pin the remainder around the back of the head.

7 For the cape, lay the black bath towel out horizontally then lay the red towel on top. Fold the red towel down about 6 inches (15

8 Drape the cape around the vampire's shoulders then tie the black satin ribbon around the neckline to secure. Add two eyes with double-sided adhesive tape and some paper fangs to complete the model.

ZOMBIE

YOU WILL NEED

2 white bath sheets for body

1 white hand towel for neck

1 white bath towel for head

1 red face cloth for blood

1 purple bath robe

*1 pair of white body
exfoliating gloves*

1 pair of plastic eyeballs

1 red felt strip for tongue

fixing kit (see page 8)

Invite your friends around for a scary movie night, with all your favorite spine chillers. This zombie model is really worth spending a little time over. It is created with floppy arms for realistic zombie stance, and we have suspended the sleeves of the robe for a spooky effect. However, if you prefer, you could pad the sleeves with two rolled-up hand towels to give it stiffer arms. Use subdued lighting in the bathroom—see which of your guests screams the loudest.

TOP TIP

To achieve a different scary effect, try "flying" the zombie from the bathroom shower rail using some fishing line or picture-hanging wire.

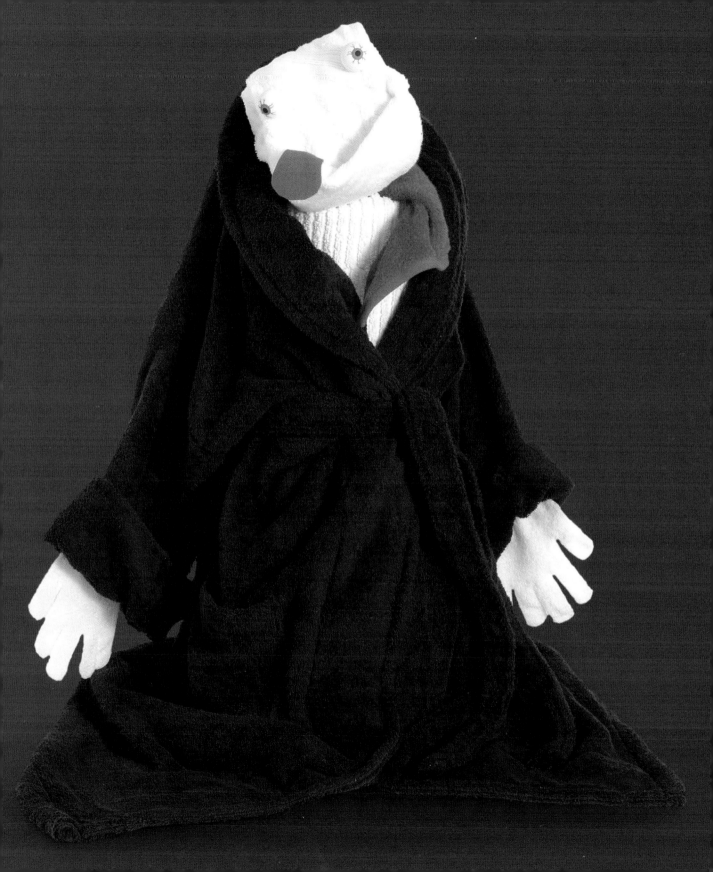

ZOMBIE

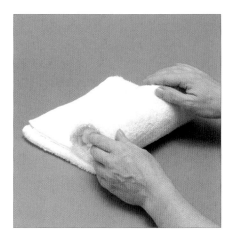

1 For the zombie's body, fold the two white bath sheets in half by bringing the short edges together. Place one sheet on top of the other then fold in half again. Roll into a thick cylindrical shape and secure the overlap with safety pins. Place on a stack of toilet rolls to give the model height.

2 Take the white hand towel and fold it in half by bringing the short edges together, then fold it in half again in the same way. Roll the towel to make a cylindrical shape then secure the overlap with safety pins.

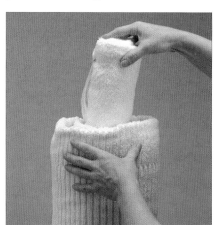

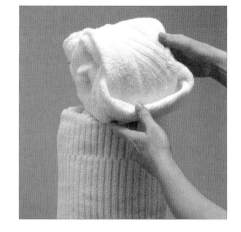

3 Insert the rolled-up hand towel into the top of the body's upright roll to act as a neck and support for the head.

4 Take the white bath towel and roll it to form head shape 2 (see page 11). Secure the overlapping corners at the back of the head. Manipulate the fold to make the mouth into a wide, gaping, zombie-like shape. Place the head carefully onto the neck. If your zombie's head seems loose then secure with a few safety pins.

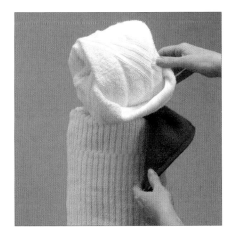

5 Insert a red face cloth into the fold at the edge of the neck to simulate blood dripping from a slashed throat.

6 Wrap the robe around the zombie's body and cover the back of the head. Tie the belt tightly around the waist to secure the robe.

7 Secure one white glove into the end of each of the zombie's sleeves using safety pins. You may need to pad the fingers a little with toilet tissue.

8 Add two eyeballs to the face, fixing with double-sided adhesive tape. Insert the red felt strip into the zombie's gaping jaw to form a blood-stained, lolling tongue.

WEREWOLF

YOU WILL NEED

1 beige bath sheet for lower body

1 beige bath sheet for padding

1 pair of white body exfoliating gloves

1 black furry bath mat for arms

1 pair of black Halloween gloves

1 beige bath towel for head

2 elastic hair bands

1 black furry bath mat for back

white card or felt for teeth

2 plastic eyes

fixing kit (see page 8)

Keep an eye on the calendar for the arrival of the next full moon. Our werewolf is in the middle of the scary transition from man to beast, getting ready to pounce on any unsuspecting visitors to the bathroom. We have used bath mats for the hairy arms and legs, but you could use any really fluffy towels as a substitute.

TOP TIP

Our werewolf is in a crouching position but, if supported, this model would work well standing up.

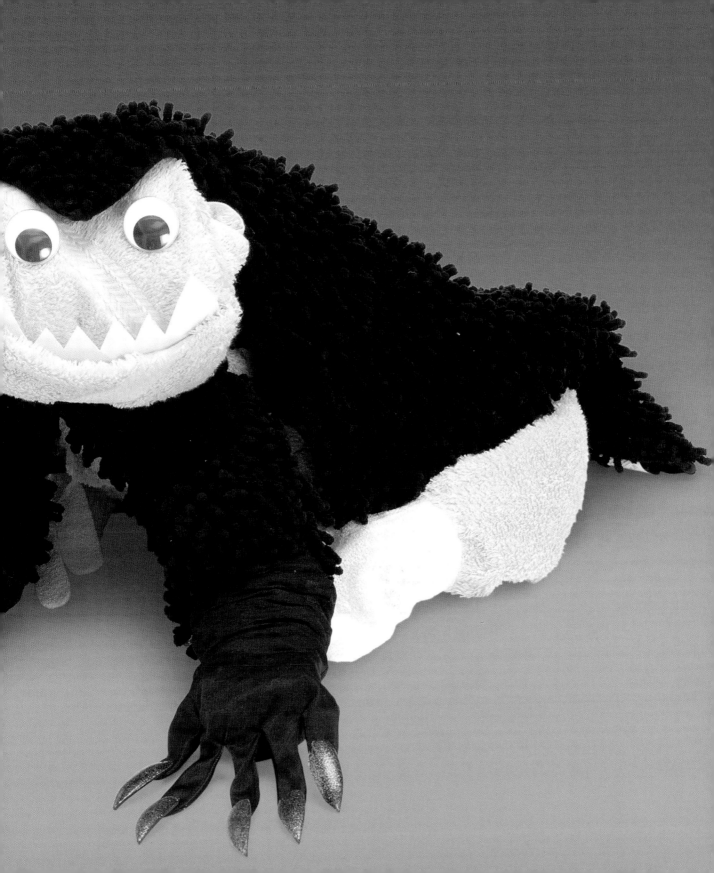

WEREWOLF

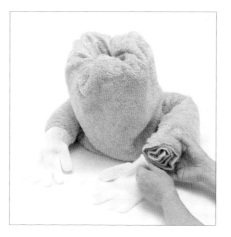

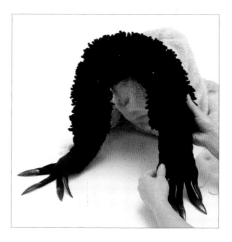

1 For the werewolf's lower body and hind legs, use the two beige bath sheets and assemble seated body shape 2 (see page 10). Sit the body upright and arrange the legs as a support on either side. Tuck each of the ends of the legs into white exfoliating gloves.

2 Roll up the black furry bath mat into a long sausage shape. Bend the shape in half and place it in front of the lower body. Lean the body shape toward the top of the arms to make a half-man, half-beast crouching pose. Tuck each end into a black Halloween glove.

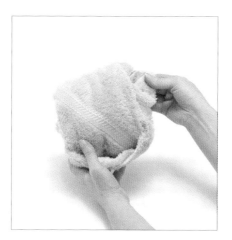

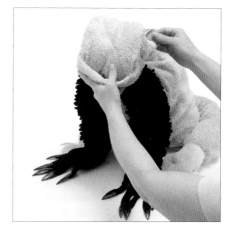

3 Take the beige hand towel and roll it to form head shape 2 (see page 11). Secure the overlap with a safety pin at the back. Pull out two small bunches of fabric each side of the top of the head to form ears, then secure each with an elastic hair band.

4 Position the head on the shoulders of the werewolf. You may need to use several safety pins to hold the head securely.

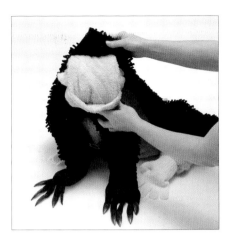

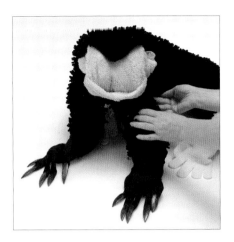

5 Place the remaining black furry bath mat along the werewolf's back in a diagonal fashion.

6 Tuck the edges around the body and bring the top corner over the top of the head (this will also help to keep the head in place).

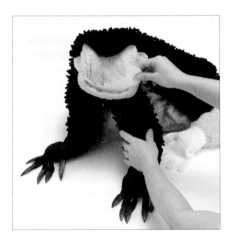

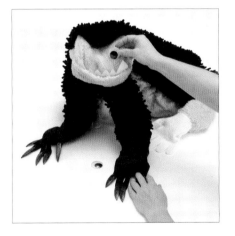

7 Take a sheet of white paper or felt and cut out a set of teeth. You may need to trim the teeth a little to fit on the lower lip.

8 Try to pinch the fabric in the center of the face to form the beginnings of a snout. Add two eyes to the face using double-sided adhesive tape to complete your werewolf model.

LASSIE

YOU WILL NEED

1 white bath towel for body padding

1 orange bath towel for body

1 white bath towel for front legs

1 orange bath towel for back legs

1 orange hand towel for head

2 white face cloths for markings

2 plastic eyes

fixing kit (see page 8)

"It's bathtime Lassie, come home!" Lassie was the rough collie who starred in the tearjerker *Lassie Come Home* (1943)—she really is the ultimate celebrity pooch. She is also a very special dog—always doing good deeds for people she meets on her journey home. Her distinctive coloring is easy to recreate using a selection of fluffy orange and white towels. She looks so cute it seems a shame to dismantle her at bathtime.

TOP TIP

You could use a white tufted bath mat to form the front legs, which would give the upper body and shoulders more volume.

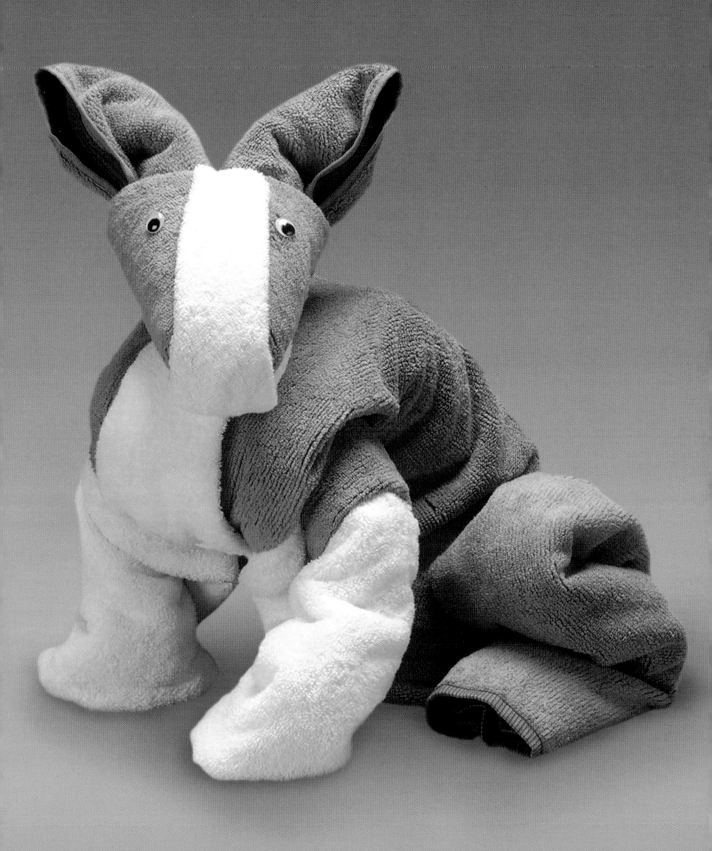

LASSIE

1 For Lassie's body padding, take a white bath towel and roll it up to form a cylinder about 16 inches (40 cm) long. Lay an orange bath towel out vertically and place the padding at the top. Wrap the bath towel around the padding and secure the overlap with safety pins.

2 Using the lower folded edge of the orange towel, lay out a white bath towel on top of it, horizontally. Fold in the top corners of the white towel diagonally. Roll it all up from the lower edge to form a long sausage to be the front legs.

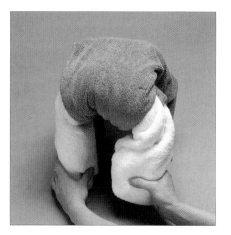

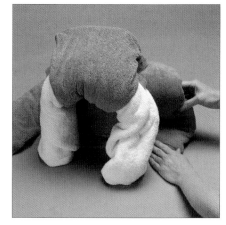

3 Gather both ends of the white towel to bring the front legs together. Hold the rolls in one hand while gently pushing the padded part toward them to form a body shape.

4 Take an orange bath towel and lay it out horizontally. Roll the towel from the lower edge to form a long sausage shape. Place the roll at the back of the seated shape and bend the ends to form Lassie's two back legs.

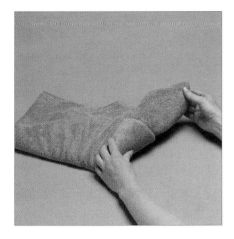

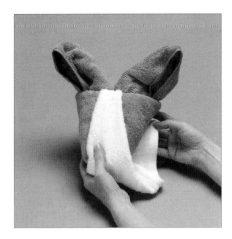

⑤ For Lassie's head, lay out an orange hand towel horizontally. Bring both side edges to meet at the center then fold the two top corners downward, also to meet the center line. Now bring the lower edge upward to meet the point at the top. Press all the folds flat using the palm of your hand.

⑥ Roll the two lower corners diagonally to meet at the center, forming a fat, pointed head shape. Use a safety pin to secure the roll at the top. You will see two corners protruding from the top of the shape. Manipulate these corners to form two ears.

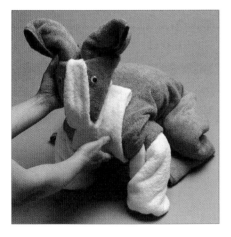

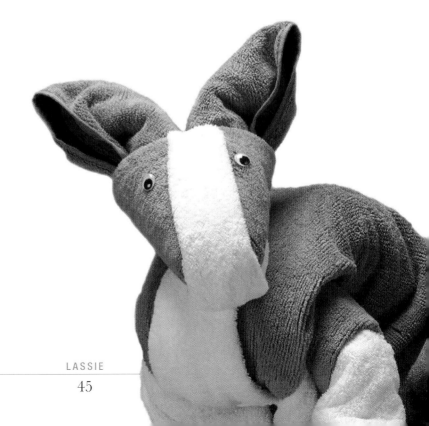

⑦ Place a corner of a white face cloth on Lassie's forehead. Wrap the remaining corners under her chin and secure with a safety pin. Pin the other white face cloth diagonally to her chest. Place the head into position on the body, securing if necessary. Add two eyes to complete your model.

KING KONG

YOU WILL NEED

*1 large white bath towel
for body padding*

*1 large grey bath towel
for body and legs*

1 large grey bath towel for arms

2 pairs of rubber gloves

1 grey hand towel for head

2 plastic eyes

fixing kit (see page 8)

Perhaps the greatest monster movie ever made, *King Kong* (1933) made a celebrity out of the young actress Fay Wray and the giant animated gorilla that fell in love with her. Our Kong has two pairs of rubber gloves for his hands and feet. Pin a small doll, Fay Wray, securely into one of Kong's rubber hands to complete your model.

TOP TIP

We used a self-patterned,
dark grey towel for our Kong,
but the model would work equally
well in black or brown.

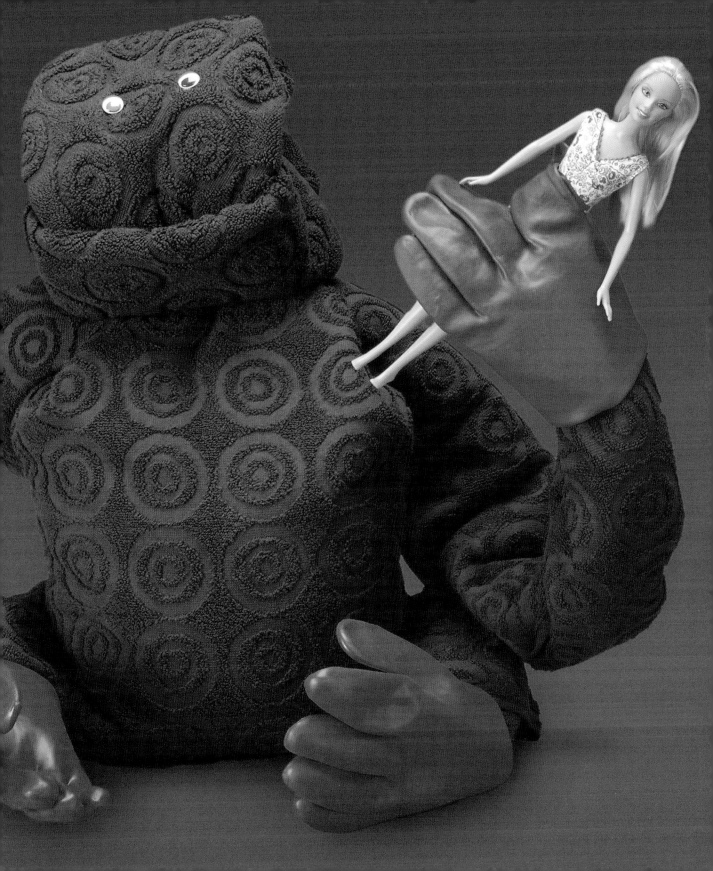

KING KONG

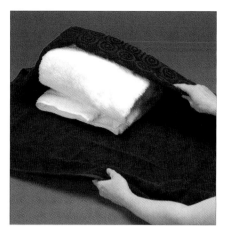

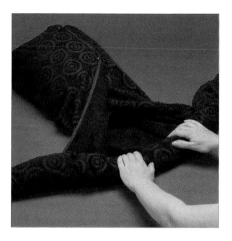

1 For Kong's body, using the large white bath towel as padding and the grey bath towel for the legs, assemble seated body shape 2 (see page 10). Wrap the grey bath towel around the padding and secure the overlap with safety pins.

2 Open out the lower edge of the grey bath towel and roll upward to meet the rolled pad inside. This shape will form Kong's body and back legs. Flip the shape over so that the overlap is at the back.

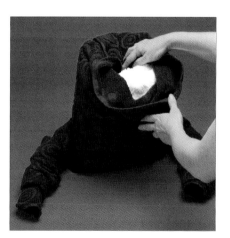

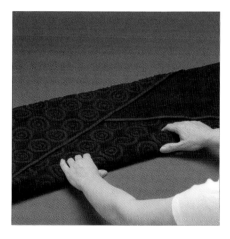

3 Slip your hand under the padded shape and stand it up on end. Bend the rolled lower edge around the sides of the body toward the front, so that the rolls form the legs, ensuring that the shape will sit steadily.

4 For Kong's long arms, lay a grey bath towel out horizontally and fold it in half diagonally from the top right-hand corner to the lower left-hand corner. Now grasp the diagonal folded edge and roll up the towel. Secure the overlapping corners using safety pins.

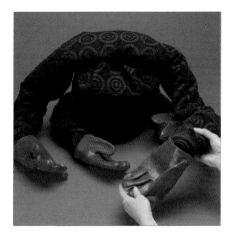

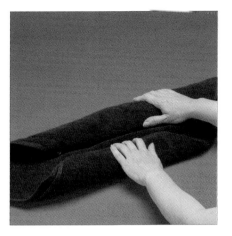

5 Place the center of the long roll on top of the padded body and secure with a safety pin. Tuck the ends of the arms and legs into the rubber gloves to form the feet and hands.

6 Use the grey hand towel to form head shape 2 (see page 11). Lay it out horizontally and fold in half by bringing the short edges together on the right-hand side. Now roll the top right-hand corner and the lower left-hand corner diagonally to meet in the center.

7 Beginning at the right-hand side, roll the shape to form a tight ball for the head. Peel back one of the remaining free points and wrap it around the rolled shape. Secure the loose edges. Place the head onto the body and secure with safety pins. Add two eyes to Kong's face and place the doll in his hand.

 # NESSIE

YOU WILL NEED

1 green bath towel for head
2 green hand towels for humps
2 plastic eyes
fixing kit (see page 8)

About 150 million years ago the Plesiosaur was one of the fiercest hunters in the world—a ferocious beast some 23 feet (7 m) in height. People have claimed that "Nessie," the celebrated Loch Ness Monster in Scotland, might be the last surviving Plesiosaur. Leave this towel recreation of Nessie afloat on the bed in your spare bedroom and ask your guests to photograph any sightings.

TOP TIP

You would think a mysterious sea monster would be green in color...but who's to say Nessie isn't pink with green spots? Try making Nessie with a colorful set of beach towels.

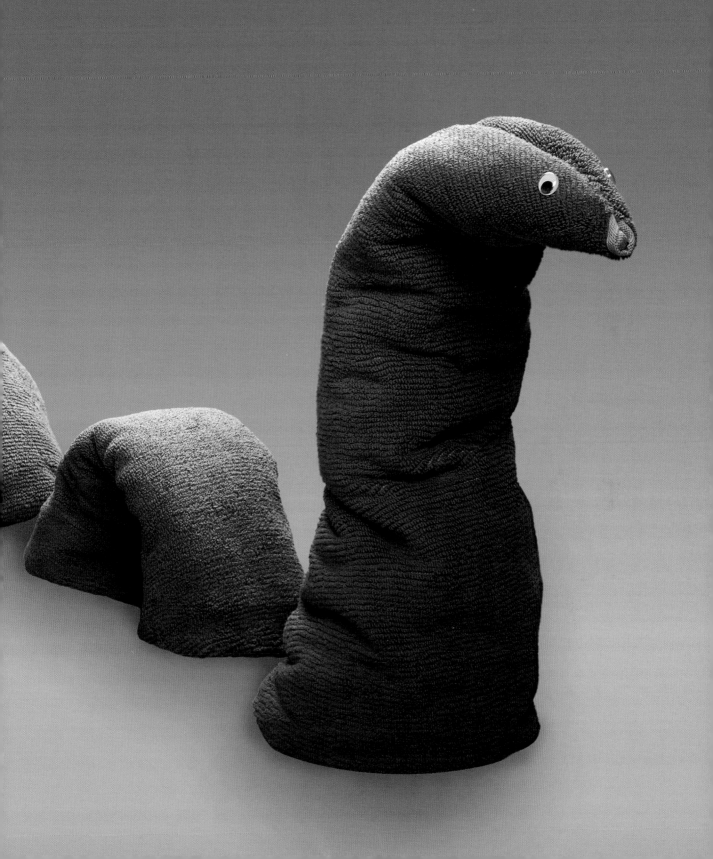

NESSIE

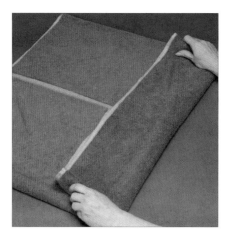

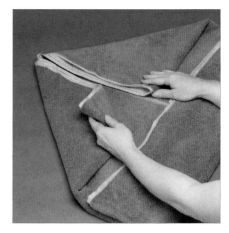

1 To make Nessie's head, lay the green bath towel out vertically, then fold the upper and lower edges to meet at the center. Indicate a crease line in the pile of the towel with your fingertip, about 6 inches (15 cm) in from the right-hand edge. Now fold along the crease line.

2 Fold the upper and lower corners of the left-hand side inward to meet at the center. Pat the diagonal folds flat using the palm of your hand.

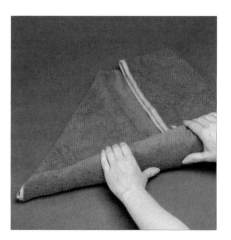

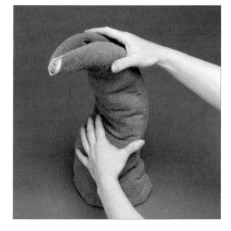

3 Grasp one diagonal fold and roll it toward the center. Do the same with the other fold, to form a long, pointed shape. This will become the head and neck. To keep the rolls in place you will need to secure them with a few safety pins.

4 Stand the shape up on the wide end and splay the fold's lower edge out a little, so that it balances steadily. Carefully bend the pointed shape to create the curved head and neck of the mysterious monster.

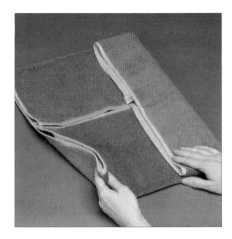

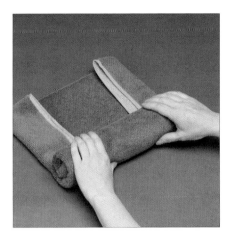

5 To make one of Nessie's humps, lay out a green hand towel vertically and fold the upper and lower edges to meet at the center. Now make a 4-inch (10-cm) fold along each of the side edges, then pat the folds flat using the palm of your hand.

6 Grasp the lower edge of the folded band and roll it up to form a cylinder. Use a few safety pins to secure the overlap to ensure that the shape does not unroll. Make one more hump in the same way.

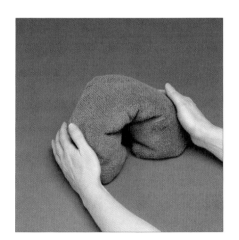

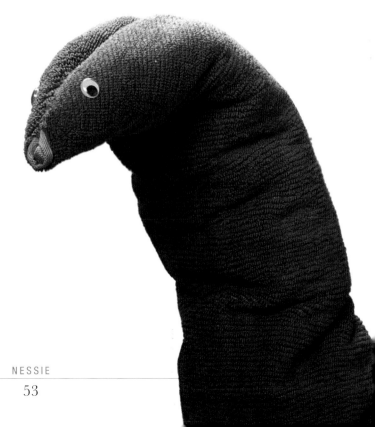

7 Bend the rolls gently to form inverted U-shapes. Splay out the folds at each end so that the shapes will stand up steadily by themselves. Place the curved humps in a row behind your Plesiosaur's head. Add two eyes to the head to complete your very own model of the Loch Ness Monster.

ANGEL

1 beige bath sheet for body

1 beige bath towel for head

1 beige face cloth for neck

1 beige net body exfoliator for hair

1 white hand towel for wings

cord or string for wings

1 white patterned bath mat for dress

1 wire coat hanger for halo

fluffy white pipe cleaners for halo

plastic eyes

small book of carols

fixing kit (see page 8)

This model is definitely one for Christmas. Make a single figure, or a dazzling host of heavenly angels to herald the start of the festive season. We used white for the angel's dress but any pale pastel color would work just as well. Hide some bathtime treats or prettily wrapped candies under the angel's skirt for your guests to find. For a singing angel, add a book of Christmas carols to the model.

TOP TIP

If you really feel adventurous, try "flying" the angel from the shower rail. You'll need lots of extra pins and some strong fishing line for this.

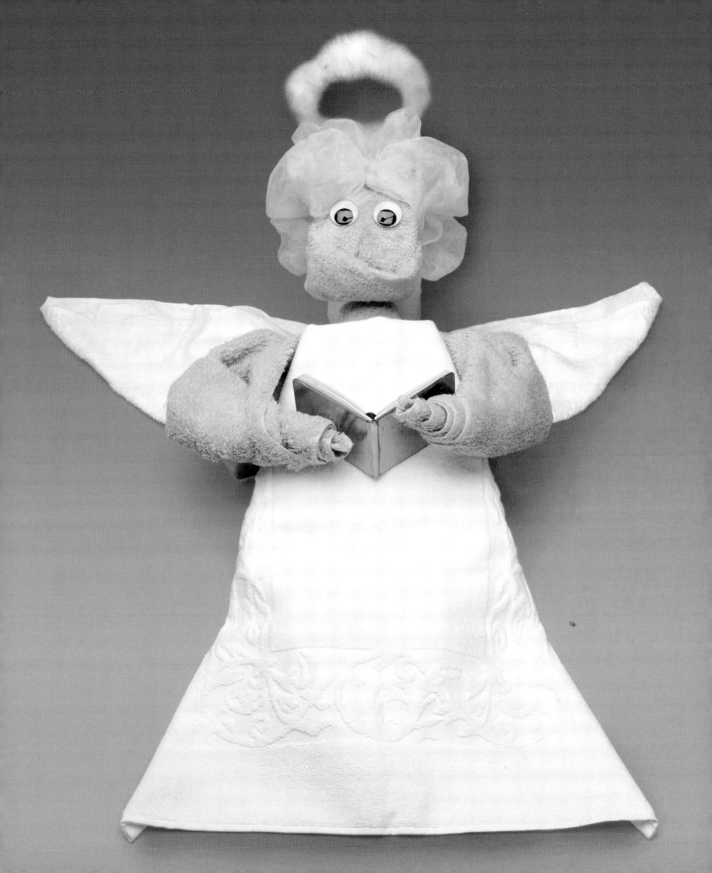

ANGEL

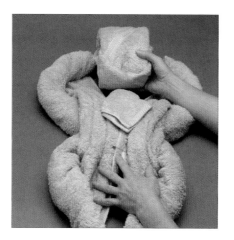

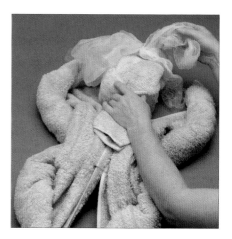

1 For the angel's body, use the beige bath sheet and roll it into the basic four-limbed body shape 1 (see page 10). Use the beige bath towel to form head shape 2 (see page 11). Fold a beige face cloth diagonally into a triangle then roll loosely to form a neck. Secure the head to the neck and body.

2 Place the beige net body exfoliator hair on top of the head. Fix the hair in place and arrange neatly.

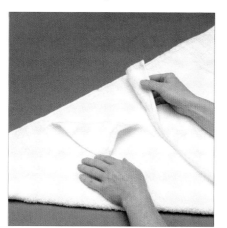

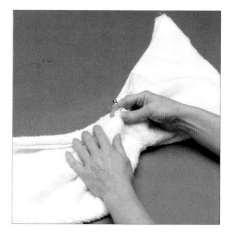

3 For the wings, take the white hand towel and lay it out horizontally. Fold both lower corners toward the center for a triangular shape.

4 Gather up the towel at the center of the wings and secure with a pin or tie with a short length of cord or string.

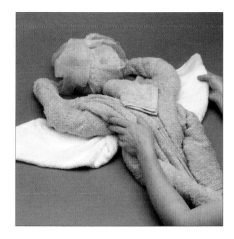

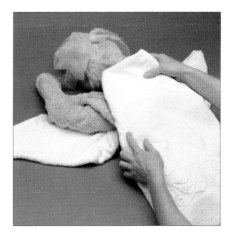

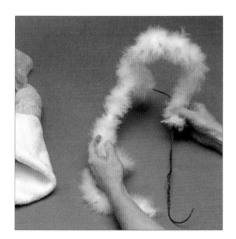

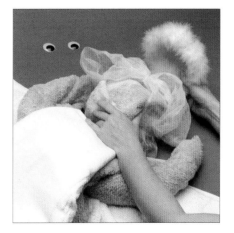

5 Lay the angel's body and head onto the wings. Arrange the folded wings into a pleasing shape.

6 For the angel's dress, take the white patterned bath mat and lay it onto the angel's body. Tuck the top corners under to form a neat shape around the armholes and neckline. You can make the dress quite long so it covers the feet.

7 For the finishing touches, take a coat hanger and bend it into an 8-inch (20-cm) diameter circle with a long stem. Wind the fluffy pipe cleaners around the circular halo.

8 Tuck the stem of the halo behind the angel's head and add two eyes using double-sided adhesive tape to the face to complete the model. Finish off your angel by placing as a small carol book in the angel's hands.

DEVIL

YOU WILL NEED

*1 white bath sheet for
body padding*

1 red bath towel for legs

1 red hand towel for arms

1 red hand towel for head

red felt and cord for tail

2 plastic eyes

toy trident

black felt for beard and eyebrows

fixing kit (see page 8)

This character certainly has a wicked devilish look about him—it must be the eyebrows. There is only one color of towel that works for this model—and that's red. In fact, you should use the brightest red you can find. If you really want to get creative, try carving two cloven hooves from dark-colored bars of soap and place them at the ends of the legs.

TOP TIP

We used a bath sheet for the body padding, but you could use a couple of toilet rolls or perhaps a toiletries bag full of bathtime goodies.

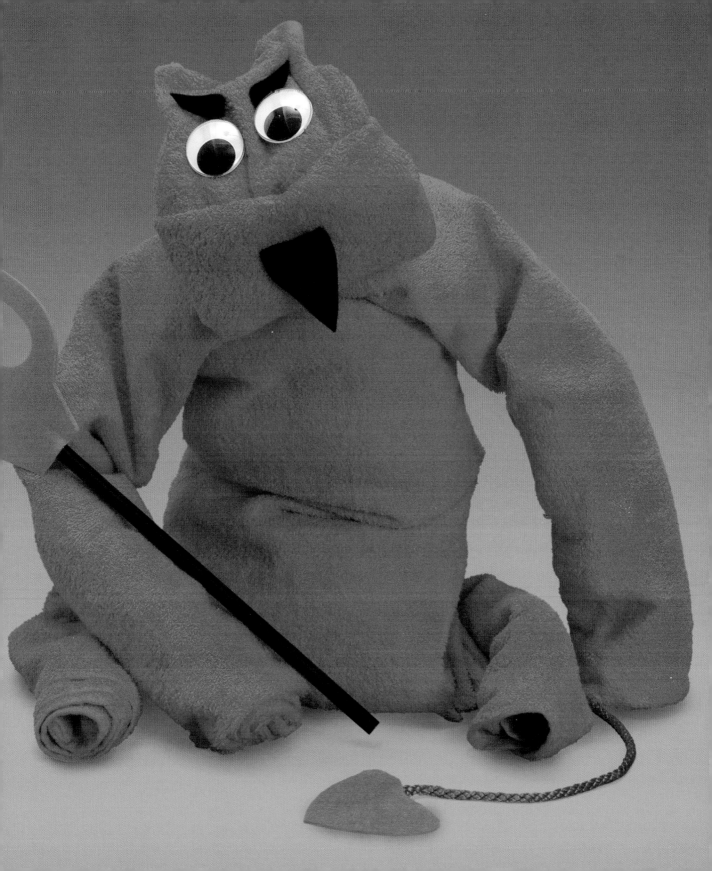

DEVIL

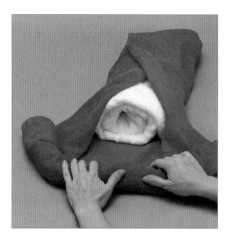

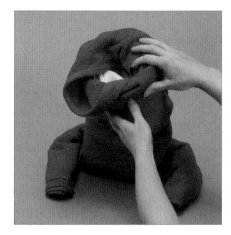

1 For the devil's body, using the white bath sheet for padding and red bath towel for the legs, assemble the seated body shape 2 (see page 10). Wrap the long edges around the pad at the top, then roll up the lower short edge to make the legs.

2 Tuck the edges of the red towel into the body roll at the top. Sit the shape on the rolled legs at the lower end. Arrange the legs to support the body and keep it steady.

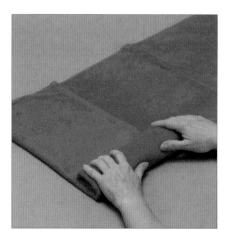

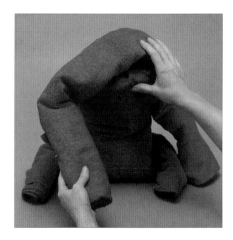

3 Lay the red hand towel out horizontally and make a 6-inch (15-cm) wide fold at each short end. Now roll up loosely from one long edge to form the arms.

4 Place the center of the roll on top of the body shape and arrange the rolled ends each side of the body to form two arms.

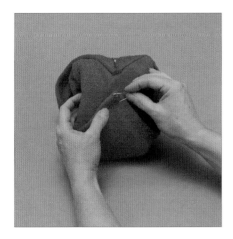

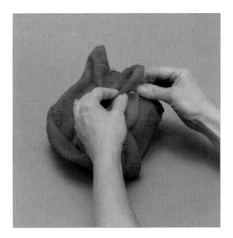

5 Take the remaining red hand towel and roll to form head shape 2 (see page 11). Use a safety pin to secure the lower corner to the rolled shape at the back.

6 Pinch two small bunches of fabric each side of the top of the head and tease the fabric into two horn-shaped protuberances. Use safety pins to hold the horns securely.

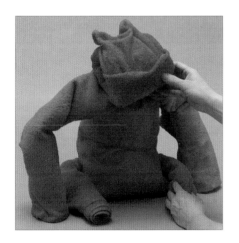

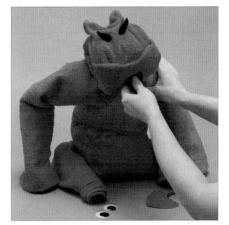

7 Place the head on the shoulders of the body shape. The head should balance quite well, but secure it with a few pins if the head begins to wobble.

8 For the devil's tail, cut out an arrowhead shape from felt and fix to the end of the red cord. Tuck the other end of the cord under the body at the base. Complete your devil by adding two eyes to the face and a trident. Add a black felt goatee beard and pointed eyebrows, just for fun.

BATHTIME
SNACKS

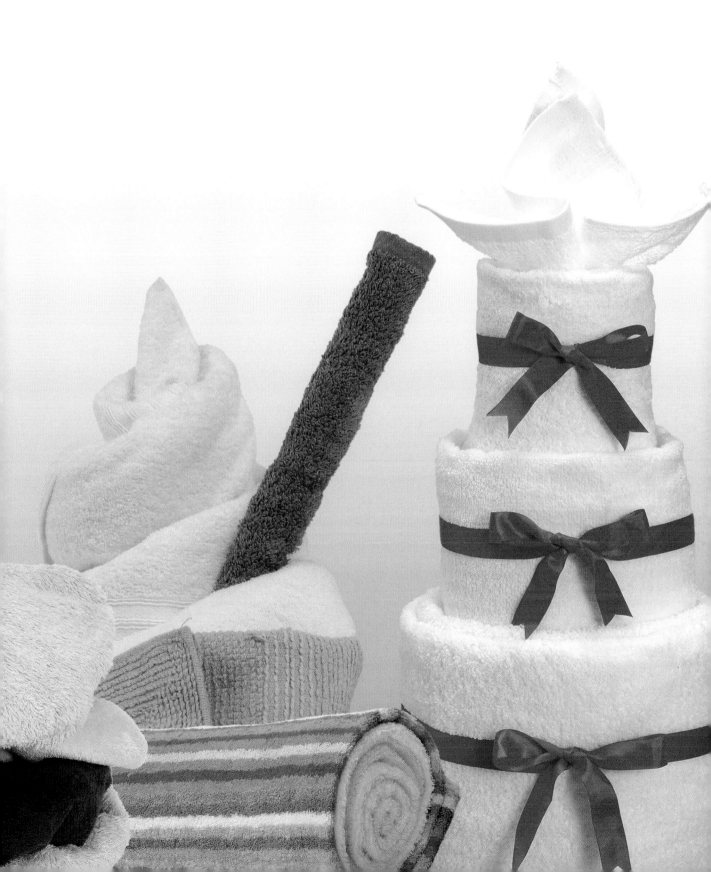

🚰🚰 CUPCAKE

YOU WILL NEED

1 beige bath towel for cake

1 white ribbed bath towel for cake case

1 pink hand towel for frosting

1 red net body exfoliator for cherry

fixing kit (see page 8)

Colorful cupcakes are really fashionable these days, and there is really nothing better than a cupcake to satisfy a sweet tooth. This cupcake is topped with a classic pink frosting and a cherry, but you can really get creative with the decorations. Tiny soaps or bath pearls would look great—you could even use foil-wrapped candies, but be sure to warn your guests which decorations are edible.

TOP TIP

Why not use shiny bath pearls dotted over the frosting to simulate popular cake decorations? Cake cases come in many different colors these days, so you could be a little adventurous with yours.

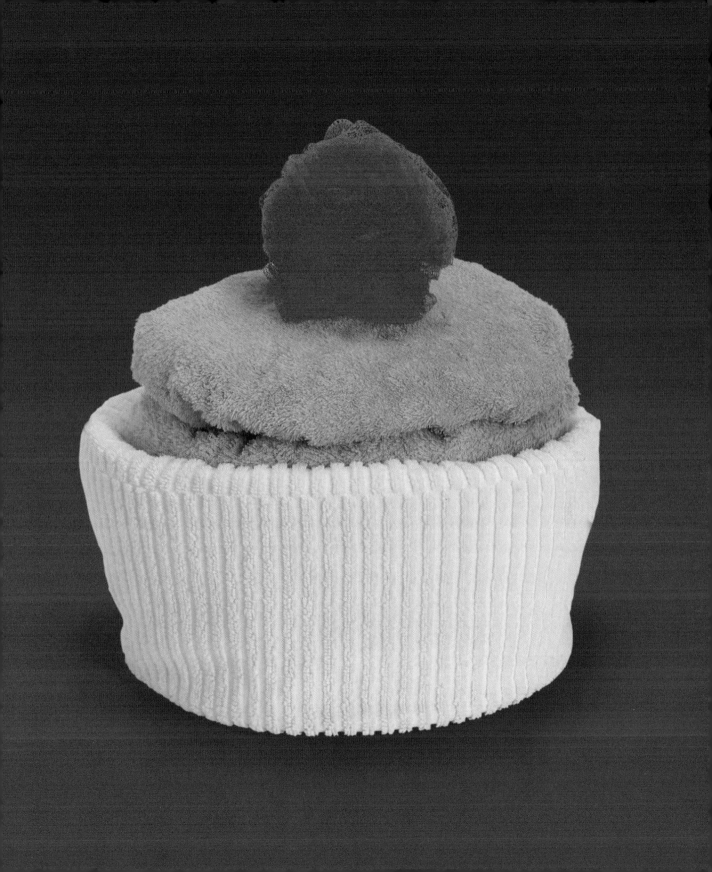

CUPCAKE

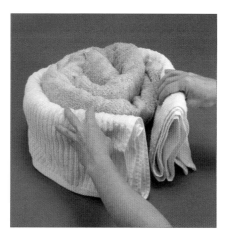

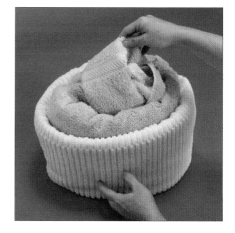

1 To make the cake, lay the beige bath towel out horizontally and roll up loosely from one long edge. Roll up the resulting sausage shape to form a loose, round coil.

2 Take the white bath towel and lay it out vertically. Try to use one that has a textured stripe or ribbed pattern to simulate the folds in a paper cupcake case. Fold the towel in half by bringing the lower edge to meet the upper edge. Now fold the resulting square in half, then in half again to form a thick band.

3 Wrap the white band around the rolled-up cake. Secure the ends of the band at the back of the cupcake using several safety pins. Overlap the ends at the base of the model to create a slightly sloping shape for the case.

4 Mold your cupcake until you are satisfied with the shape. Now reach into the center of the cake and tease out the inner end of the roll. Pull the end of the roll upward and spread out the folds a little to make a domed shape.

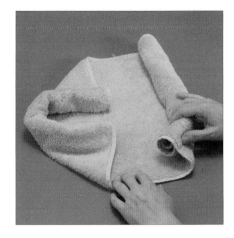

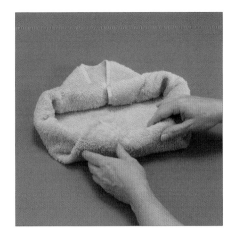

5 For the frosting, take a small pink hand towel and lay it out horizontally. Divide the towel into thirds. Roll both short ends in loosely. At each end, bend the roll toward the center, making a soft "V" shape. The four rolled ends should butt against each other at the center.

6 Take the loose points that lie at the top and bottom of the rolled frosting shape and wrap around the rolled-up ends to form a soft, rounded disc shape. Use safety pins to secure the shape.

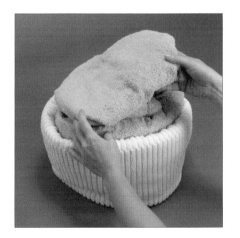

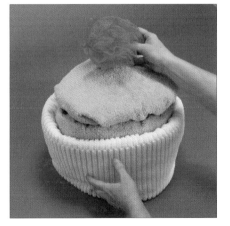

7 Place the frosting on the top of the cake. If necessary, tease out the inner roll of the cake part to achieve a pleasing, rounded shape.

8 Use a red net body exfoliator as the cherry decoration for your cupcake. A red or pink bath bomb, pretty soap, or rounded sponge are other decorative alternatives.

 # WEDDING CAKE

YOU WILL NEED

2 white bath sheets for base layer

2 white bath towels for second layer

2 white hand towels for third layer

1 red satin ribbon for trim

1 white face cloth for trim

fixing kit (see page 8)

We've called this classic model a wedding cake, but it would be just as suitable as a special birthday gift or a thoughtful housewarming token. Simple white towels are set off with striking red satin ribbons, but a similarly delightful effect can be achieved by using pastel or even chocolate-brown towels, with lace or tassel trimmings. If you give this towel arrangement as a gift, wrap it up in a large square of clear cellophane so the layers keep their shape.

TOP TIP

As an extra treat, decorate the top of each layer with a row of colorful foil-wrapped chocolates. No doubt they will be eaten long before bathtime.

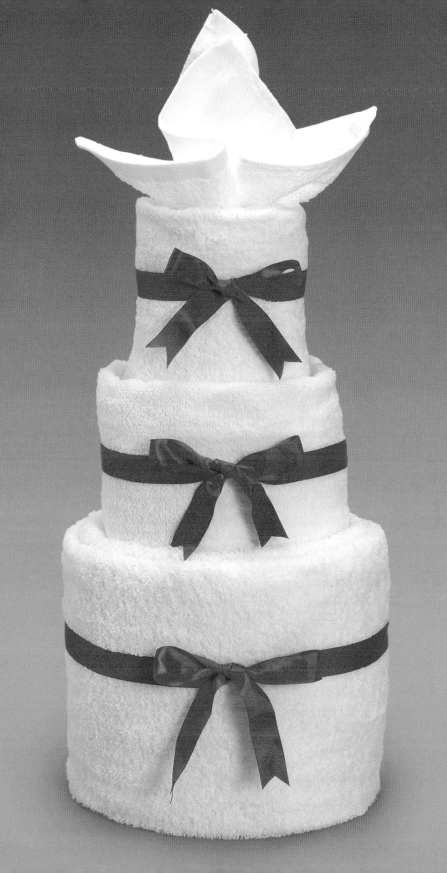

WEDDING CAKE

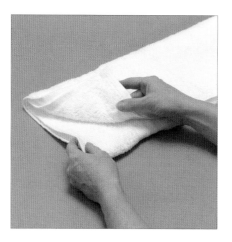

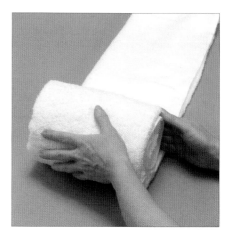

1 Lay one white bath sheet out flat horizontally and fold into thirds, folding the lower edge upward first so a fold, rather than an edge, lies across the top. If the towel is very wide, fold it into quarters.

2 Roll up the folded strip tightly from one end. Now fold the second white bath sheet in the same way as the first.

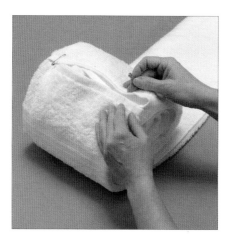

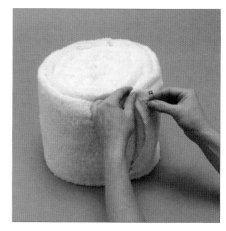

3 Pin the end of the second white towel to the edge of the first and roll it tightly around the first roll to make a large base.

4 Sit the resulting drum shape flat and secure the loose edges at the back using a few safety pins.

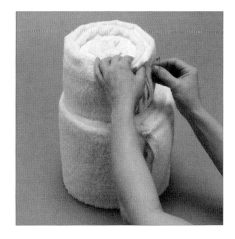

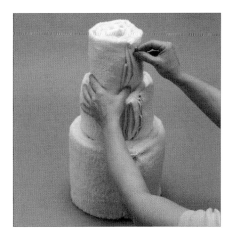

5 Make the second layer of the cake in the same way, but this time using the two white bath towels. Secure the edges at the back and set on top of the base layer.

6 Make the third layer of the cake in the same way using the two white hand towels, and arrange it on top of the first and second layers.

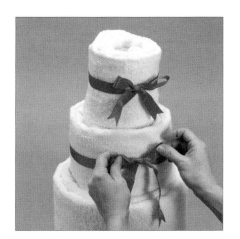

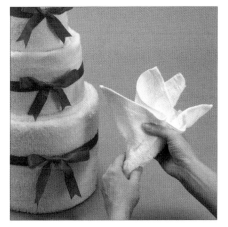

7 Wrap a length of red satin ribbon around each layer of the cake and finish with pretty bows. You could use lace or other decorative trimmings or even cut-out paper bands, if you prefer.

8 Pick up a face cloth from its center and pinch it into points. Tuck the cloth into the top layer of the cake as a final decorative flourish.

ICE-CREAM CONE

YOU WILL NEED

1 beige waffle texture bath mat (or beige towel) for cone

1 white hand towel for cone padding

1 white bath sheet for ice-cream

back scrubber or face cloth for chocolate finger

fixing kit (see page 8)

This ice-cream cone looks quite impressive but is really quite easy to make. The addition of the chocolate finger makes it extra special. We used a bath mat for the cone because the fabric is stiffer and holds its shape better. However, you could use a biscuit or beige-colored towel, instead, and ideally one with a texture or waffle pattern.

TOP TIP

You could also make an ice-cream tub using the same swirly ice-cream method, plus the cup from the cupcake model. Simply add a face cloth as a biscuit wafer to complete the effect.

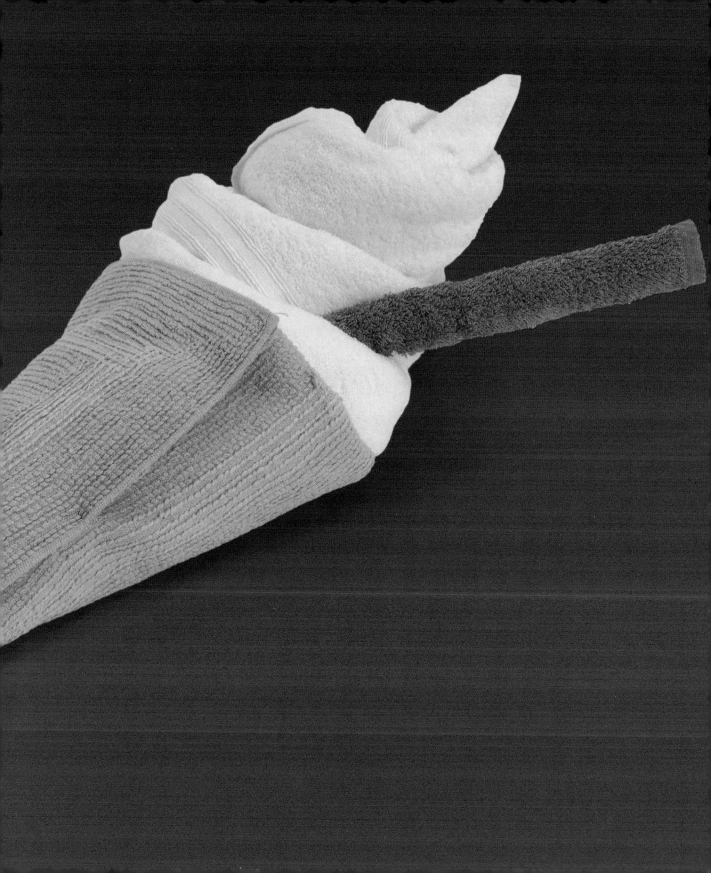

ICE-CREAM CONE

1 Take the beige bath mat and lay it out horizontally. Divide into three vertically by making lines with your fingertip. Fold the right-hand edge inward along the vertical line.

2 Roll the bathmat into a cone shape and fix the overlap securely in place using a few safety pins. Try to conceal the pins so they do not spoil the appearance of your model.

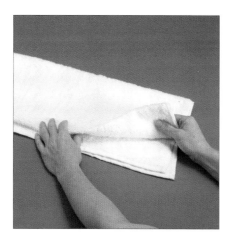

3 To pad the cone, lay the white hand towel out vertically then fold in half by bringing the top edge to meet the lower edge. Repeat the process to form a thick band. This will help retain the cone's three-dimensional shape and support the ice-cream.

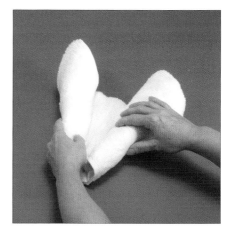

4 Roll the top left-hand corner toward the center. Do the same with the top right-hand corner. This forms a pointed triangular shape to support the cone.

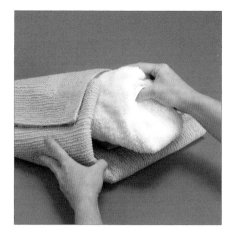

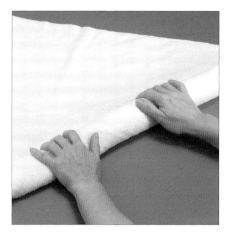

⑤ Insert the triangular shape into the bathmat cone and press well down into the point. As a nice surprise for your guests you could also tuck a few bathtime goodies such as tiny bottles of bath foam or pretty soaps inside the padding.

⑥ Take the white bath towel and lay it out horizontally. Beginning at the lower right-hand corner, roll it up diagonally to form a long, thin, tapered shape to create the ice-cream.

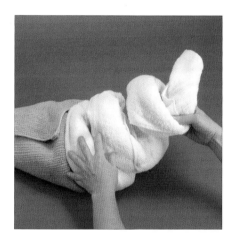

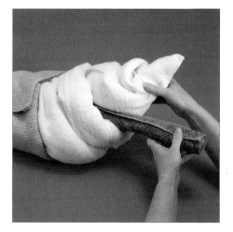

⑦ Place one end of the roll inside the cone and coil the roll around until it resembles a tapering swirl of ice-cream. Use a few safety pins to secure the ice-cream spiral to a point at the back of the cone. Adjust the folds so the ice-cream cannot unwind.

⑧ Finally, add the chocolate finger to make your ice-cream cone extra special. We used a tightly rolled-up chocolate-colored face cloth, but a sisal back scrubber would do the job just as well.

CANDIES

YOU WILL NEED

1 striped hand towel for humbug

1 striped bath towel for candy

*1 white bath sheet
for inside candy*

*brightly colored face cloths
for wrapped candies*

*net body exfoliators
for wrapped sweets*

elastic hair bands

fixing kit (see page 8)

This pile of assorted candies is extremely quick and simple to make and will look really pretty in any bathroom. For some extra fun, fill them with bath sponges, soaps, or tiny bathtime goodies for you or your guests to enjoy. You could also try filling a laundry basket with several candies to create possibly the world's largest bowl of candies.

TOP TIP

We used a face cloth to pad the wrapped sweet but you could use an assortment of bath treats as a substitute. This could be a really novel gift wrap idea for a birthday or Christmas present.

CANDIES

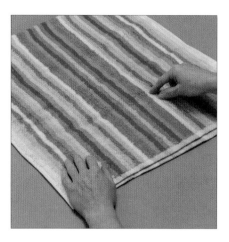

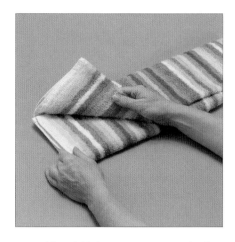

1 Take a striped hand towel and lay it out vertically then fold in half by bringing one short edge to meet the other. Make horizontal guide lines in the fluffy pile using your fingertip to divide and mark the towel into thirds.

2 Now fold the towel along each of the two guidelines to form a thick band. Flatten out the fabric using the palm of your hand.

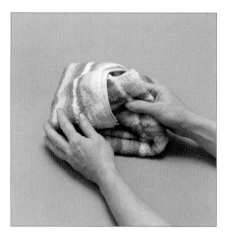

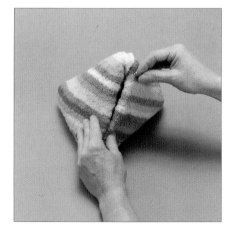

3 Grasp the left-hand end and bring it toward the center of the band. Take up the other end and tuck it inside the first end. This will form a fat square shape. You may secure the overlap with a few safety pins at this point.

4 Now use a few small safety pins to close one end of the shape (you could insert some bathtime treats inside the shape at this point). Now refold the other end so it is at right angles to the first and secure in the same way. This forms the characteristic triangular humbug shape.

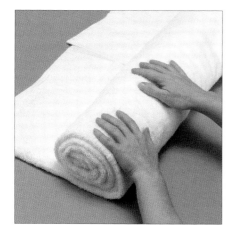

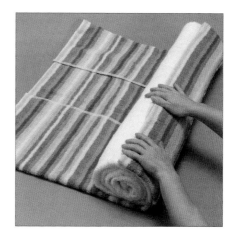

1 To make the second candy (and a really easy and fun way to organize your bath towels), simply fold a white bath sheet in half, by folding the short edges toward the center, making a square shape. Now roll the sheet up tightly to form a slim sausage shape.

2 Fold the short edges of a stripy hand towel toward the center, making sure it is the same width as the white roll. Wrap around the outside of the white roll. Secure the overlap with safety pins.

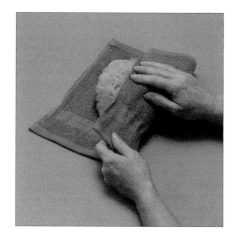

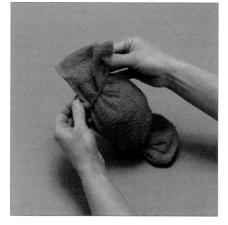

1 To make the third candy, take a brightly colored face cloth (or striped hand towel) and lay it out vertically. Place a net body exfoliator (or a face cloth) in the center near the short end as stuffing. Roll the face cloth and secure the overlap with a safety pin.

2 Gather the ends of the face cloth together using hair band elastic (or you could use cable ties or ribbon). Then spread out the folds to resemble a wrapped sweet.

BURGER

YOU WILL NEED

2 beige bath towels for buns

2 beige bath towels for padding

1 brown bath towel for burger

1 yellow hand towel for cheese slice

fixing kit (see page 8)

This fun burger looks good enough to eat. Elvis was well known in his later years for his large appetite for fast food, but even the King of Rock 'n' Roll would have trouble eating this enormous cheeseburger for his lunch. If you really want to impress your house guests, give them a burger with fries. Cut the biggest yellow sponge you can find into fry-shaped fingers— arrange them next to the burger with a dish of red bath gel for dipping.

TOP TIP

Ring the changes by adding
a green face cloth as lettuce
or a red one for tomato.

BURGER

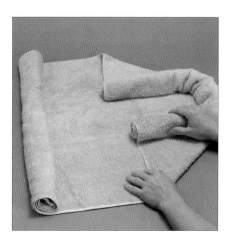

① For the bun, lay a beige bath towel out horizontally and make vertical guidelines in the fluffy pile, using your fingertip to divide and mark the towel into thirds. Roll both short ends to meet the guidelines. Now bring the rolled ends toward the center to form a curved shape on one side.

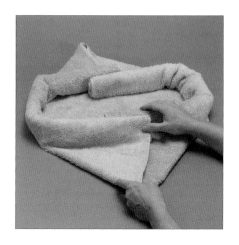

② Take both ends of the roll on the other side and bring toward the center as previously. A soft, pointed fold will have formed at the lower and upper edges. These points will be used to secure the bun padding in the next step.

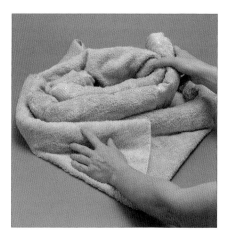

③ Take the second beige bath towel and lay it out horizontally. Roll up into a loose sausage shape beginning at the lower long edge. Roll the sausage up and secure the end using a safety pin. This will form the padding for the bun-half.

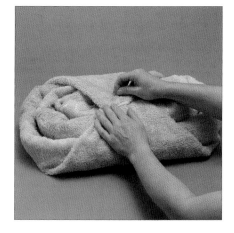

④ Place the bun padding into the shape made in step 2. Bring the pointed folds that lie on the upper and lower edge of the bun to meet at the center. Secure the points together using a safety pin. Make another bun-half in the same way.

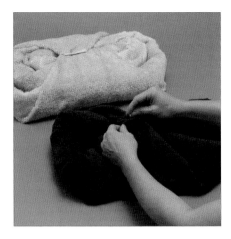

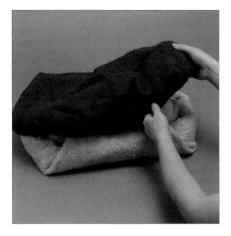

5　Take the brown bath towel and roll up into a long sausage shape in the same way as for the bun padding. Secure the pointed overlaps using a safety pin so it does not unroll itself.

6　You may now begin to assemble your burger. Flip over the brown towel shape and place on top of the first bun half.

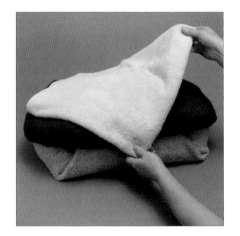

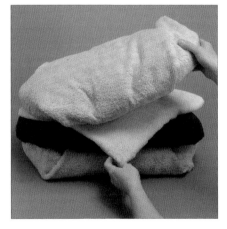

7　For the cheese slice, take the yellow hand towel and fold it in half by bringing the short edges together. Place the resulting square diagonally on top of the burger.

8　Finally, flip over the second bun-half and place on top of the yellow towel to complete your juicy burger.

HOT DOG

YOU WILL NEED

*2 white hand towels
for bun padding*

1 beige bath towel for bun

1 brown bath towel for sausage

1 red face cloth for tomato sauce

fixing kit (see page 8)

It is said that a gentleman called Charles Feltman sold the hot dog way back in 1874 in New York City, but its origin is unclear. The hot dog has also been attributed to an obscure butcher said to have invented the "little-dog" sausage in Europe. Who would have thought that a snack as simple as this would remain a popular fast food favorite today? If you like yours with extras, why not tuck a few beige-colored net body exfoliators inside to look like fried onions?

TOP TIP

If you prefer a squirt of mustard to liven up your hot dog, just substitute a dark-yellow hand towel for the red, then roll, bend and apply in the same way.

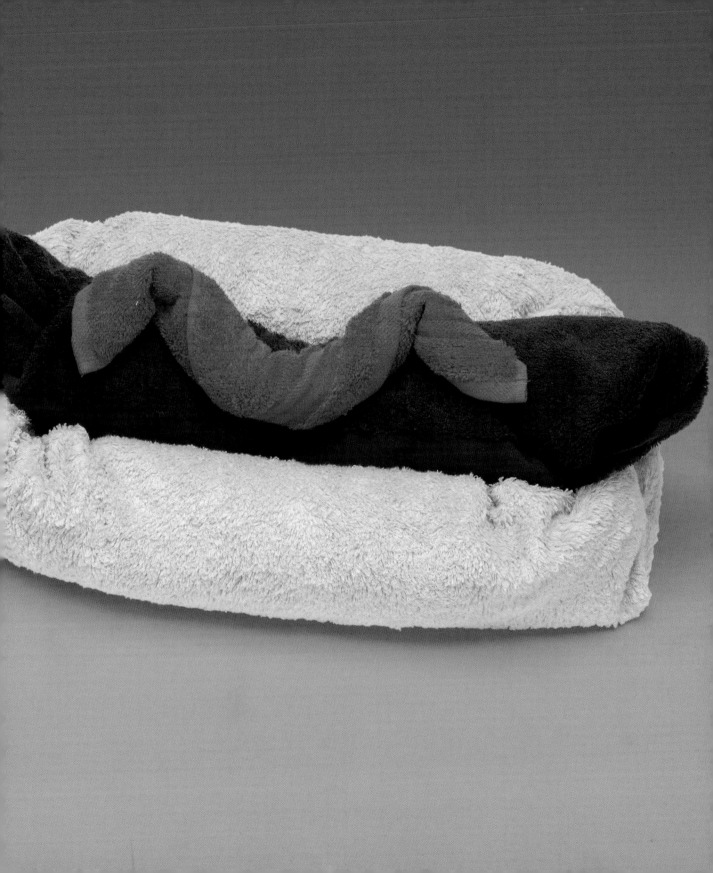

HOT DOG

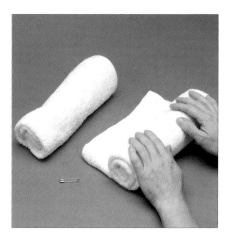

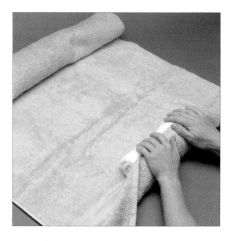

1 Fold each white hand towel in half to form a square, then in half again to form a thick band. Roll each into a tight cylinder. These two cylinders will form the padding in each half of the bun so it holds a nicely rounded shape

2 Lay the beige bath towel out vertically and lay a white cylinder halfway along the top and bottom edge. Roll up the towel enclosing the cylinders so the rolls meet at the center.

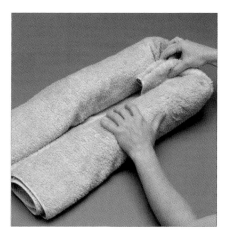

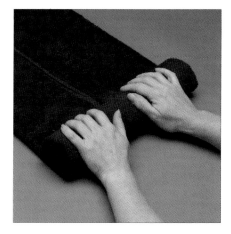

3 Tuck the side edges inwards around the inner padding rolls to form the split hot dog bun shape. You may need to use a few safety pins at this point to keep the shape secure. Tuck in all the tapes at the towel edges so they are not seen.

4 For the hot dog sausage, take the brown bath towel and lay it out vertically. Fold the long side edges to meet at the centre. Now roll up the towel from the lower edge stopping short of the top edge by about 8 inches (21 cm). Open out the top edges.

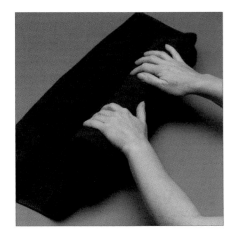

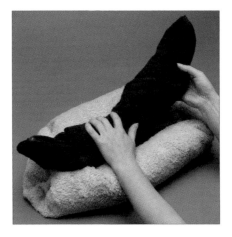

5 Continue to roll the sausage upwards then wrap the corners that were opened out in the previous step around the ends of the sausage. Pull the remaining edge around the center of the sausage and use a safety pin to secure.

6 Take the sausage at both ends and bend slightly to resemble a real hot dog sausage. Place the sausage inside the bun and arrange the folds neatly. Use a few safety pins to secure the sausage in place.

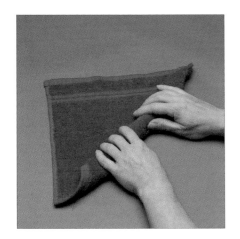

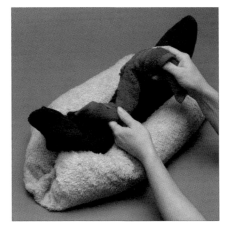

7 Roll the red face cloth up tightly in a diagonal fashion beginning at one corner. Use a safety pin to secure the overlap if necessary. Bend the rolled up cloth into a zig-zag shape. If necessary, use a few large safety pins on the underside to fix one bend in the zig-zag shape to the next.

8 To complete your hot dog, simply arrange the rolled-up face-cloth tomato sauce in a zig-zag stripe along the hot dog sausage.

WATER CREATURES

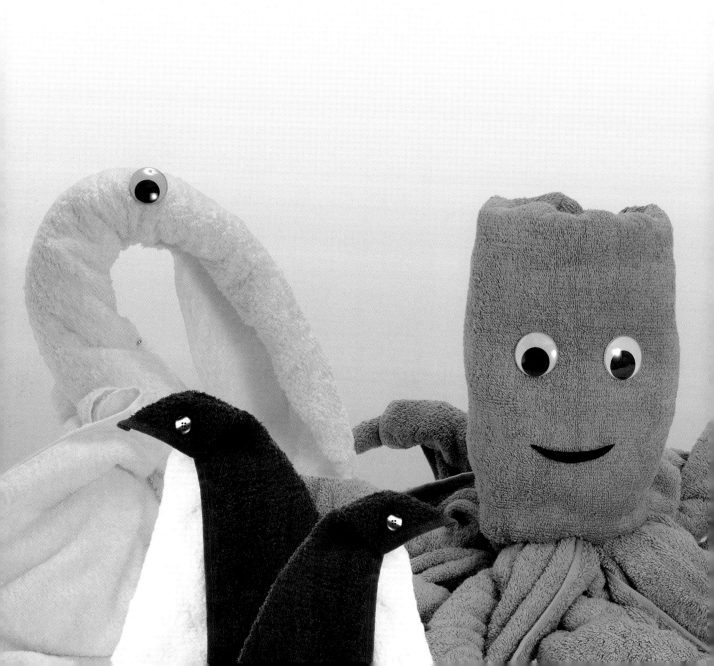

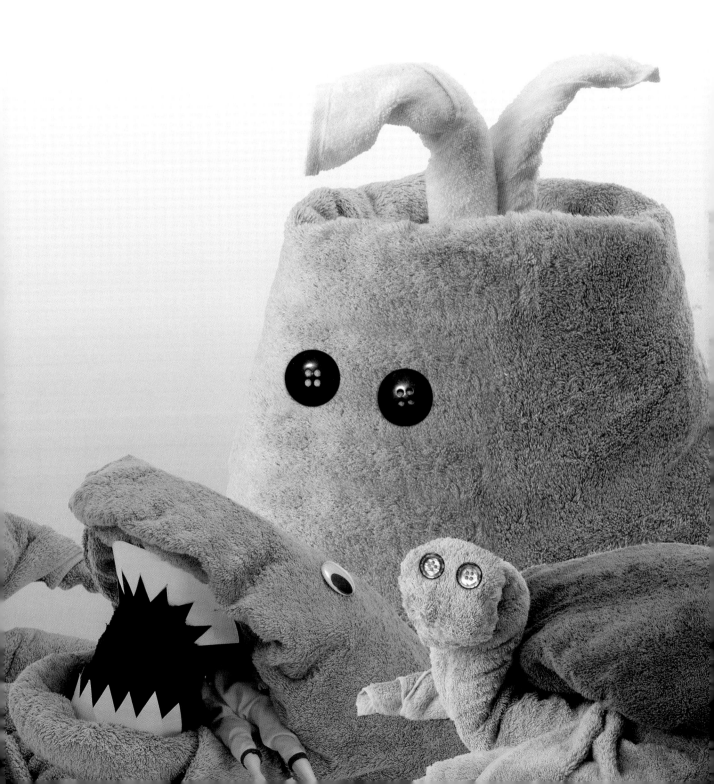

ANGEL FISH

YOU WILL NEED

1 yellow hand towel

2 colored face cloths for tail fins

2 plastic eyes

fixing kit (see page 8)

You can normally find angel fish swimming in a tropical paradise. Towelling angel fish can be made from towels in a single color or a combination of pastel or bright colors. As a simple shape, the angel fish translates well for both large and small towels, and for face cloths, too. It's a simple task to create a whole shoal of little fishes to swim across the foot of the bed. It's not quite the same as being in a tropical paradise, but it's still lots of fun for your guests.

TOP TIP

Square face cloths are excellent for making a little entourage of tiny fish to accompany a larger fishy fellow made from a bath towel.

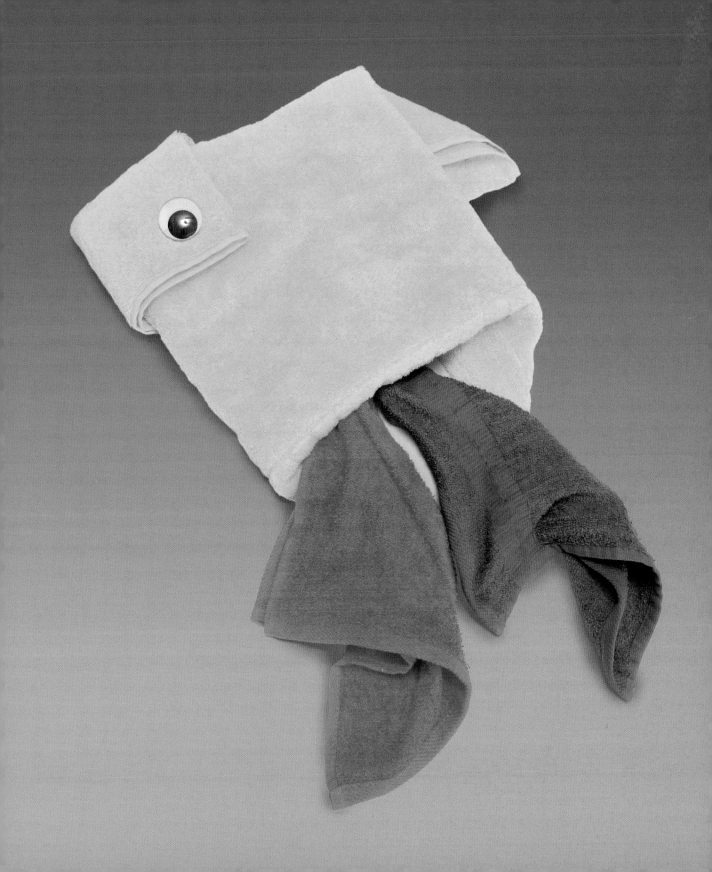

ANGEL FISH

1 Lay the yellow hand towel out horizontally, then fold in half widthways by bringing the left-hand edge over to meet the right. Press the fold flat using the palm of your hand.

2 Fold the top left-hand corner underneath the shape. Press the fold flat. The diagonal edge should lie approximately at the halfway point along the top and left-hand edges. Now fold the resulting square in half, then in half again to form a thick band.

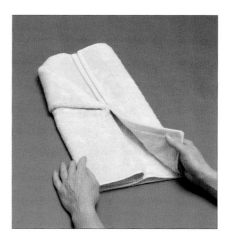

3 Fold the shape in half widthways to indicate the center then open out the shape again. Fold each side inward so they meet at the center crease line. Press the folds flat.

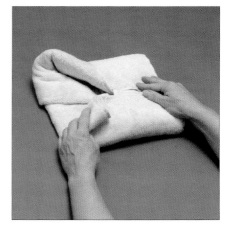

4 Divide the shape roughly into four again but horizontally this time, then fold the top and bottom edges toward the center and press the folds flat.

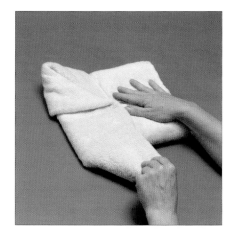

5 Pull out the left-hand point that lies inside the top fold. When the point is released from the fold, arrange it so it points downward, then press it flat.

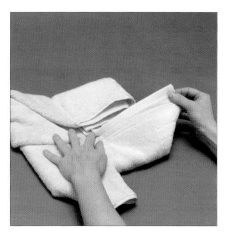

6 Repeat with the other point that lies inside the fold on the right-hand side, but this time arrange it so that it points away from the shape. Repeat with the point that lies inside the upper fold.

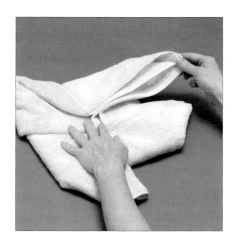

7 Slip one hand under the shape and lay the other flat on the top. Now flip the shape over to the other side, keeping all the folds in place. The previous points will now resemble fins.

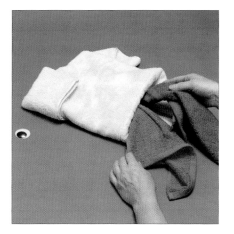

8 Take the face cloth and hold it in the center. Run the cloth through your hands to form a fin shape. Add it to the tail by tucking it under the fold and repeat with another face cloth. Add an eye to finish off the tropical fish.

SHARK

YOU WILL NEED

2 gray hand towels for fins

1 black hand towel for jaw support

cord or ribbon for jaws

1 gray hand towel for jaws

1 gray bath towel for head

1 gray hand towel for head

2 plastic eyes

white card for teeth

fixing kit (see page 8)

Just when you thought it was safe to go back in the water… here is a scary shark, hungry for lunch. You could construct this model on top of a bed or on the bathroom floor for more impact. For a gruesome scene, place a toy doll in the shark's mouth as a lunchtime snack. The circling fins look particularly menacing; your guests had better watch their step as they hop into the bath or shower.

TOP TIP

To make your model extra scary, use a red or pink towel as the jaw support.

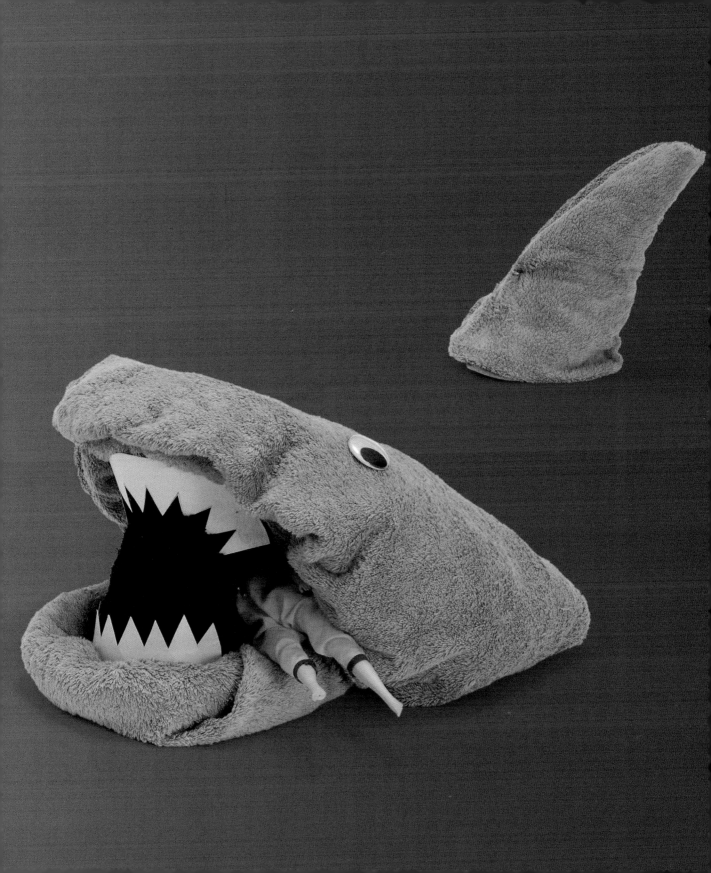

SHARK

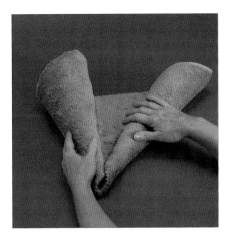

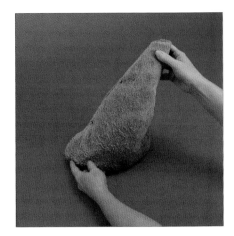

1 For the circling fins, take one gray hand towel and lay it out vertically. Fold it in half by bringing one short edge to meet the other then repeat to form a thick band. Pick up one lower corner and roll it diagonally to meet the center. Repeat with the other corner. This forms a triangular dart shape.

2 Use several safety pins to secure the rolls together. Set the shape on your work surface (or the bed) and squeeze and manipulate the fabric so it stands steadily by itself. Make another fin in the same way.

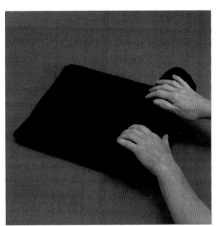

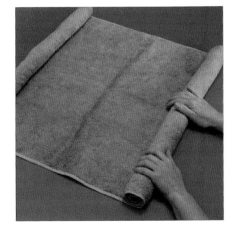

3 Take the black hand towel and fold it in half by bringing the short edges together. Repeat, then roll the band to form a tight cylinder. This will support the shark's jaws (and keep them apart so you can later insert the teeth).

4 For the jaws, take one gray hand towel and lay it out vertically. Roll both short edges to about a third the way across the towel, toward the center.

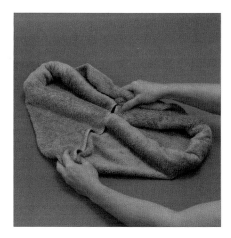

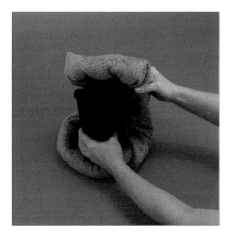

5 Bring the ends of the rolls to the center and then gather the side edges together. You can tie the center with a short piece of cord or ribbon for extra security, if necessary.

6 Place the black rolled jaw support inside the lower jaw, then bring the upper jaw over to rest on top. Arrange the rolls so the top jaw slightly overshadows the lower jaw.

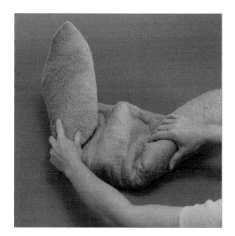

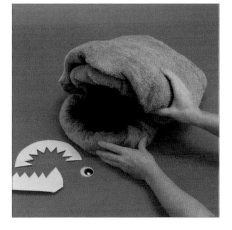

7 For the head, take the gray bath towel and the remaining gray hand towel and fold both in half with the short edges together. Place one on top of the other then fold into thirds to form a thick band. Roll both lower corners diagonally to the center to form a triangular shape. Secure the rolls together.

8 Place the head onto the jaws and arrange the fold so it stands steadily. Cut out the teeth from white card or felt, then insert them into the jaws. Now add a pair of menacing, beady eyes to complete the model.

WHALE

YOU WILL NEED

1 blue beach towel for tail and support

1 blue beach towel for body

2 white face cloths for spout

2 large buttons for eyes

fixing kit (see page 8)

"Ahoy there!" Ever contemplated a bit of whale-watching from the comfort of your own bathroom? You don't even have to set foot aboard ship. Create your very own Moby Dick in blue beach towels with white face cloths to create a water spout at the top of its head. To look authentic, the whale's body needs to be quite a bulky shape. To keep it looking substantial, add extra padding to the whale's body shape with an additional rolled-up guest towel or place spare toilet rolls inside the body.

TOP TIP

You could make your own pod of whales in various sizes using different-sized towels.

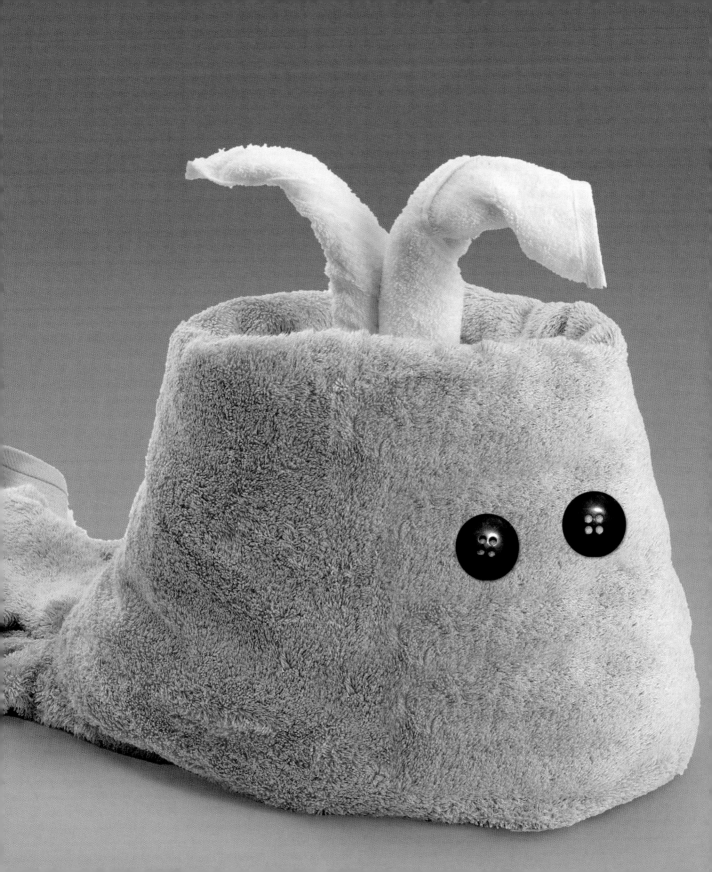

WHALE

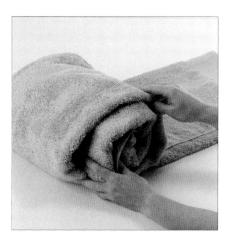

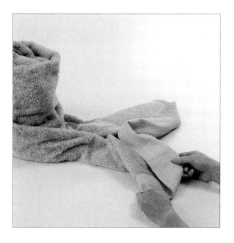

1 For the whale tail and body support, take one of the beach towels and lay it out horizontally. Fold it roughly into three by bringing the upper and lower edges to the center and overlapping them. Roll the left-hand end up loosely toward the center.

2 Stand the rolled part on end, then open out the folds at the other end of the towel. Now fashion the hem into a nice double-pointed whale tail.

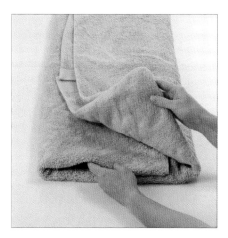

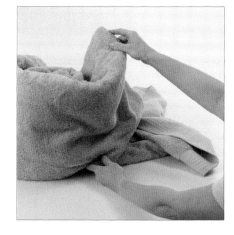

3 For the main body shape, take the remaining beach towel and lay it out vertically. Fold it in half by bringing the top and lower edges to meet at the center. Now fold the shape roughly into three, without flattening it, by bringing the side edges toward the center and overlapping them.

4 Now pick up the folded shape and wrap it around the rolled body support created in step 1. Overlap the edges at the back of the emerging whale shape. The overlap will be hidden behind the finished model.

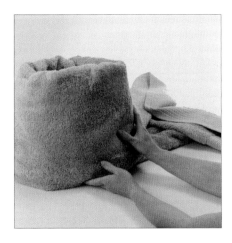

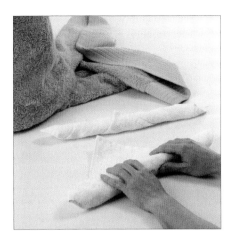

5 Secure the overlapped edges using a few safety pins, if necessary, to keep the towel in place. Mold the towel into a soft shape over the support beneath.

6 Now take the two white face cloths and roll each of them diagonally from one corner, to form two neat rolls that are tapered at both ends.

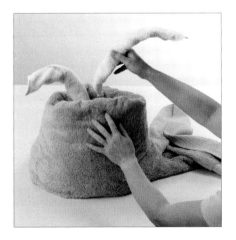

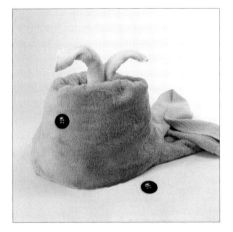

7 Tuck one end of both rolls into the opening in the folds at the top of the whale's head and then fashion them into the shape of a frothy water spout.

8 Stick on button eyes with double-sided adhesive tape.

KILLER WHALE

YOU WILL NEED

1 white bath towel for lower jaw and underbody

1 black bath towel for head and upper jaw

2 black face cloths for pectoral fins

1 black bath towel for back and tail

1 bath sponge for padding

1 black face cloth for dorsal fin

2 plastic eyes

fixing kit (see page 8)

The killer whale (or orca) is a member of the dolphin family—although it is a little larger. This magnificent beast is instantly recognized because of its characteristic black-and-white coloring and is considered to be one of the fastest-moving marine creatures. But don't worry… killer whales rarely gobble up humans—they tend to prefer seals.

TOP TIP

This whale shape translates easily into a blue whale simply by changing the color scheme.

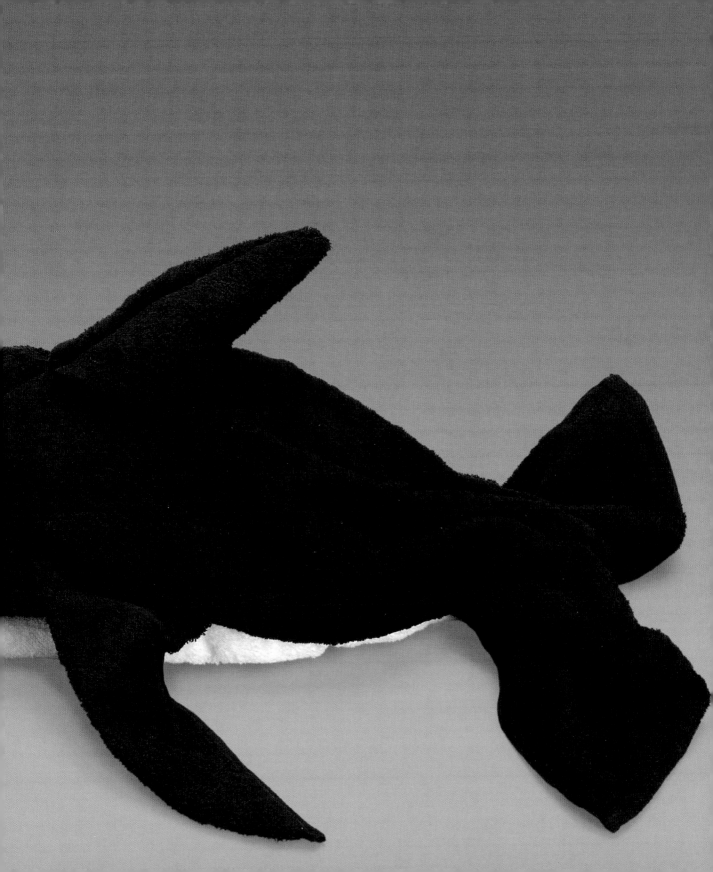

KILLER WHALE

1 For the lower jaw and underbody take the white bath towel and fold it in half by bringing the short edges to meet in the center. Now fold it in half again by bringing the two short edges together. Fold the top left corner of the resulting rectangle toward the center.

2 Loosely roll the top right-hand corner toward the center of the towel.

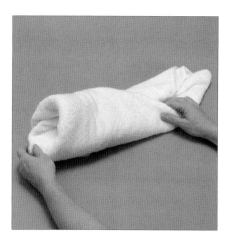

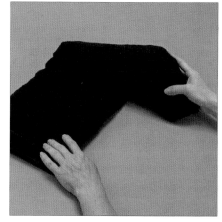

3 Wrap the lower left corner around the roll to form a loose roll that is tapered at both ends. Manipulate the left-hand end into a pointed jaw.

4 For the front of the head and upper jaw, take one black bath towel and fold it in half by bringing the short edges together. Now, fold the resulting rectangle into three horizontally, to form a thick band. Roll diagonally from both lower corners to form a triangular shape.

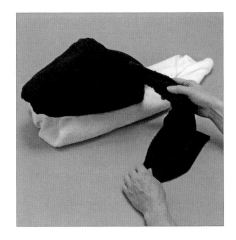

5 Place the shape onto the body then manipulate the folds to form the upper jaw and head. Use a few safety pins to hold the shape together if necessary. Fold two face cloths in half diagonally then tuck into the folds at each side to form two pectoral fins.

6 For the whale's back and tail fin, take the remaining black bath towel and fold it in half by bringing the short edges together. Keeping the tape edges at the lower edge, fold the two corners toward the center and overlap.

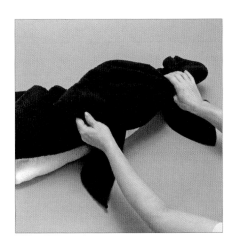

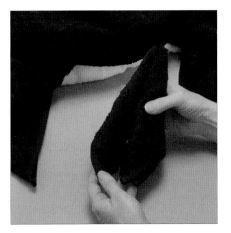

7 Flip the folded shape over and place it on top of the head and jaws. Tuck the side edges under the shape and manipulate the free edge toward the right-hand end into a tail-fin shape. Use a bath sponge under the towel along the back in order to make a fatter shape if necessary.

8 Take the remaining black face cloth and fold it in half to form a rectangle. Now roll both upper corners toward the center then use a safety pin to hold securely. Squeeze and bend the shape to form a curved, pointed dorsal fin for the whale's back. To finish your whale, position two eyes on the head.

KILLER WHALE

OCTOPUS

YOU WILL NEED

2 blue bath towels for tentacles
1 blue bath towel for head
2 plastic eyes
strip of black paper for mouth
fixing kit (see page 8)

The octopus inhabits many diverse regions of the seabed, and is particularly fond of coral reefs. An octopus is very intelligent (for an invertebrate) and its favorite form of locomotion is jet propulsion. Did you know that an octopus has three hearts and its blood is light blue? Amazing! We used blue towels for our octopus, but you could use any color you like—they do change color in the wild.

TOP TIP

You can accessorize the octopus with some sea shells or fish-shaped soaps.

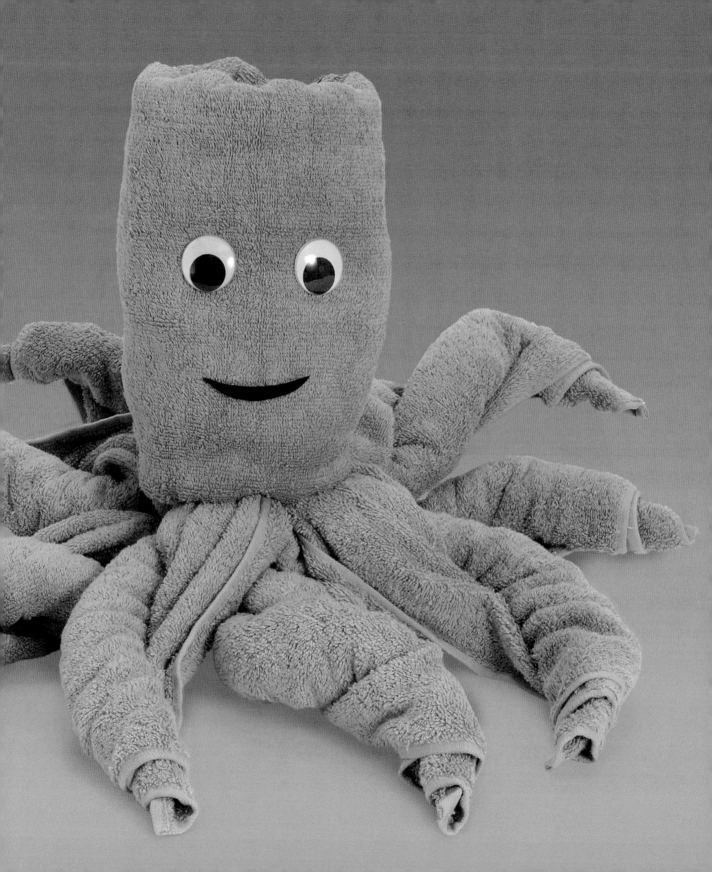

OCTOPUS

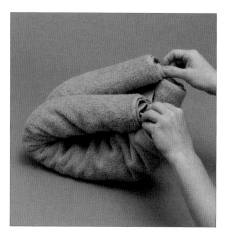

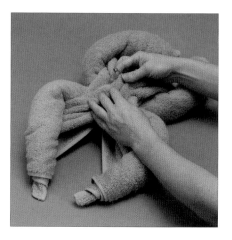

1 For the octopus's eight tentacles you will need to use two blue bath towels. Roll each of the towels into the basic four-limbed body shape 1 (see page 10).

2 Place the first body shape on your work surface and use a safety pin to hold the center together.

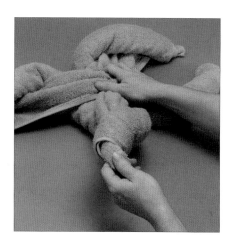

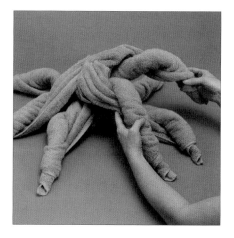

3 Holding the center firmly, pull and stretch each limb to achieve the long, slim shapes that will become the octopus's tentacles.

4 Place the second body shape on top of the first, then stretch the rolls as before. Gather up the center of the limbed shape to provide a base for the head and to give a little height.

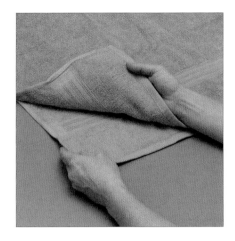

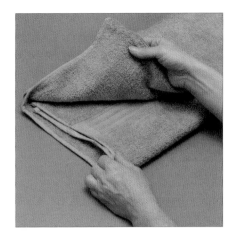

5 For the head, lay the blue bath towel out vertically, then fold in half by bringing the short edges together.

6 Now fold both short edges toward the center, overlapping to form a thick band.

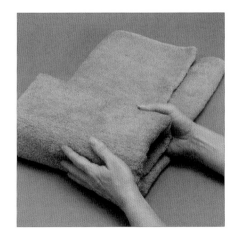

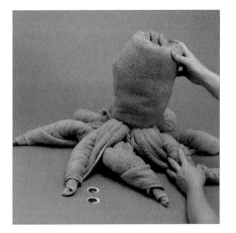

7 Roll the band loosely from both ends toward the center to form a soft, cylindrical shape that will be used for the head. Secure the rolls together at the back using a few safety pins. Manipulate the top edge into a softly rounded shape.

8 Place the head onto the raised center of the tentacles. Place two eyes on the front of the octopus's head and attach with double-sided adhesive tape to complete the model.

TURTLE

YOU WILL NEED

1 pale green beach towel for body and legs

1 dark green beach towel for shell

1 pale green hand towel for head and neck

2 medium buttons for eyes

fixing kit (see page 8)

Our towelling turtle is quite at home either in or out of the water. You can rest him on the foot of a bed or balance him on a shelf or laundry basket beside the bathtub. The turtle is made of three towels and is a bit of a balancing act, so construct him "in situ," otherwise he might fall apart if he's moved too far once he's completed. Try twisting the turtle's head gently so that it sits at a slight angle—this gives the model more character.

TOP TIP

Use the space under the shell as a handy hiding place for lots of bathtime treats for your house guests.

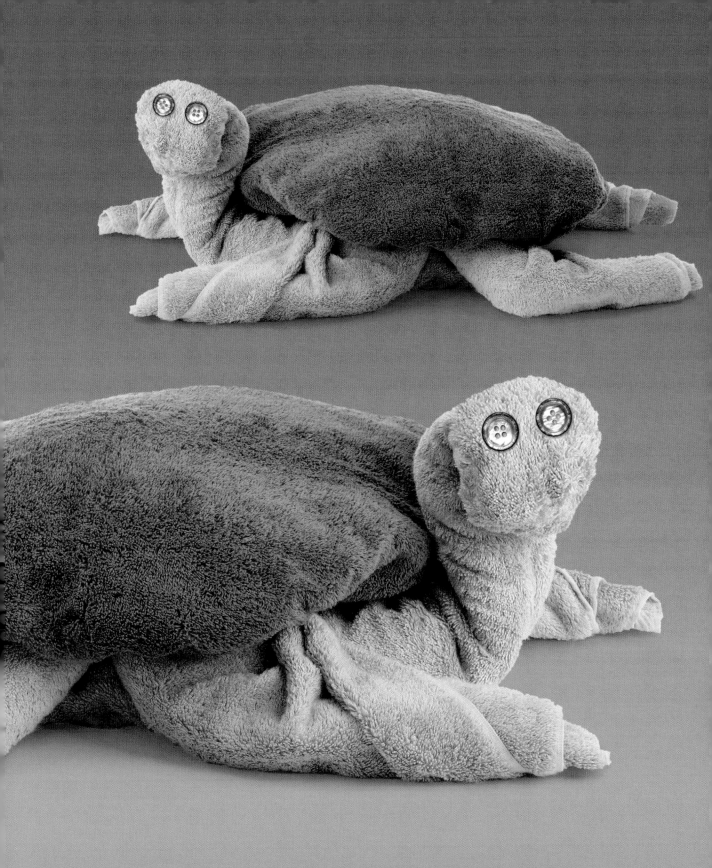

TURTLE

1 For the turtle's body, use the pale green beach towel and model it into the basic four-limbed body shape 1 (see page 10). Lay the body shape on a flat surface and arrange the legs.

2 For the shell, take the dark green beach towel and lay it out horizontally, then fold it in half by bringing both side edges to meet at the center. Now fold the shape into three by bringing the sides toward the center and overlapping them.

3 To complete the shell, fold the shape into three in the same way as before, but this time bring the lower and upper edges toward the center and then overlap them. Secure the resulting square shape using a safety pin.

4 Flip the shape over to the other side and place it on top of the turtle's body. Slip your hands into the shape at each side and pull out the folds located on the inside. You can now begin to mold the edges and corners to make a plump, rounded shape.

5 For the head and neck, take the pale green hand towel and lay it out horizontally. Make a crease in the center with your fingertip, then bring the bottom two corners upward to meet the crease and form a pointed shape.

6 Fold up about 3 inches (7.5 cm) at the bottom point, then roll both diagonal edges tightly toward the center. This will cause the pointed end to curl up slightly. Secure the rolls together with a safety pin, then flip the shape over.

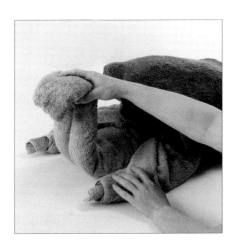

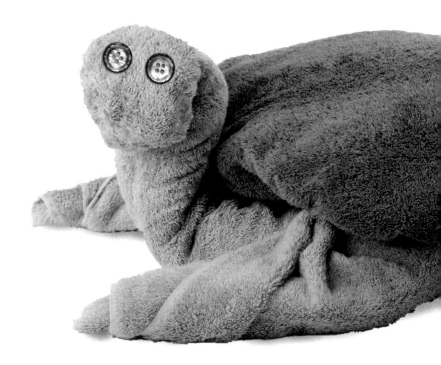

7 Tuck both the two free ends under the turtle's body, leaving the curved neck and head protruding at the front. Bend the neck a little more to form an arched shape. Curl the end of the neck over to form a head, and secure with a safety pin. To finish, stick on button eyes with double-sided adhesive tape.

TURTLE

FROG

YOU WILL NEED

1 apple-green bath towel for legs

1 apple-green bath towel for head

2 plastic eyes

fixing kit (see page 8)

"Ribbit... ribbit." Is it a frog or really a handsome prince under an evil spell? You could try kissing him to find out, but you might be disappointed. Luckily there are no magical spells here—just some clever rolling and folding and a bit of manipulation to achieve that cheeky "wide-mouthed frog" look. As a thoughtful gesture, why not hide some pretty soaps, chocolates or a welcome note inside the folds of your frog model, just to surprise a curious guest?

TOP TIP

We used bright apple-green towels for our frog, but in the wild, frogs come in all sorts of colors. Try brightly colored spots, just for fun.

FROG

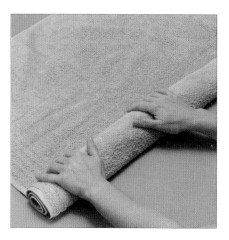

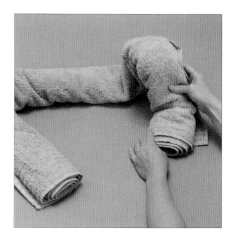

1 Lay one apple-green bath towel out horizontally, then roll up from the lower edge to form a long sausage shape. Secure the overlap at the center with a safety pin so the roll does not come undone. This roll will form the back legs of the frog.

2 Fashion each side of the roll in turn into a frog leg. The shape should resemble an "M" with a flat section at the center. Splay each end of the rolled-up towel to form the frog's webbed feet.

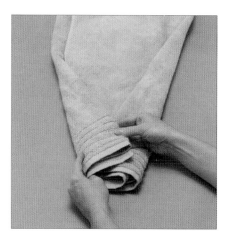

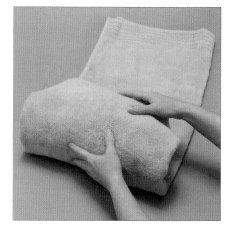

3 Lay the second apple-green towel out vertically. Divide it into three equal parts by making vertical creases in the pile. Bring the side edges inward to overlap in the center by folding along the crease lines. Now fold the top two corners inward diagonally to meet at the center.

4 Roll up the folded towel from the lower end to approximately halfway. Secure the roll at each side using two safety pins. This will form the frog's head.

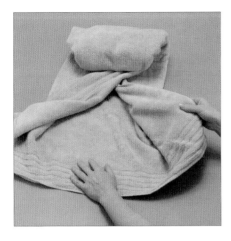

5 Carefully open out the folds of the bottom half of the towel.

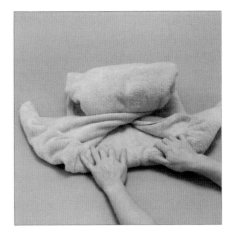

6 Now roll up the towel from the lower edge, stopping just below the head roll.

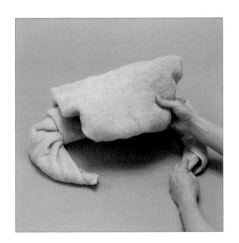

7 Grasp both ends of the rolled-up section and wrap them around the head to create a crescent shape. These will be the frog's arms.

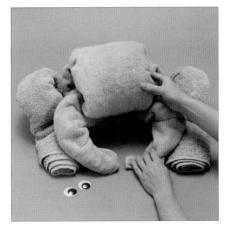

8 Place the head and arms onto the flat section at the center of the frog's legs. Arrange the arms in order to balance the head. Add two eyes to the top of the head to complete the model.

FROG

PELICAN

YOU WILL NEED

*1 white bath towel
for head and neck*

*1 white bath towel
for body and wings*

2 plastic eyes

fixing kit (see page 8)

"What a wonderful bird is the pelican, his beak can hold more than his belly can." That's what Dixon Lanier Merritt said, anyway. Our pelican hasn't had his dinner yet, and his beak is quite a modest size. The pelican is quite an upright shape, so you may have to "persuade" the towels to behave. Try washing and starching them before you begin, to give the fabric extra stiffness.

TOP TIP

Just for fun and authenticity, why not give Mr Pelican some fish-shaped soaps for his dinner?

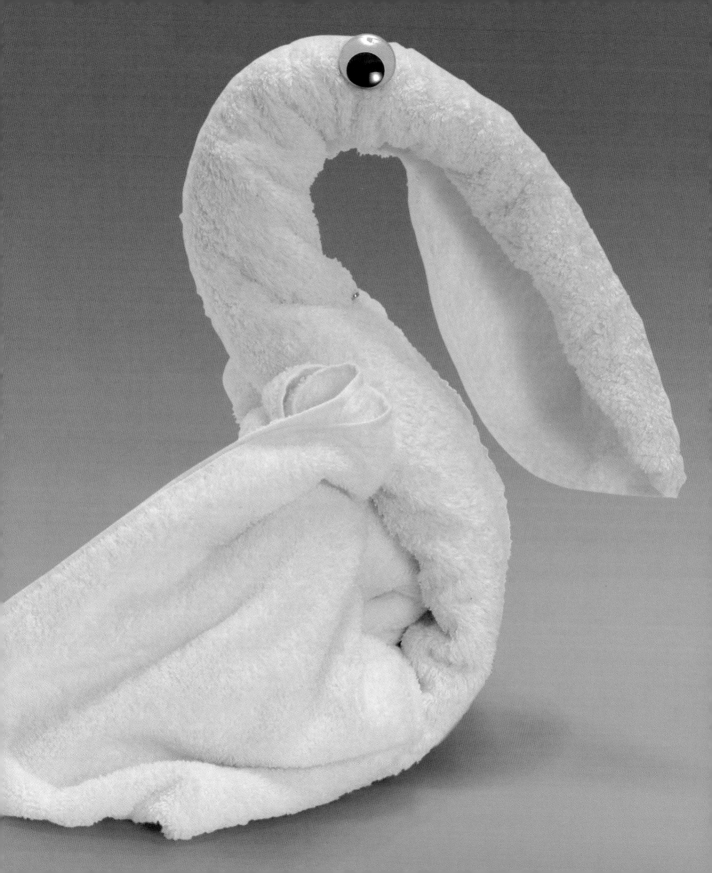

PELICAN

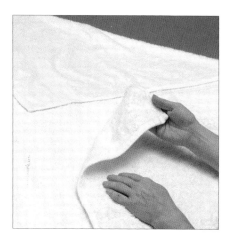

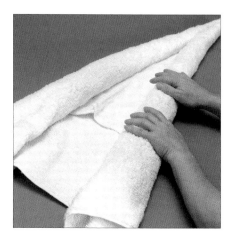

1 Lay one white bath towel out vertically and make a horizontal crease along the center line. Bring the top and lower corners on the right-hand side inward to meet the center crease-line, forming an arrowhead shape.

2 Hold one diagonal fold and roll it up tightly toward the center line. Do likewise with the other fold to form a long, thin pointed shape. The pointed end will form the pelican's head.

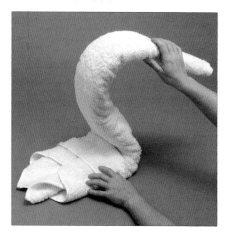

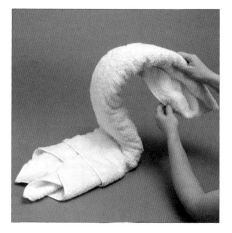

3 Flip the shape over. Place one hand on the center of the rolls, and bend the pointed end to form an "S" shape. This will become the pelican's head and neck. You may have to coax the towel a little at this stage so it stays in the correct shape.

4 Hold the head and keep it supported throughout the next step. Pinch the towel fabric under the head and gently pull it downward to form the pelican's long beak and large gullet.

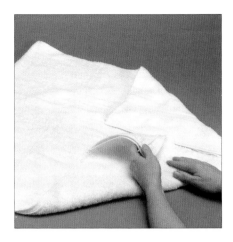

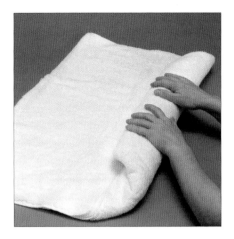

5 Lay the second white bath towel out horizontally. Bring the left edge across to meet the right edge. Make a horizontal crease to indicate the center line, then fold the upper and lower right-hand corners down to meet it.

6 Roll up the folded shape from the pointed end toward the center. Stop rolling when you reach the halfway point, then secure the roll using a safety pin at the center.

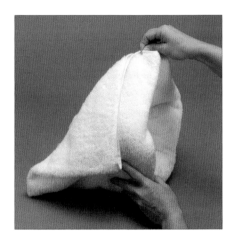

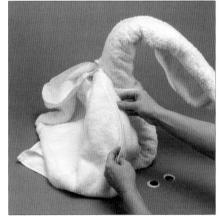

7 Fold the shape in half across the center of the rolled section to form the pelican's wings.

8 Place the pelican's wings onto the body behind the curved neck, then arrange the folds to resemble flapping wings. Add two eyes to the head using double-sided adhesive tape to complete your model.

PENGUIN

YOU WILL NEED

*1 square black face cloth
for back*

*1 square white face cloth
for front*

2 small buttons for eyes

fixing kit (see page 8)

Penguins always look just like a row of gentlemen in evening dress, lining up in an extremely orderly fashion. Because this penguin project is made solely from face cloths, each penguin forms a small, neat shape. This project makes one small penguin, but perhaps you could enchant your house guests with two cute penguins arranged on the side of the bath, ready to dive into the water. Of course, there is nothing to stop you from making king-size penguins.

TOP TIP

Try stuffing the little penguin's body with a couple of tissues, a small bar of soap, or an envelope of bath gel, so that he stands up by himself and has a nice plump stomach.

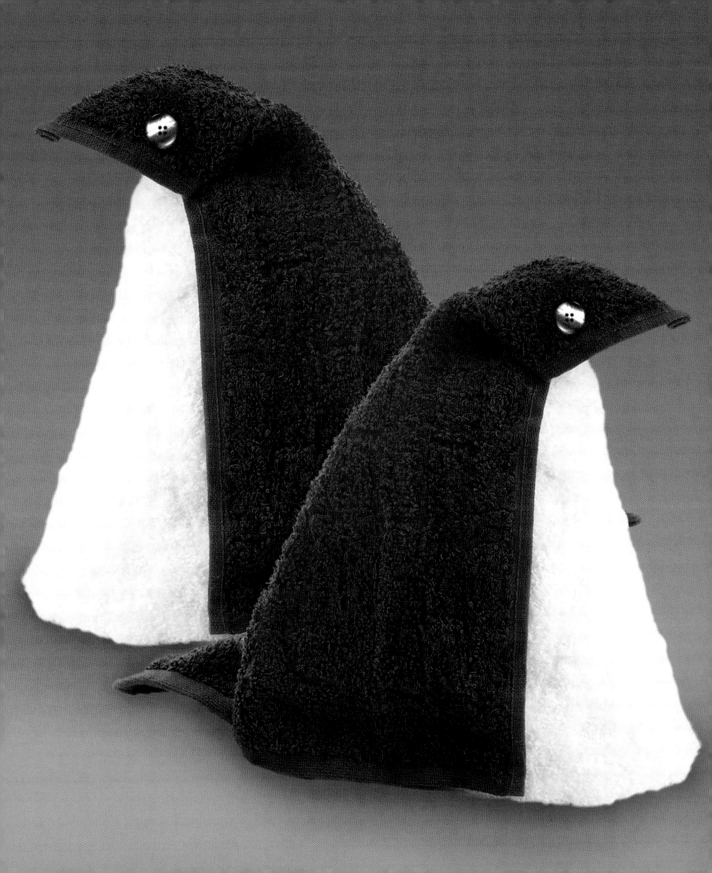

PENGUIN

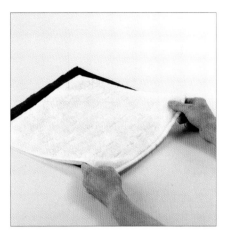

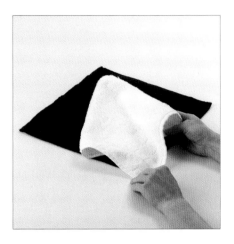

1 For the penguin's body, place the black face cloth down flat on the surface. Position the white face cloth on top of it, arranging the top so that it lies about ³/₄ inch (2 cm) from the top point of the black face cloth underneath.

2 Take the left-hand and right-hand corners of the white face cloth in turn, and fold them underneath to form an arrow shape.

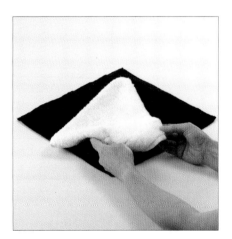

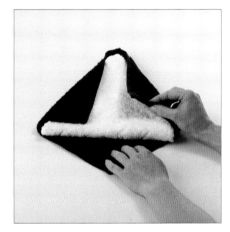

3 Now tuck the bottom point of the white arrow shape underneath, so that the face cloth resembles a tall triangle in shape.

4 You can now bring the edges of the black face cloth over the sides of the white triangle toward the center, one quarter of the way across on both sides.

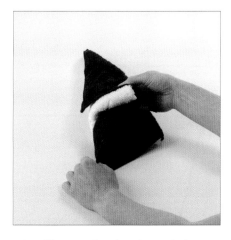

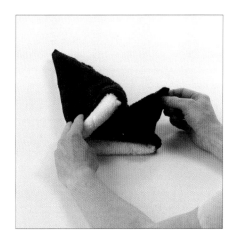

5 Place one hand underneath the shape and flip it over to the other side, so that the black side is facing you. Now bring the left-hand edge to meet the right, thus folding the shape in half. Press the shape flat with the palm of your hand.

6 Pick up the lower-front edge of the shape, then bring the lower point of the black face cloth up through the center to form the penguin's tail.

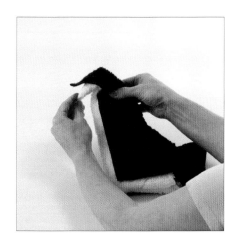

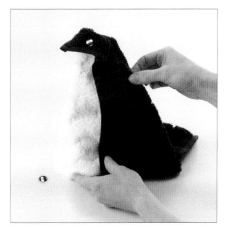

7 Pinch the folds at the back of the penguin's neck about 2 inches (5 cm) down from the top point, then fold the point over and arrange it to form a beak shape. Press the resulting shape between your fingers to hold the fold secure. Stand the penguin shape upright and open out the base slightly, so it stands up properly.

8 Gently pull out the black face cloth along the penguin's spine so that it forms a softly curved shape. Attach button eyes to the penguin's head.

 # SWAN

YOU WILL NEED

*1 fluffy white sheet towel
for body*

sunglasses

fixing kit (see page 8)

Seven swans a-swimming? Well, maybe just one or two would be enough to make the point. This elegant bird works perfectly alone, or a pair can be used to great effect when arranged symmetrically. You could place some attractive fragrant soaps or bottles of bath product on the swan's back for your guests to enjoy at bathtime.

TOP TIP

For maximum impact, try using the largest, fluffiest and most luxurious white sheet towels you can find.

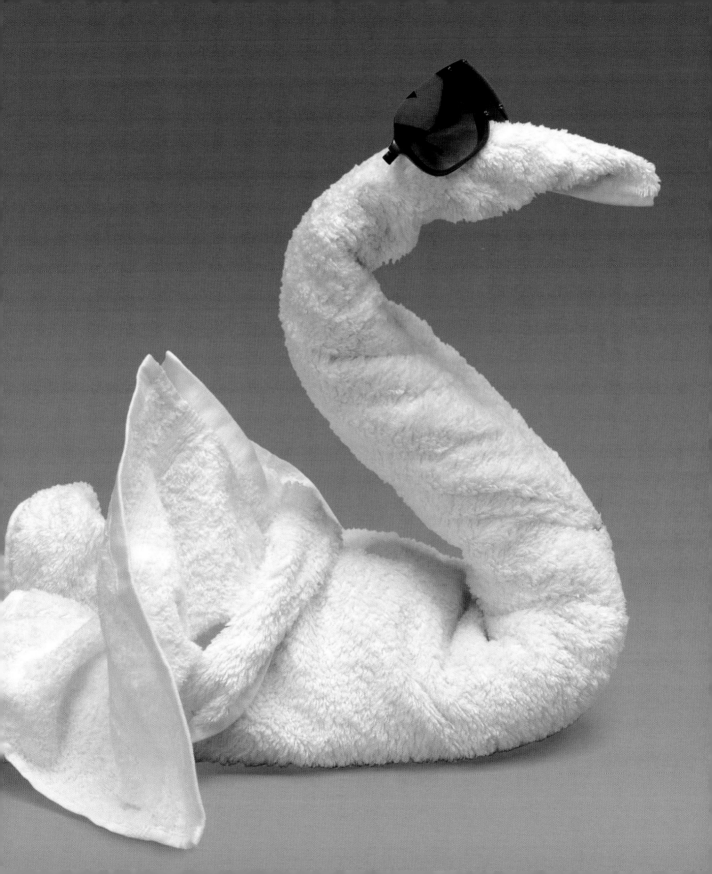

SWAN

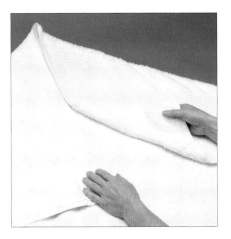

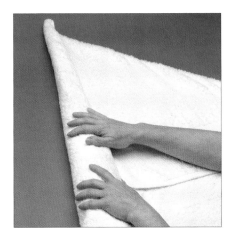

① Lay out the towel horizontally, then fold in half widthways to indicate the center and press the fold flat. Open up the towel again, then fold the top two corners down to meet at the center. Press the diagonal folds flat using the palm of your hand.

② Now roll the towel tightly along the diagonal edge along one side, toward the center.

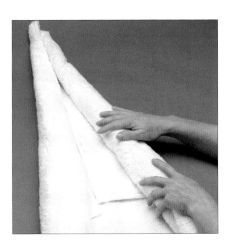

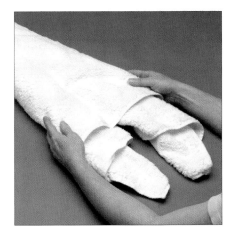

③ When the first side is rolled up tightly, do the same on the other side so the shape is symmetrical. Make sure the first roll does not loosen as you complete the second roll.

④ Now slip one hand underneath the rolled-up shape and place the other hand on top. Quickly flip the shape over to the other side. This is the swan body.

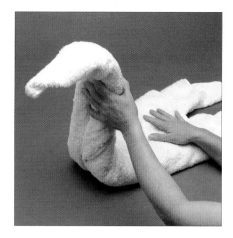

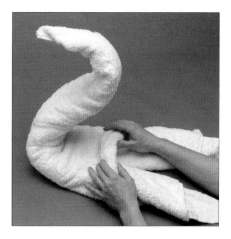

5 Place your hand on the swan's back and shape the rolled point to form the curved neck. You may have to use a little gentle force to make the neck stay in shape.

6 Locate the edge of the towel that lies across the rolled-up points at the back. Take the edge and roll it back on itself. This action will cause the points to splay outward.

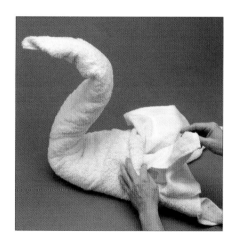

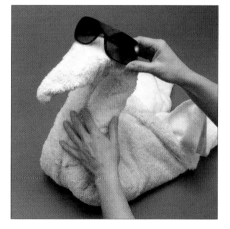

7 Coax the points out a little more and arrange them to form the swan's wings. This will also help the stability of the shape. If you like, you can tuck a face cloth into each side to make the wings appear larger.

8 Add a pair of sunglasses to complete this elegant fowl. The weight of the sunglasses also helps to maintain the nicely curved shape of the neck. Use a couple of safety pins to keep the sunglasses in place.

WILD BEASTS

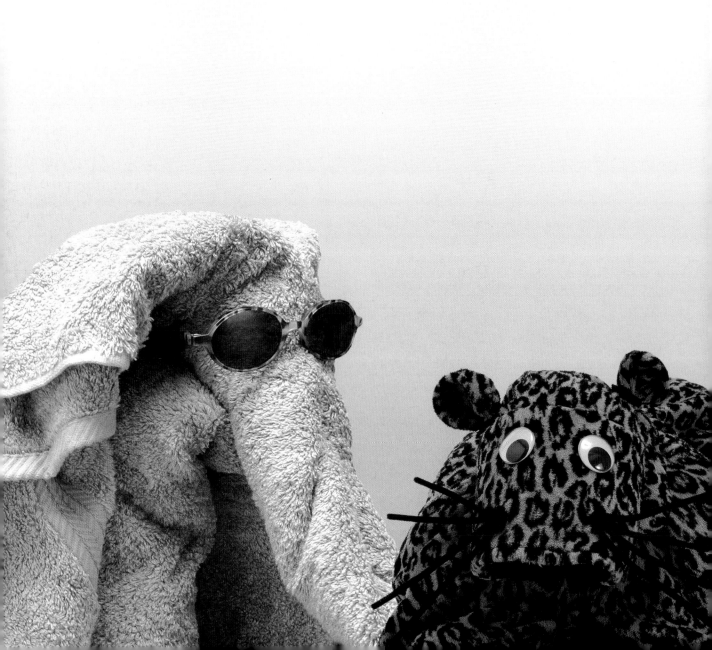

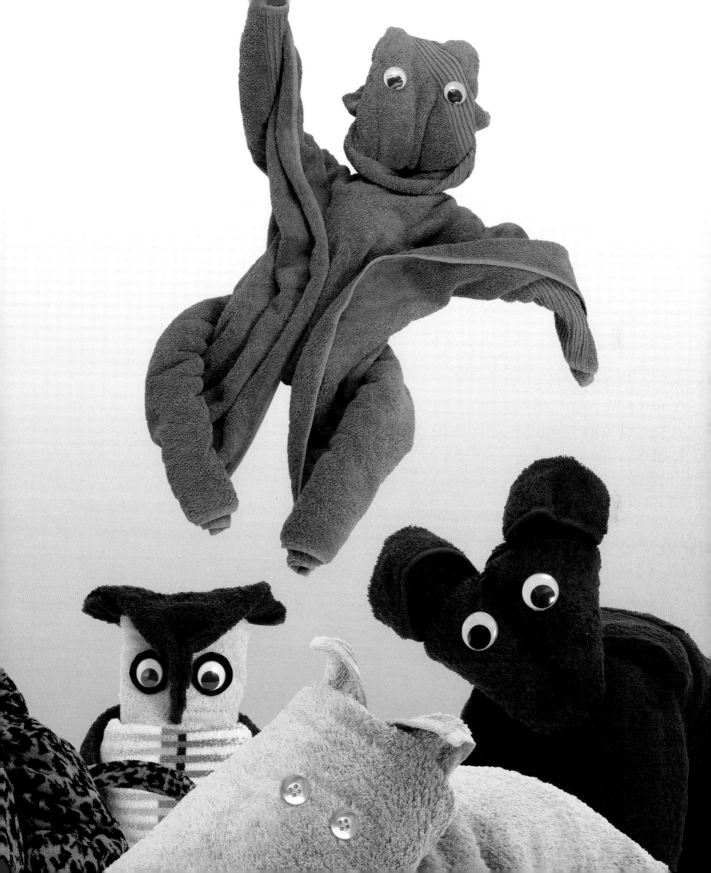

GRIZZLY BEAR

YOU WILL NEED

1 brown bath sheet for body

1 blue bath sheet for body padding

1 brown bath towel for legs and shoulders

1 brown hand towel for head

2 plastic eyes

fixing kit (see page 8)

This grizzly looks rather cute and cuddly—not a scary maneater at all… or is he? The color of a grizzly's coat can vary from blond to pale beige, deep brown, red or even gray, so you have quite a bit of scope with the color scheme. All grizzlies like to eat fish and are very happy living close to water—an ideal bathroom inhabitant.

TOP TIP

This cuddly bear model translates well into any bear-like species. Try using white fluffy towels to make yourself a polar bear.

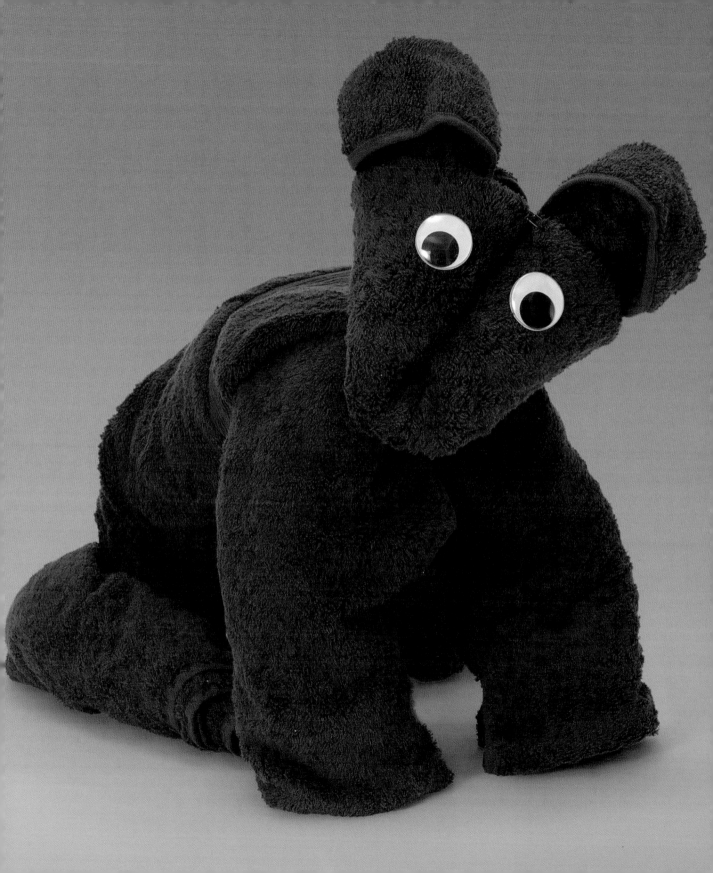

GRIZZLY BEAR

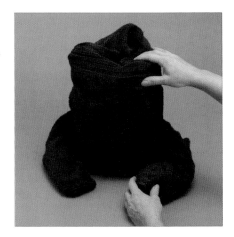

1 Lay the brown bath sheet out vertically. Fold and roll the blue bath towel following seated body shape 2 (see page 10), to form the body padding. Place it close to the upper edge of the towel. Wrap the two top edges around it and roll up the lower edge to meet the base of the padding.

2 Bring the hind legs around the sides of the padded body and arrange so the model is balanced. Use a few safety pins to secure the overlap, then tuck the top edges down inside the padding roll so the neck edge is neat.

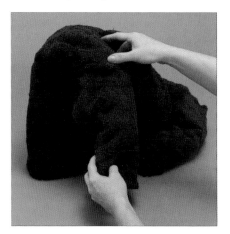

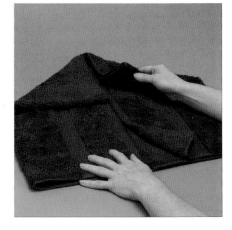

3 For the front two legs and shoulders, roll up the brown bath towel into a long sausage shape, beginning at one short edge. Use a few safety pins to secure the overlap if necessary. Now bend the roll in half and place in front of the grizzly's body. Secure the top of the roll to the shoulder area.

4 Use the brown hand towel to form head shape 1 (see page 11). Lay it out vertically, fold in half by bringing the short sides to the center and then fold down the top two corners.

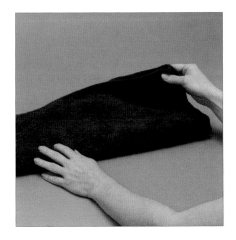

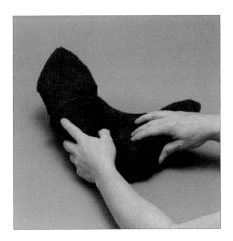

5 Now bring the lower edge up to meet the top edge, forming a rectangle. The multiple thicknesses serve to make a solid, neat triangular head shape in the next step.

6 Take up each lower corner in turn and roll it tightly in a diagonal fashion toward the center of the rectangle. Use a large safety pin to hold the rolls securely at the top. Tuck any loose corners inside the shape at the back.

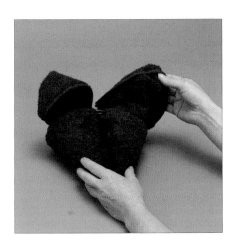

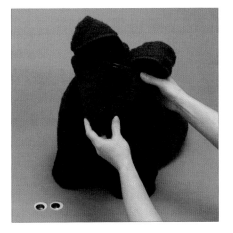

7 For the ears, manipulate the two points that protrude from the top of the head. Try to make two matching rounded ear shapes. It helps if the head is securely pinned together at this point, so it doesn't unroll while you do the shaping.

8 Place the head in position on the grizzly's shoulders. If the head does not balance by itself then use a large safety pin to secure it. Add two eyes to the grizzly's face using double-sided adhesive tape to complete the model.

ELEPHANT

YOU WILL NEED

*1 gray bath towel
for body and legs*

1 gray hand towel for head

sunglasses

When you visit the zoo, make sure you have a supply of fresh bananas at the ready when it comes to feeding time for the elephants. Hungry elephants are not happy elephants—but our towelling model looks very contented and at ease. Using mid-gray towels will give the best result. Folding your very own Jumbo makes for a stunning display in the bathroom or guest room. Using sunglasses as a finishing touch gives it a contemporary look.

TOP TIP

If your bath towel is too big, the elephant's legs may look too long. Simply fold up both short ends a little way before rolling the towel, which shortens the legs and makes for a sturdier form.

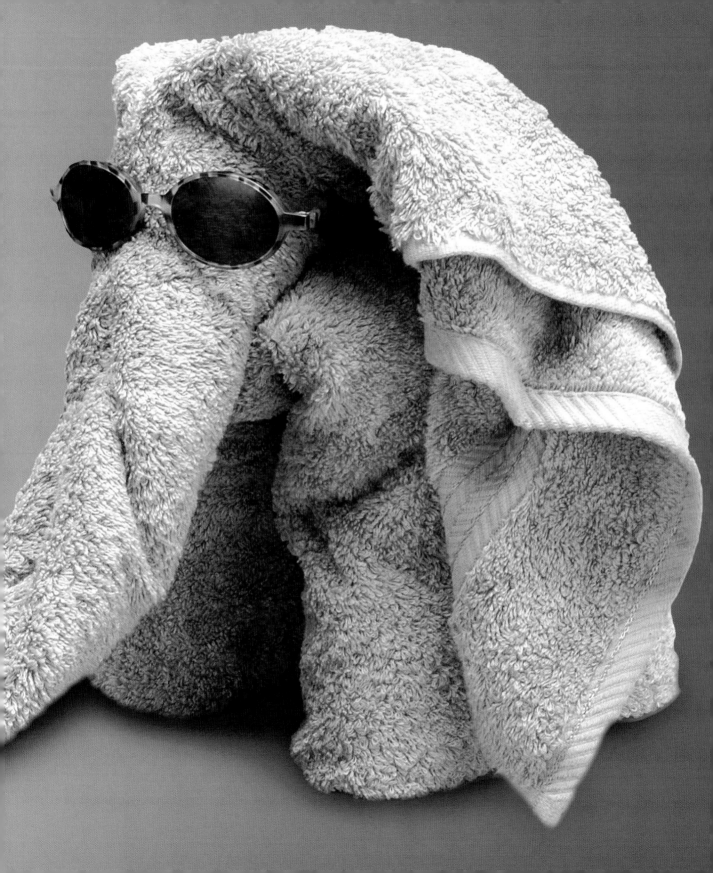

ELEPHANT

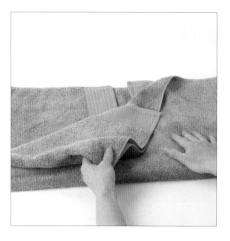

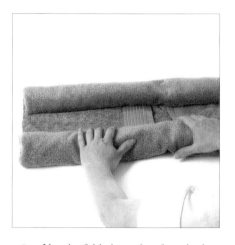

1. Lay the gray bath towel out horizontally, then fold both sets of short side edges to the center. Now find the center of the towel and fold it in half lengthwise. Crease along the fold, then open out the towel again.

2. Use the folded towel to form body shape 3 (see page 11). Roll the folded towel from the lower edge to the center, then do the same from the upper edge. Don't flatten out the folds or make the rolls too tight or the shape will end up being too skinny.

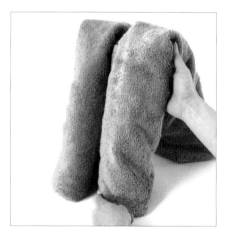

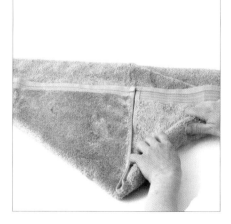

3. Grasp the rolls firmly at each end and bend the shape in the middle, to form the elephant's body and legs. The body should stand quite steadily by itself, but try opening out the ends of each roll slightly if it seems a bit wobbly.

4. Use the gray hand towel to form head shape 1 (see page 11). Lay it out horizontally and bring the two short side edges to meet at the center. Pick up the lower right-hand corner and roll it diagonally toward the center.

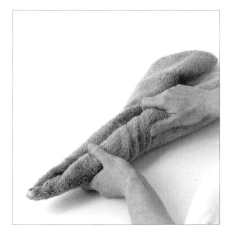

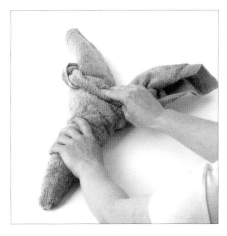

5 Do the same with the lower left-hand corner, and start to form the trunk. Take care to keep each side of equal thickness. As you continue to roll, the trunk will begin to curl upward.

6 Flip the shape over to the other side and start to fold the right-hand edge of the towel over the trunk to hold the first rolls in place.

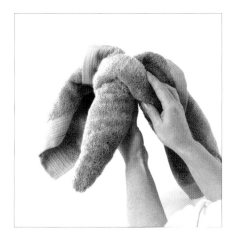

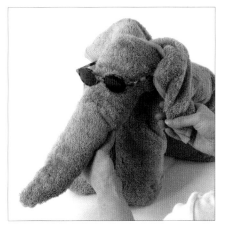

7 As you continue to roll, two ears will form. Rearrange the folds if necessary so that the head is perfectly symmetrical.

8 Balance the elephant's head on the body or secure it in place with safety pins. Complete your elephant with a pair of trendy sunglasses.

HIPPO

YOU WILL NEED

1 gray hand towel for body padding

2 gray beach towels for body and legs

1 gray hand towel for head

4 medium buttons for eyes and nostrils

fixing kit (see page 8)

In the wild, hippos are usually found wallowing happily in lovely, cool mud pools to keep their temperature down during the midday heat. Fortunately, our hippo has never seen a mud bath in his life—so no big, dirty footprints to clean up. Use your largest and fluffiest beach towels for this model— the emphasis is on the nice, plump body shape and wide nose that are characteristic of a real hippo.

TOP TIP

If you do not have any large beach towels, try using two hand towels overlapped at the edges and held securely with safety pins. The hippo will not be spoiled if there are a few hems showing here and there.

HIPPO

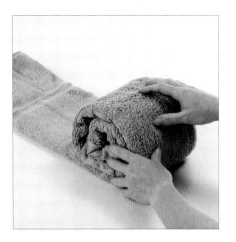

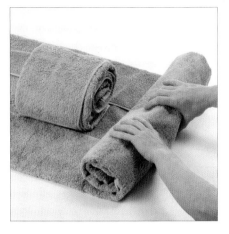

1 Lay one gray hand towel out vertically, and fold it in half by bringing the long side edges together. Repeat once more, but do not flatten out the resulting folds. Now roll up the folded shape loosely, beginning at the right-hand edge, to form a fat cylinder. This creates the bulk of the body padding.

2 For the body, lay the two gray beach towels out horizontally, one on top of the other, then place the rolled-up cylinder horizontally in the middle. Bring the top and lower edges to meet the cylinder at the center. Roll up both short edges so that they touch the ends of the central cylinder to make the legs.

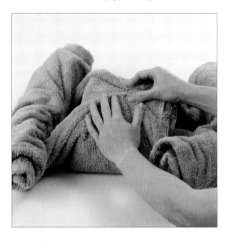

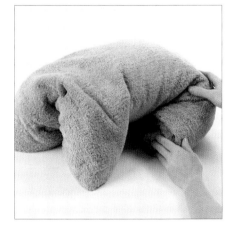

3 Wrap the top and lower folds of the beach towel around the central cylinder and secure the edges in the middle with a large safety pin. Now slip your hand under the shape and flip it over to the other side.

4 You will now see the beginnings of a plump hippo body. Tuck the back legs under the body a little so that the back arches slightly. The two front legs can splay out and point forward.

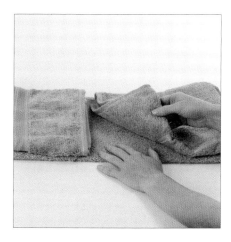

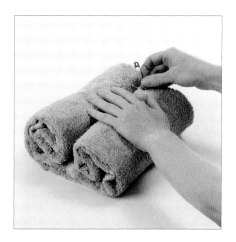

5 For the hippo's head, lay out the last gray hand towel horizontally. Fold the towel into three widthwise, then bring the short side edges to meet at the center, as shown. Flatten out the folds using the palm of your hand.

6 Roll up the left-hand edge toward the center, then do the same with the other side to make a symmetrical shape. Use a large safety pin to hold the rolls together at one end of the shape. The other end can be left free, in order to form a wider nose shape.

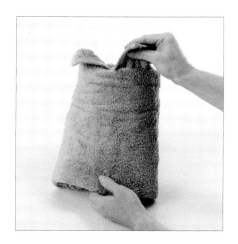

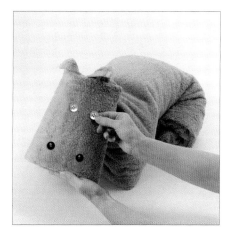

7 Now flip the rolled head shape over to the other side. Place your hand into the rolls at the top edge and locate two corners of the rolled-up towel. Pull these corners outward gently to form two cute hippo ears. Lay the head on top of the front legs, angled slightly to give a bit of character.

8 To complete the model, stick on button eyes and nostrils with double-sided adhesive tape.

CROCODILE

YOU WILL NEED

1 green beach towel for body

1 green hand towel for head

1 green beach towel for tail and back

2 large buttons for eyes

fixing kit (see page 8)

"Never smile at a crocodile." Wow, this guy has what you could call a really toothy grin. However, our towelling model is perfectly harmless and isn't actually likely to eat anyone for lunch. This model makes quite a large shape, so ensure that you place your crocodile across the foot of a bed, or on the bathroom floor, so that he has room to stretch out his long tail. A bright green towel was used to make this crocodile, but a darker shade would be equally effective. Try a towel with a heavy texture, to emulate the crocodile's thick skin.

TOP TIP

Use smaller towels to make lots of tiny baby crocs to entertain your younger house guests or the children in your family.

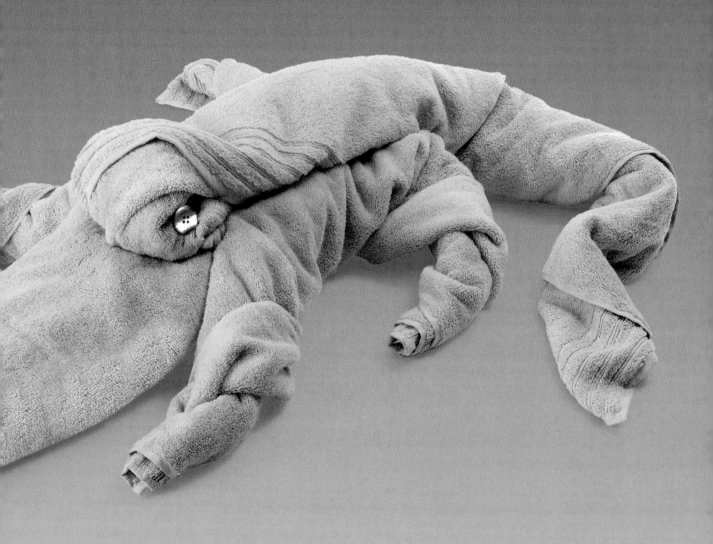

CROCODILE

1 Take one of the green beach towels and roll it into basic four-limbed body shape 1 (see page 10). Then lay the shape on a flat surface and arrange the legs. The back legs can be tucked under the body, while the two front legs can be splayed out toward the front.

2 To make the head, lay the hand towel out horizontally, then fold it into three equal parts by bringing the short side edges inward and overlapping them at the center. Roll the top and lower edges to meet at the center. Secure the rolls together at the center using a large safety pin.

3 Slip your hand under the rolled head shape and flip it over to the other side. Now rest it between the front legs of the crocodile, making sure the back edge of the head is butted up against the central body folds.

4 Take the remaining beach towel and roll it up very loosely in a diagonal fashion, beginning at the lower right-hand corner, to form a long sausage shape that is tapered at each end. This will form the tail, the back and the eye sockets on top of the crocodile's head.

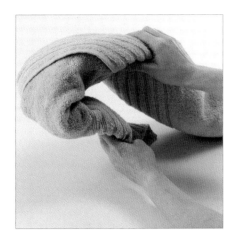

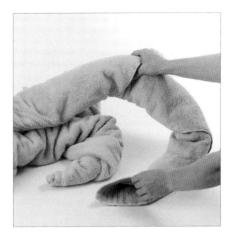

5 Fold one pointed end of the towel under the rolled sausage shape. This will form the basis for the crocodile's eyes and hide the join between head and body.

6 Now lay the rolled sausage shape onto the crocodile's body. Fashion one end into a long, slightly wavy shape for the tail, and place the thicker part of the roll along the body.

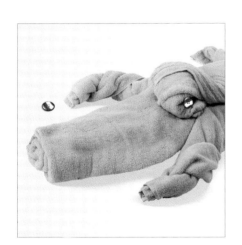

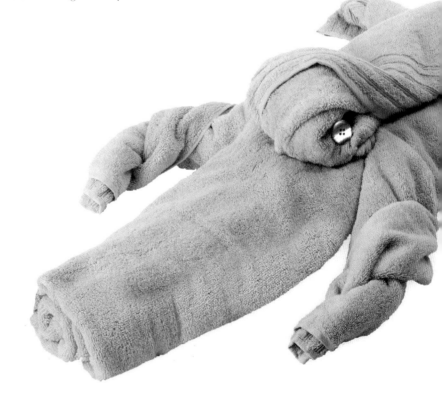

7 Stick on the button eyes with double-sided adhesive tape in the space formed between the towels in step 5.

 # LEOPARD

YOU WILL NEED

leopard-print bathrobe for body

3 beige bath towels for padding

1 robe belt for neck and tail

2 black elastic hair bands

1 black hand towel for padding

2 plastic eyes

4 fluffy black pipe cleaners for whiskers

fixing kit (see page 8)

We made use of a leopard pattern bathrobe to create this model. The shape of the robe translates well to an animal shape. Our leopard looks ready to pounce, but you could coax his body (with the use of few supporting toilet rolls) into a standing pose. This shape works well for any big cat if you have the correctly patterned or colored robe… perhaps a tiger, cheetah or even a lion, using a big fluffy bath-mat mane?

TOP TIP

You could use a brightly colored dog collar, or a pretty ribbon, to secure the neckline instead of using the robe belt.

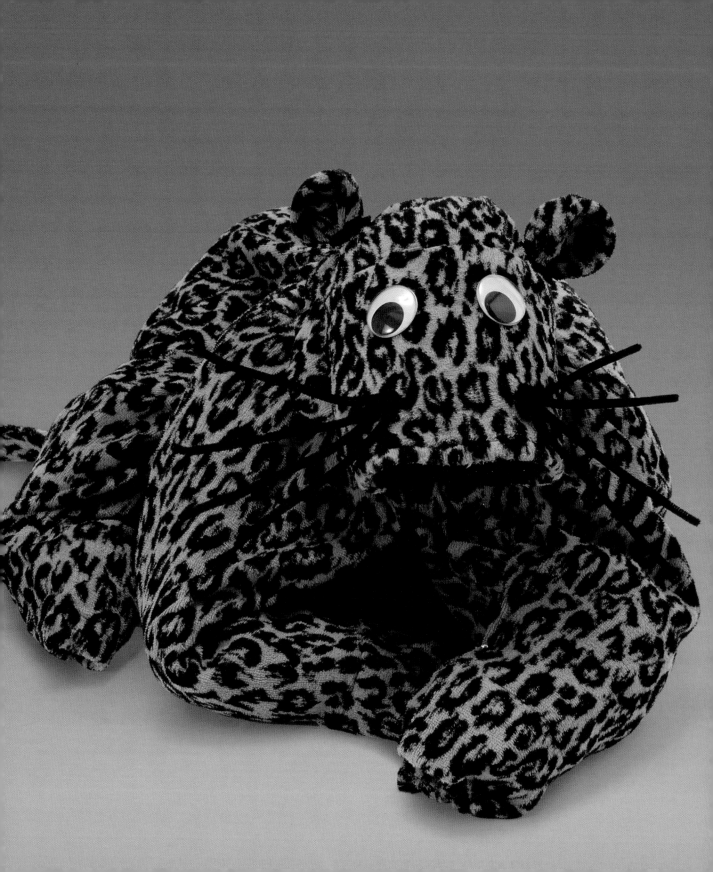

LEOPARD

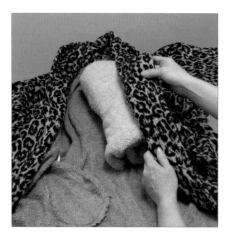

1 Remove the robe belt then lay the bathrobe out flat. Fold and roll one of the beige bath towels following seated body shape 2 (see page 10), to form the body padding. Place the roll between the armholes. Wrap the robe around it, using safety pins to hold the robe securely at the center.

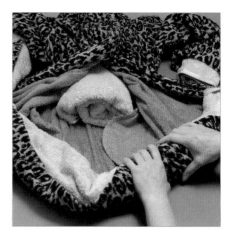

2 Now roll up the remaining two beige bath towels, beginning at one long edge. These two sausage shapes will form the hind and foreleg padding. Insert one roll into the sleeves, and then wrap the hem of the robe around the other. Pin the center of the hind leg roll to the underside of the body.

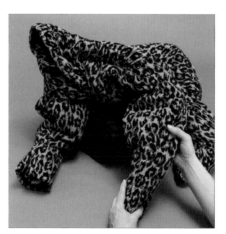

3 Flip the model over and arrange the legs so the model stands steadily. You may need to balance the body on another towel pad or toilet roll to give a little height.

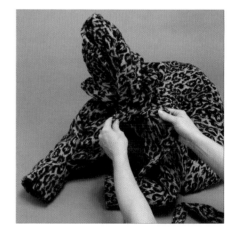

4 Now take the belt and tie one end tightly around the collar and neckline of the robe. This gives the leopard a neck. Pull any loose fabric through the neck tie—this will form the head. Now pass the loose end of the belt under the body to form the leopard's tail at the back.

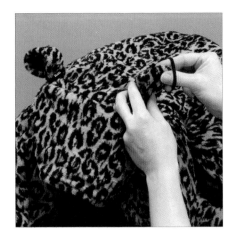

5 Take the two elastic hair bands and wind each around a fold of fabric each side of the top of the head. Pull the fabric through the bands to form small, rounded ears.

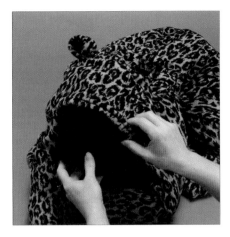

6 Fold the black hand towel in half, then in half again, then it roll up tightly as padding. Insert the roll into the folds of fabric in front of the tied neckline.

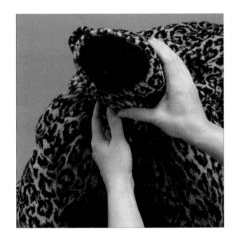

7 Fold any excess fabric under the leopard's chin and pin in place securely. Arrange the head into a pleasing shape and make sure it is balanced on the shoulders. You could use a carefully concealed bottle of shampoo as a prop if necessary.

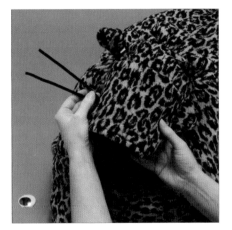

8 Now to add the finishing touches. Add two fluffy black pipe cleaners folded in half to each side of the nose for the leopard's whiskers. Finish off by adding the leopard's eyes with double-sided adhesive tape.

PANDA

YOU WILL NEED

1 white hand towel for body

1 black beach towel for legs

1 black hand towel for body

1 white hand towel for head

1 black face cloth for ears

black-and-white paper for eyes

1 medium button for nose

fixing kit (see page 8)

You would be extremely lucky to see a panda in the wild these days, so imagine how surprised your house guests would be to find their very own panda sitting in the bathroom. It's not exactly the bamboo forests of southwest China, but perhaps you can use some bamboo-style accessories to complete the look. This model has quite a few layers, so remember to use safety pins to hold the shape together. You could make two little panda bear cubs to complete the family, using hand and guest towels.

TOP TIP

You could follow exactly the same methods using dark-colored towels to make a brown or black bear for your bathroom.

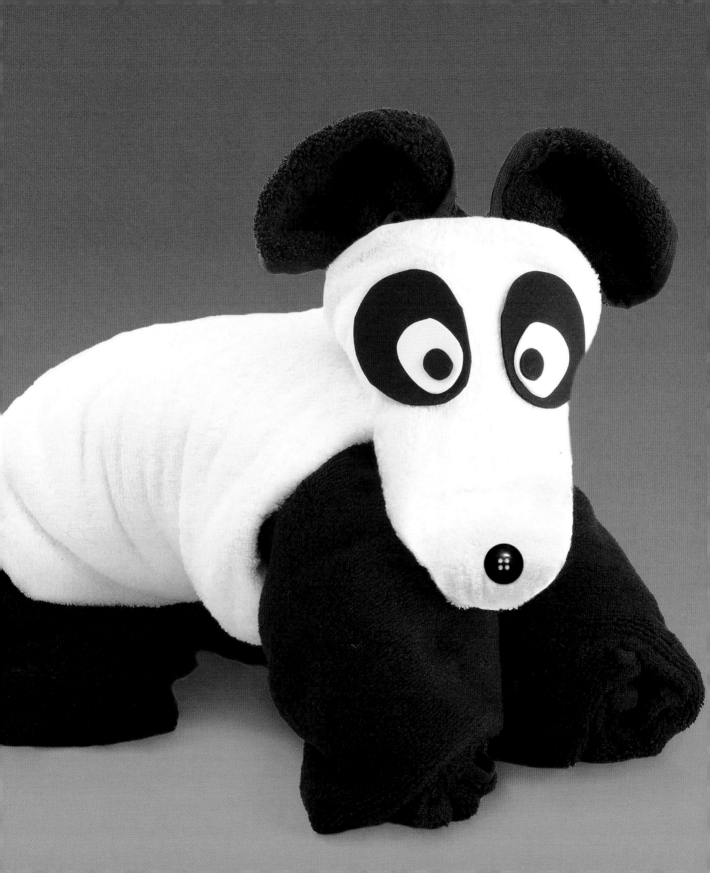

PANDA

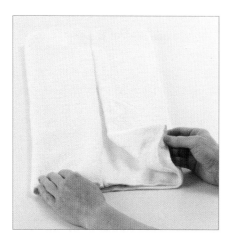

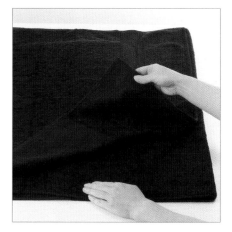

1 Lay one white hand towel out horizontally. Fold it in half by bringing the sides to meet at the center, then repeat to make a thick rectangular shape. This will form the underside of your panda.

2 Now take the black beach towel and lay it out horizontally and centrally on top of the folded white towel. Using the tip of your finger, divide the black towel into three vertically, then fold it along these lines. Now fold the black hand towel in half and place it on top, for extra thickness.

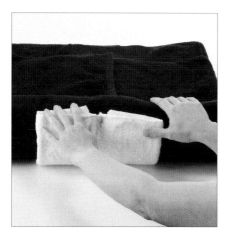

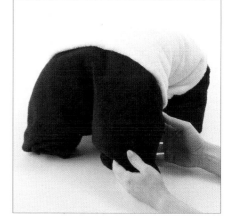

3 Indicate the center of the folded black towel horizontally, then roll the upper and lower edges to meet at the center point, with the white hand towel on the outside. The rolled-up sausage shapes will form the panda's legs. Use a safety pin to secure the rolls at the center.

4 Take the rolled shape in both hands and carefully bend it in half, taking care not to loosen the rolls as you do so. Stand the panda's body on a flat surface and arrange the rolls at each lower leg, so that it is able to stand up firmly by itself.

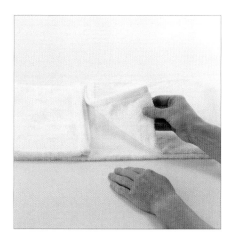

5 Use the remaining white hand towel to form head shape 1 (see page 11). Lay it out horizontally. Fold it in half by bringing the lower edge up to meet the upper edge. Make a 3-inch (7.5-cm) fold along the lower edge, then fold in the side edges to meet at the center.

6 Take the lower right-hand corner of the folded towel and roll it toward the center of the upper edge. Do the same with the other side to form a triangular shape. Now slip one hand underneath the shape and flip it over to the other side. Use a safety pin to hold the shape secure at this stage.

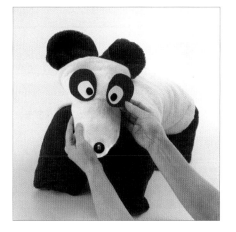

7 Take the black face cloth and fold it in half diagonally, then roll it up loosely from the diagonal edge. Fold the two pointed corners over to form two rounded ear shapes. Now fold the face cloth in half and tuck it into the top of the panda's head. Secure the panda's head to the body with safety pins.

8 Cut out eyes from black-and-white paper and position them on the panda's face. Use double-sided adhesive tape on the reverse side to keep them in place. Finish off with a button nose.

MONKEY

1 brown bath towel
for body and arms
1 brown hand towel for head
2 plastic eyes
fixing kit (see page 8)

This cheeky little guy can be arranged to sit on a bed or chair quite easily (although his head may need a little assistance from a safety pin). The body shape holds together very well due to the nature of the rolls and twists, allowing a little more scope for creative expression. You can hang the monkey by one or both arms from the shower rail in the bathroom, but be sure to use another safety pin to secure his arms so that he stays put.

TOP TIP

If you choose to use straight pins instead of safety pins, make sure that they are large and have colored glass heads. This will ensure that they do not get lost in the fluffy pile of the towel.

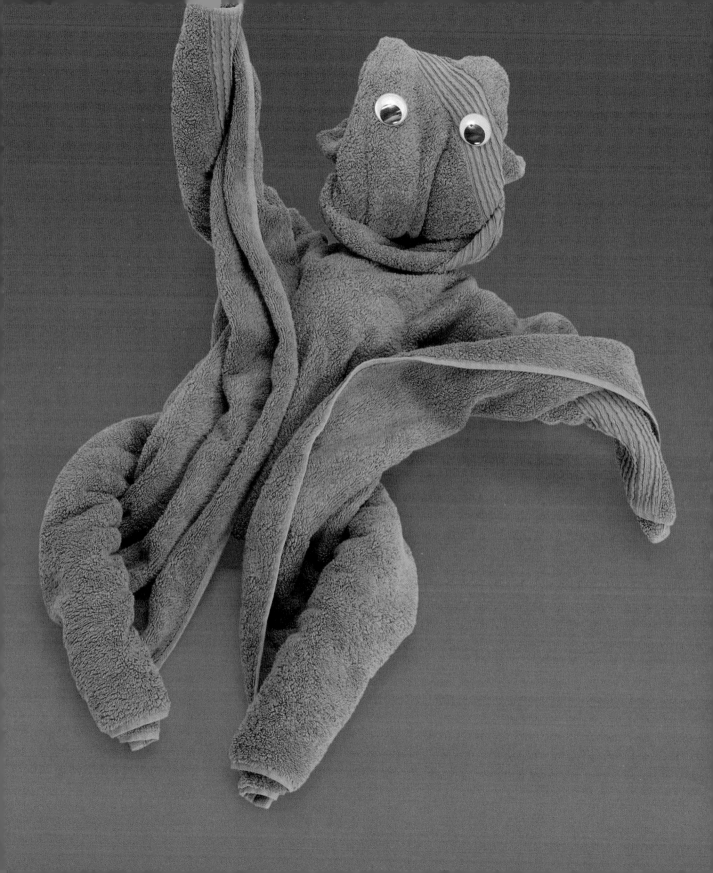

MONKEY

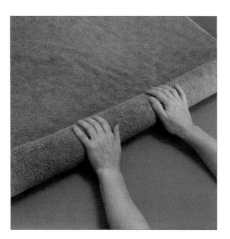

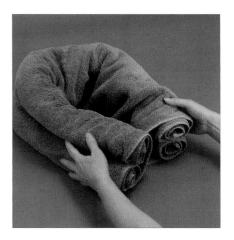

1 Use the brown bath towel to form the basic four-limbed body shape 1 (see page 10). Lay the towel out vertically. Fold it in half lengthways and press the fold flat to indicate the center, then open out flat again. Roll both the short edges tightly toward the center.

2 Grasp the rolled-up towel in both hands and bend it in the middle. Make sure that the rolls do not loosen as you do so and that the rolls face outward.

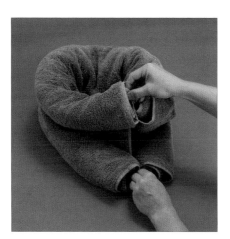

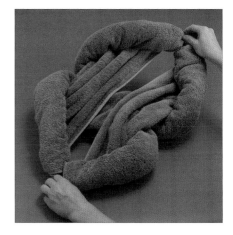

3 Find the corner of the towel inside each roll and pull each one out a little. Take two corners in each hand, then pull out firmly. This can be a little difficult at first.

4 The rolls will tighten as you pull out the points, which in turn will twist to form the monkey's arms and legs. The area in the center can be manipulated to form the body.

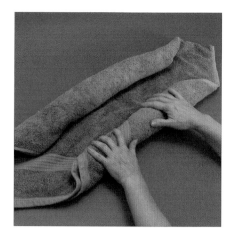

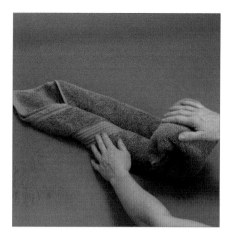

5 Use the brown hand towel to form head shape 2 (see page 11). Lay it out flat vertically, then fold in half to form a square. Press the fold flat. Now roll the towel diagonally from the top left and bottom right-hand corners toward the center.

6 Hold the rolls in one hand then roll the bottom point up toward the free points using the other hand. This will form a tight ball shape and the basis of the monkey's head.

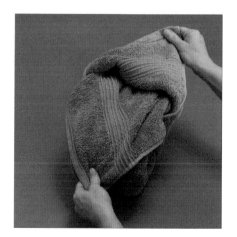

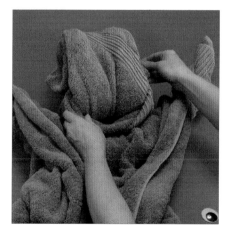

7 Turn the rolled shape over and peel the top layer of the point backward to cover the shape and to form the monkey's mouth. Tuck all the ends into the folds behind the head and secure using a safety pin.

8 Arrange the monkey's body so he can sit up or hang from the shower rail. Balance the monkey's head on top using a safety pin to secure the head to the body. Add eyes to the head using double-sided adhesive tape.

OWL

YOU WILL NEED

1 brown-striped bath towel for body

1 beige bath towel for body padding

1 beige bath towel for head

1 brown face cloth for ears and beak

1 brown guest towel for wings

black felt rounds for eyes

2 plastic eyes

2 pumice stones or soap bars for feet

fixing kit (see page 8)

This little bird fellow looks very serious indeed. We have not been specific about the owl species, but if your inner ornithologist gets the better of you, then you could make your model quite accurate using correctly colored towels. Perhaps use brown-and-white fluffy towels to make a barn owl, or plain white for a snowy owl? There are several hundred species of owl around the world, so there are plenty to choose from.

TOP TIP

This model would work well as a base for any perching bird, with different-colored towels. You could even make chickens or a Thanksgiving turkey.

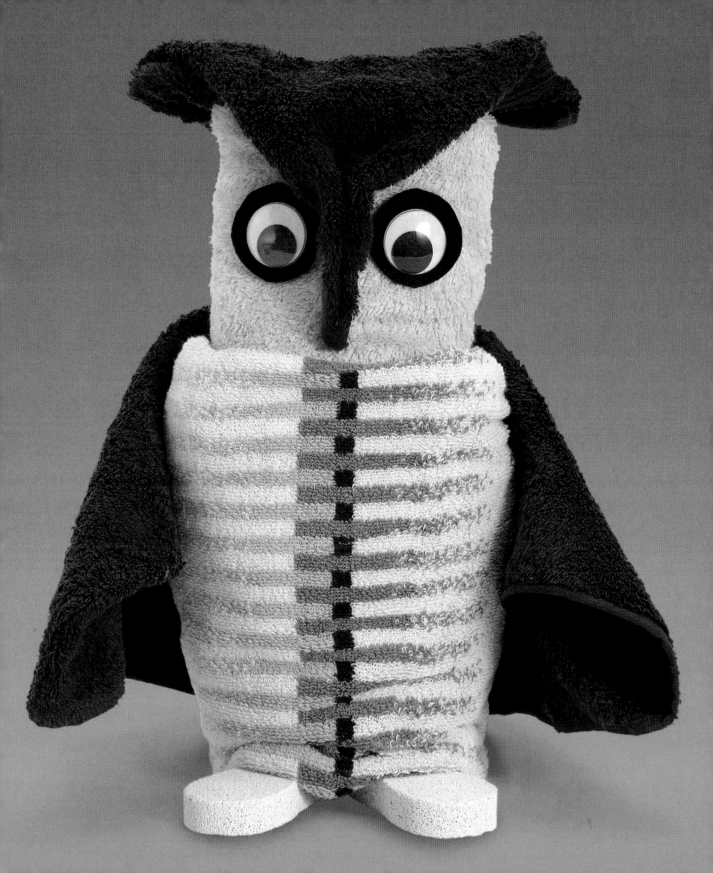

OWL

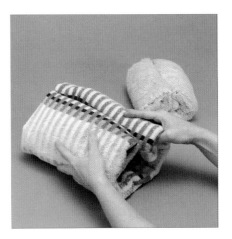

1 For the body, lay the striped bath towel out vertically and fold in half, short edges together. Fold the beige bath towels to form two cylinders and secure the overlap with safety pins. Wrap the striped towel around one cylinder and secure the overlap. Keep the other cylinder for the head.

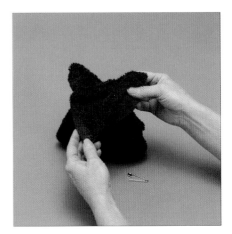

2 For the ears and beak, take the brown face cloth and lay it out flat. Pinch the two diagonally opposing corners into two pointed ear shapes. Hold the folds in place with two small safety pins.

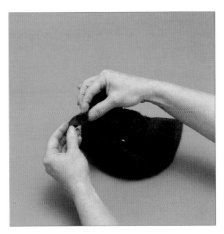

3 For the beak, grasp the corner of the face cloth that lies between the ears, then pin together from underneath to form a pointed shape.

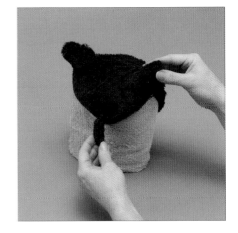

4 Place the beak and ears onto the rolled head. You may need to use a few safety pins to hold it securely in place. Pull the beak down over the face and tuck the remaining corner neatly into the back of the neck.

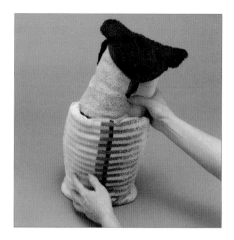

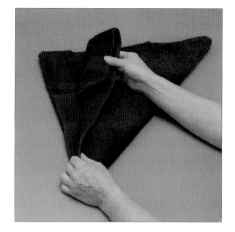

5 Place the rolled head with beak and ears onto the body.

6 For the wings, take the remaining brown guest towel and lay it out horizontally. Fold in half by bringing the short edges to the center. This will form a square shape. Fold the square diagonally to make the triangular wings.

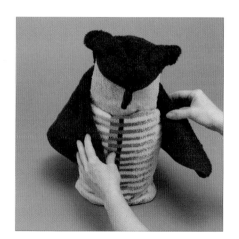

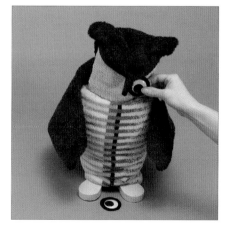

7 Secure the center of the long top edge of the wings to the back of the neck with safety pins. Bring the points around toward the front of the body. Arrange the folds so they curve slightly away from the model on both sides.

8 Finally, your owl needs big eyes to see in the dark. Cut two 2-inch (5-cm) diameter circles from the black felt. Fix an eye to the center of each, then position on the owl's face with double-sided adhesive tape. Add two soap or pumice stone feet to the base to complete the model.

PORCUPINE

YOU WILL NEED

1 beige bath towel for body

1 beige hand towel for head

1 brown bath mat for quills

2 plastic eyes

fixing kit (see page 8)

Porcupines are largely nocturnal so you would have to be lucky to see them in daylight. Instead, they are mostly seen at night, often foraging for food. They are usually found among the high branches of trees and love to chew and gnaw. A porcupine is occasionally found in human habitats. You can have your own bathroom porcupine with this project— but give it space and keep away from its spiny quills.

TOP TIP

With a little imagination and differently colored towels, this model can be used to create any spiny or fluffy creature that is similar in shape, such as a skunk, racoon, or beaver.

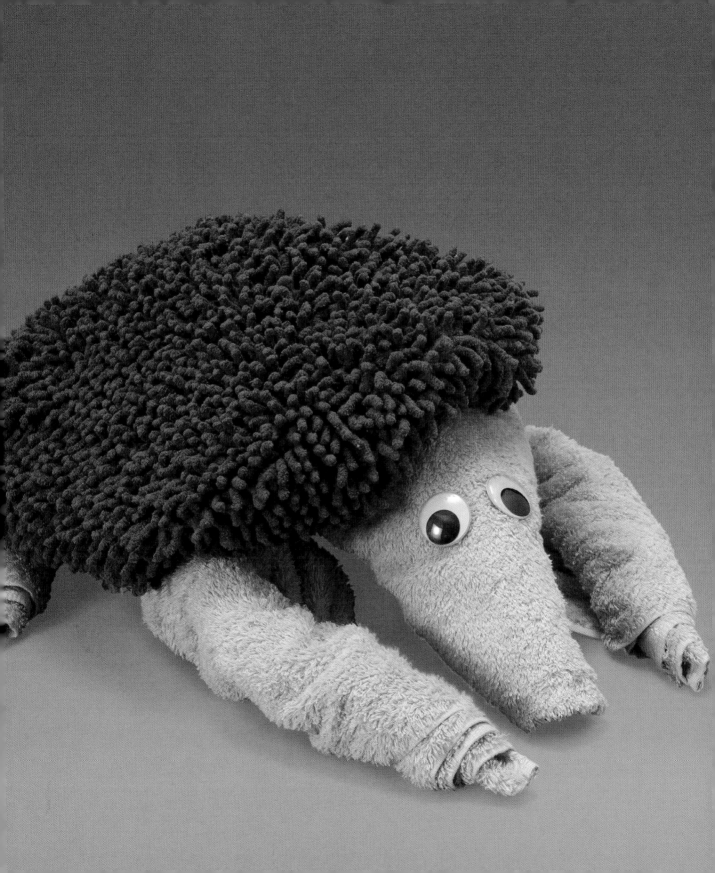

PORCUPINE

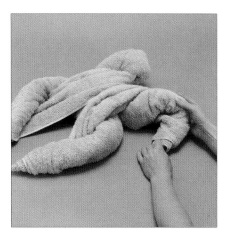

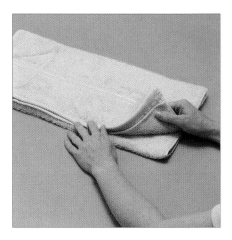

① Using the beige bath towel, roll it into the basic four-limbed body shape 1 (see page 10). Use a safety pin to secure the center of the body. Place the body in position, then arrange the four legs neatly pointing forward.

② Use the beige hand towel to form head shape 1 (see page 11). Lay it out vertically and then fold it in half by bringing the short edges together. Fold in half again to form a wide band.

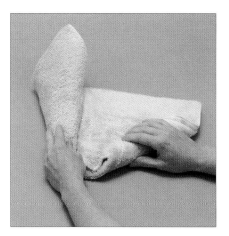

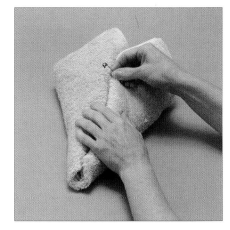

③ Pick up the lower left-hand corner and roll diagonally toward the center of the band. Now pick up the lower right-hand corner and repeat. This forms a pointed head shape, tapering to the nose.

④ Use a large safety pin to secure the rolls close to the top of the head shape. Use another pin closer to the nose, if necessary. Pick up the head and flip it over to the other side so the pins are hidden from view.

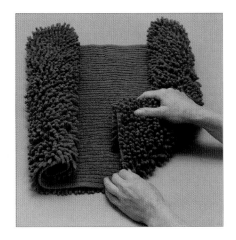

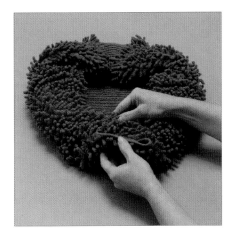

5 Lay out the bath mat horizontally with the wrong side upward, for the porcupine's coat. Roll both short edges toward the center about a third of the way across the mat on both sides. Fold the lower two rolled ends toward the center. This forms a point at the lower edge. Do likewise at the upper edge.

6 Fold both upper and lower points around the rolled ends, and secure using safety pins. This will form a softly rounded shape that can be molded to fit the porcupine's body.

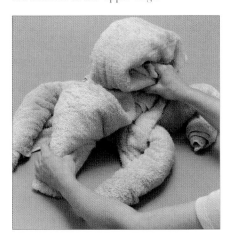

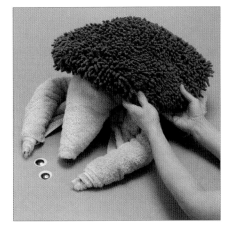

7 Position the head in front of the body. Roll up the remaining bath towel into a sausage shape, then into a loose coil to form a rounded pad in order to support the spiky bath mat. Place the pad onto the porcupine's back.

8 Flip over the bath mat to the right side and place on top of the body. Place two dark beady eyes on his face. If your porcupine is looking a little flat, simply tuck a bath sponge under the bath mat along the back to raise the profile.

SEASIDE

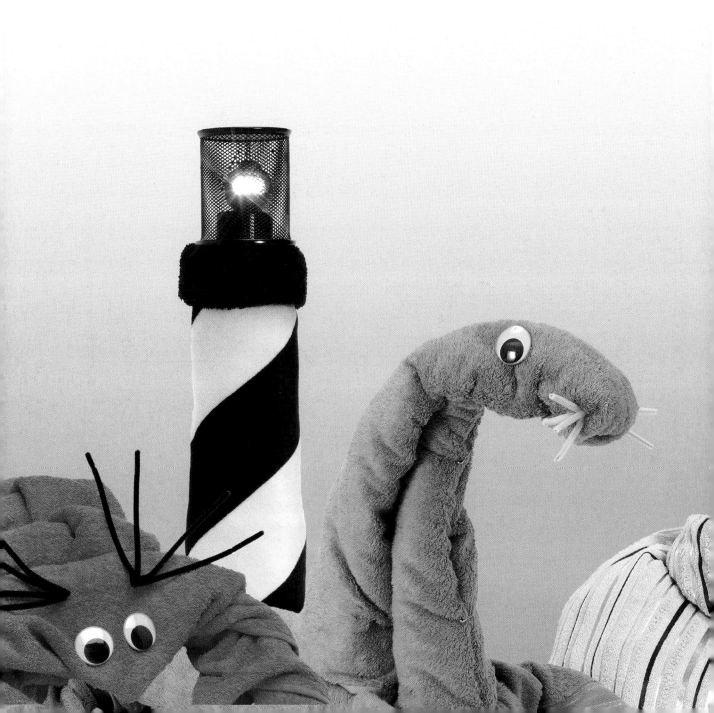

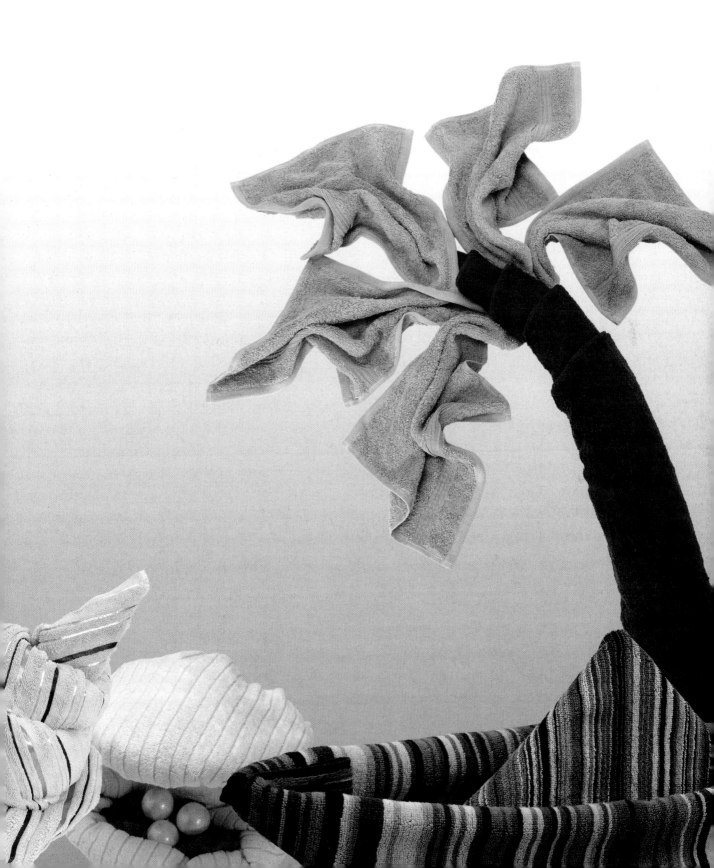

LIGHTHOUSE

YOU WILL NEED

1 red hand towel for plinth

1 black-and-white striped beach towel for tower

1 white hand towel for padding

1 black face cloth for top

mesh pencil cup or clear plastic tub for light casing

small flashlight for light

fixing kit (see page 8)

This model is a version of the 208-foot (63-m) high Cape Hatteras Lighthouse on South Carolina's Outer Banks. In 1999, due to land erosion and the encroaching sea, the local townsfolk decided to move the whole thing half a mile inland. It was jacked up and moved, very slowly and precariously, along roll beams to a new safe location, where it remains today. Your lighthouse won't be so hard to maneuver, however. Simply pick it up and place it wherever you want. You could even try a red-and-white towel for your lighthouse instead.

TOP TIP

Instead of the flashlight, you could use a red or yellow bath bomb in a plastic food tub as a beacon.

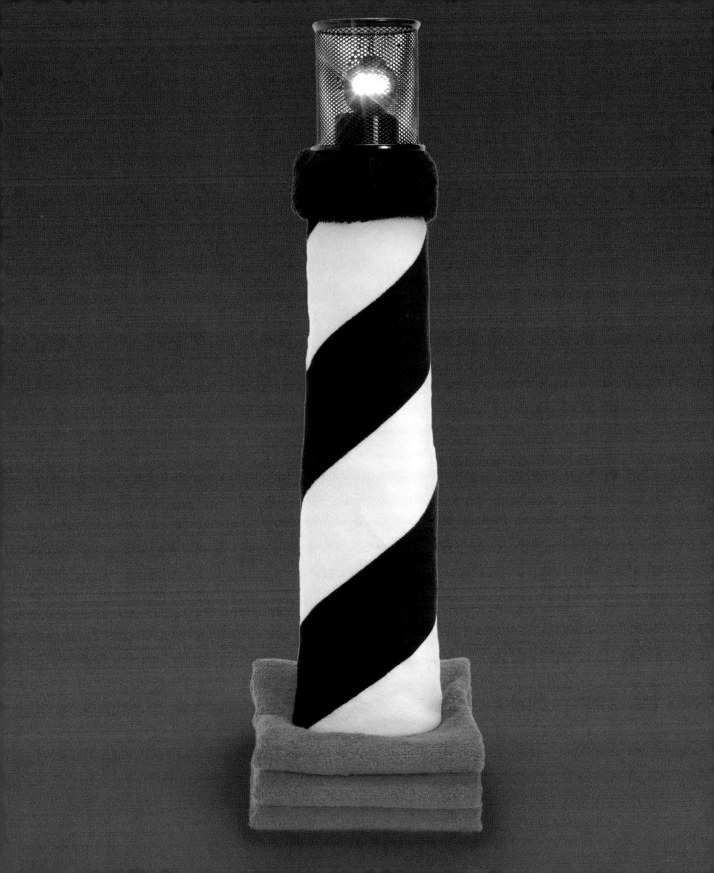

LIGHTHOUSE

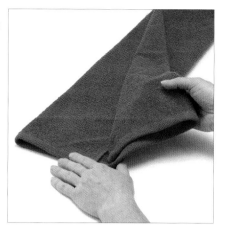

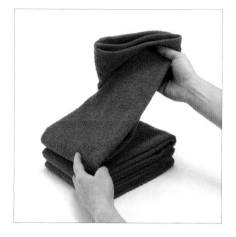

1 For the plinth, take the red hand towel and lay it out vertically. Fold it in half by bringing the tapes to the center and then fold in half again to form a long band.

2 Press the folds of the band flat using the palms of your hands. Now fold the band in a concertina-like fashion to form a thick, rectangular box shape. This will form a sturdy base for the lighthouse to stand on.

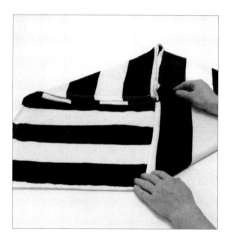

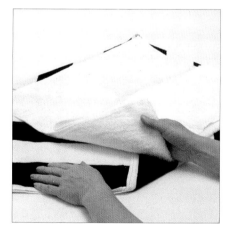

3 For the lighthouse tower, lay the black-and-white striped towel out horizontally and fold in half by bringing one short edge to meet the other, forming a square shape. Now fold three corners toward the center.

4 Fold the small white hand towel in half to form a square and place it on top of the striped towel. This provides padding and stability to the lighthouse tower.

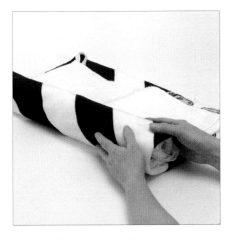

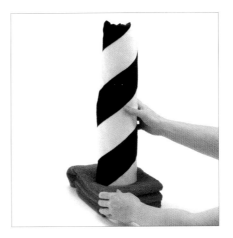

5 Roll up the towel from the remaining corner, then secure the overlap using a few safety pins. Manipulate the roll so it is a little wider at the base than it is at the top. This will provide extra stability and be more authentic in appearance.

6 Balance the rolled tower on the red folded plinth. It should stand securely on its own, but if it looks a bit wobbly, simply secure with a few pins around the base.

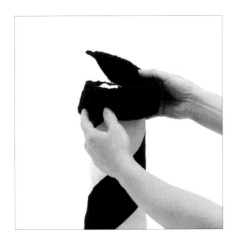

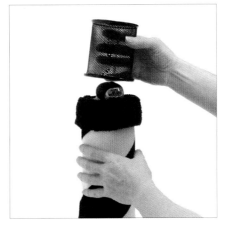

7 Take the black face cloth and fold two diagonally opposing corners toward the center. Now roll the shape into a loose sausage, beginning at one of the folded edges. Wrap the face cloth around the top of the lighthouse and secure the overlap with a safety pin.

8 To complete the lighthouse, place a small flashlight at the top then cover it with a metal mesh pencil cup.

SAILING BOAT

YOU WILL NEED

1 small hand towel, striped

Don't we all love to relax in the sunshine beside the ocean, listening to the sea lapping the shore and watching all the little sailing boats floating by? Make your own sailboat for the bathroom. You could place your boat on a blue towel with a few ripples to suggest water. This is a simple model to make in paper, but a little tricky using a floppy towel, so use towels that are as stiff as possible.

TOP TIP

Try a few practice runs with a small square of paper before you make your towel boat.

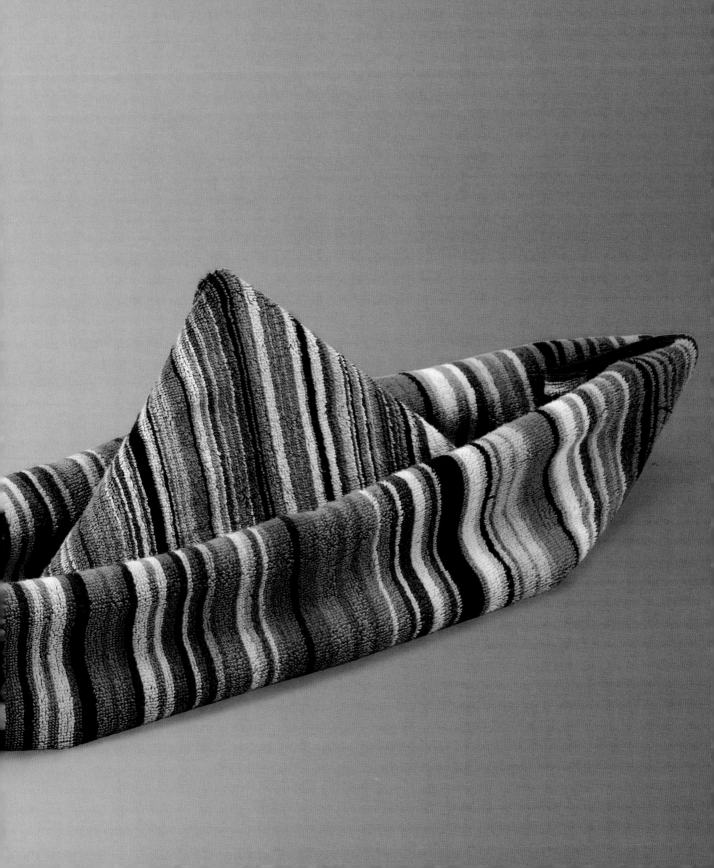

SAILING BOAT

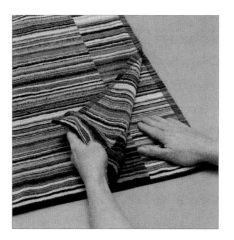

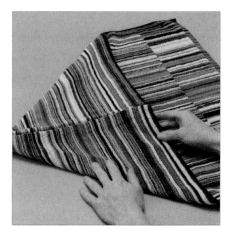

① Lay the towel out horizontally. Fold in half by bringing the short edges together on the right-hand side.

② Bring both corners of the folded edge toward the center to form a pointed arrowhead shape. Press the folds flat using the palm of your hand.

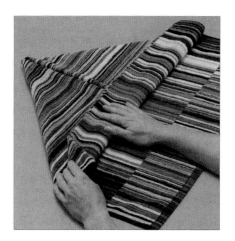

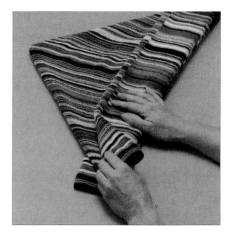

③ Now pick up the top layer of the lower edge and fold it upward toward the point. Slip your hand underneath the folded shape and carefully flip it over to the other side. Repeat with the remaining layer.

④ Take up the folded shape at each side now, and gently ease the sides together to form a diamond shape. This can be a little tricky if the towels are soft.

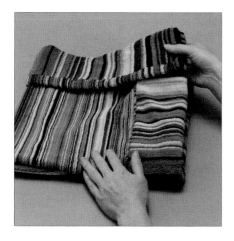

5 Make sure that the corners of the base edge folds overlap. You can secure the overlaps with a few safety pins just to make sure that the boat doesn't fall apart in the next step.

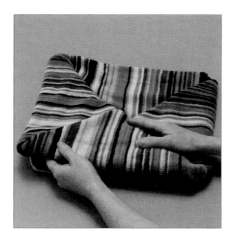

6 Fold the top point of the diamond shape toward the bottom, taking care to keep the initial folds in the correct positions. Press the shape flat using the palm of your hand.

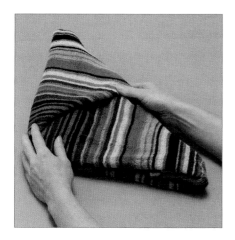

7 Slip your hand under the folded shape and flip it over to the other side. Repeat the last step to form an inverted triangular shape, then press flat as before.

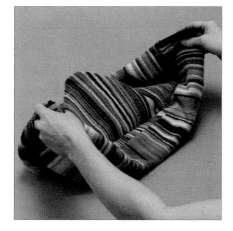

8 Gently bring the left and right points of the triangle together so the towel falls into a diamond shape again. Grasp both sides of the upper corner and draw gently outward to form the boat shape.

PALM TREE

YOU WILL NEED

1 brown bath towel

5 green face cloths

Everyone needs a reminder of the beach when it's cold and snowy outside. You can re-create a taste of the tropics in your bathroom any time of year—just use your bath towels. These amusing palm trees are so simple to make that in a short time you could create an entire desert island, full of palms gently swaying in the breeze. You could also place colored round soaps or candy at the top of the trunk, to look like coconuts.

TOP TIP

This palm tree will not stand up by itself and should be displayed on a flat surface.

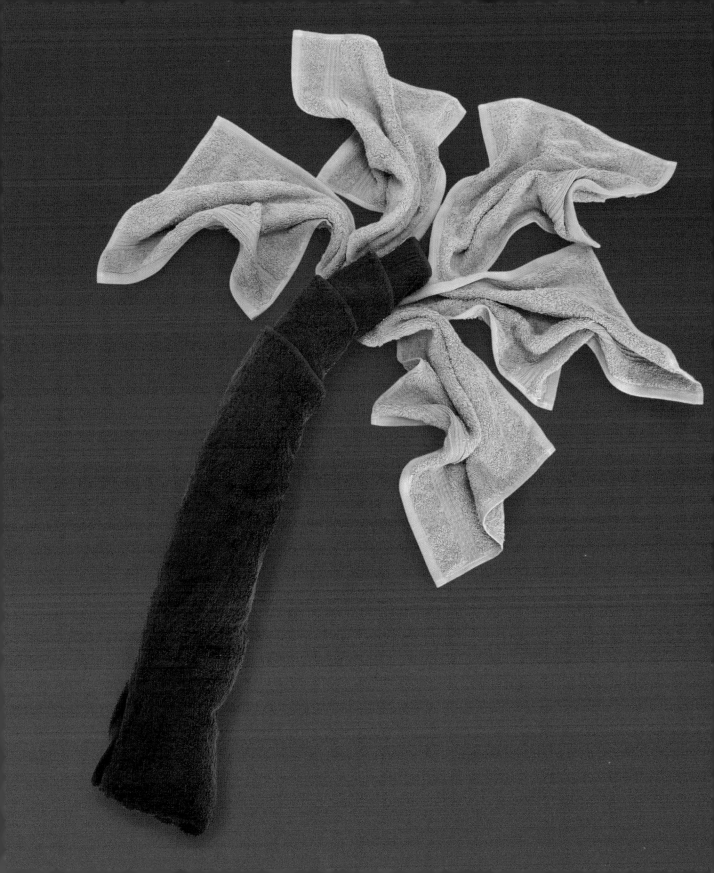

PALM TREE

1 Lay the brown bath towel out flat horizontally and roll the towel up tightly and evenly across the width from the right-hand side to the left-hand side.

2 Grasp the roll firmly in one hand and find the corner of the towel inside the roll at the top. Pull the corner out of the roll to make the tapered palm tree trunk.

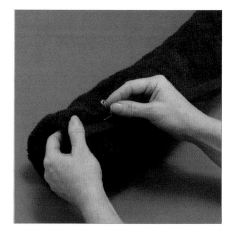

3 Tuck the lower ends of the trunk inside the lower rolled layers to make a thicker shape.

4 Use several safety pins to hold the overlap secure. You can turn the trunk around so they will be obscured when you arrange the completed model.

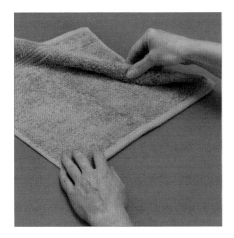

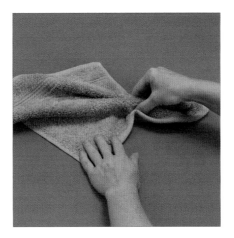

5 For the palm leaves, take up a green face cloth and lay it out flat. Hold the bottom left-hand corner then pinch the fabric just below the top right-hand corner to make a diagonal pleat and fold.

6 Do likewise to make a second diagonal pleat in the face cloth and fold by pinching the fabric above the lower right-hand corner.

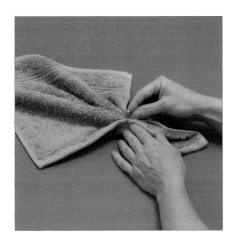

7 Use a small safety pin to hold the pleats secure at the center. This will allow you to manipulate the leaves in the finished model.

8 Lay the tree on a flat surface and bend the shape slightly. Place the face cloth leaves at the top and arrange into a pleasing design.

CLAM SHELL

YOU WILL NEED

1 aqua-and-white ribbed hand towel

1 white elastic hair band

1 white and 1 blue face cloth for padding and base

bath pearls or shell shaped soaps to fill the shell

fixing kit (see page 8)

This is a small, simple design made from one towel with the addition of a face cloth inside. It stands by itself and you can fill it with lovely scented bath pearls or a pretty soap. We have used an aqua-and-white ribbed towel for the shell but you can use any color that complements your bathroom. The design works as a king-size shell, too—making lots more room for bathtime goodies inside.

TOP TIP

If you don't have a textured or ribbed towel, choose one that has narrow stripes to simulate the ridged surface of the shell.

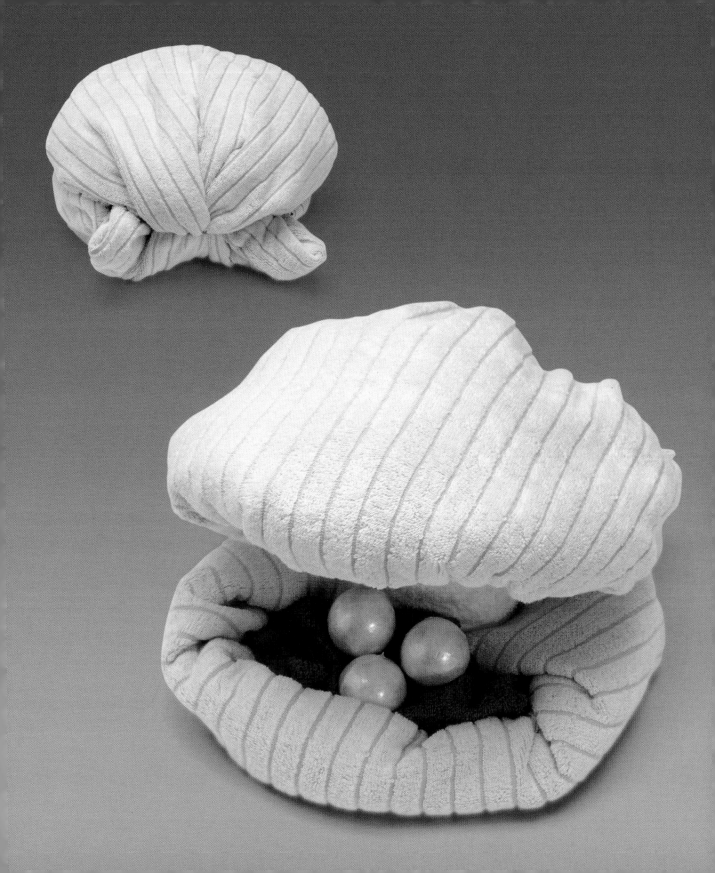

CLAM
SHELL

1 Lay the ribbed hand towel out vertically and fold in half by bringing the short edges toward the center. Take the elastic hair band and wrap tightly around the center to gather up the fabric.

2 Begin to roll the lower half of the clam shell. Take up the lower edge and roll up tightly toward the gathered center. Stop rolling about 4 inches (10 cm) from the elastic band.

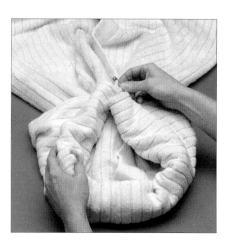

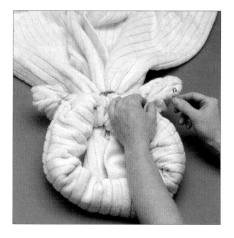

3 Take both ends of the roll and bend so the ends meet in the middle, forming a dish shape. Use a large safety pin to secure the ends together. This will hold the bath pearls or soaps when the model is finished.

4 Tease out two hemmed edges close to the elastic band in order to form the fan-shaped hinge that joins the halves of a clam shell. You may need to manipulate the fabric a little to achieve a pleasing shape. Use a safety pin or two to keep the hinge in position if necessary.

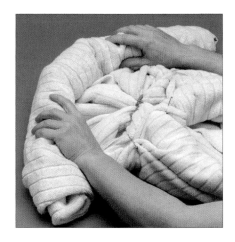

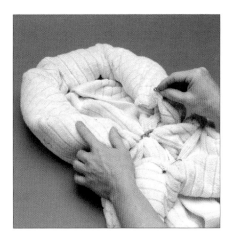

5 For the top half of the clam shell, roll down the upper edge of the hand towel in the same way as before. However, this time, continue to roll closer to the gathered center and the roll will then begin to curl and bend into shape.

6 Bring both ends of the roll together and fix securely with safety pins.

7 The upper half of the clam shell needs to be a rounded shape, so will require a little padding. Take the white face cloth now and roll it into a thin sausage shape, beginning at one corner. Coil the sausage loosely, then place inside the shell.

8 Bring the upper half of the clam shell over the base. Tease the folds at the hinge so they don't interfere with the opening and closing action. Fill the base of the shell with bath pearls or with tiny shell-shaped soaps, sitting on a blue face cloth.

DOG WHELK

YOU WILL NEED

2 striped bath towels

fixing kit (see page 8)

The characteristic spiral whorls of a dog whelk shell conceal a sinister driller-killer. Did you know that dog whelks feed on other shelled creatures, such as mussels, top shells and limpets? They use sharp grinding teeth on their tongue to drill a small hole in the shell of their prey then eat the flesh inside. You can often find shells of their prey with holes drilled through them—handy for making a necklace. Make your own dog whelk for the bathroom and perhaps embellish the scene with pebbles, shells and plastic crabs.

TOP TIP

Shells come in all shapes but follow the same spiral form. Try using the basic method with thinner towels to make longer, slimmer shapes.

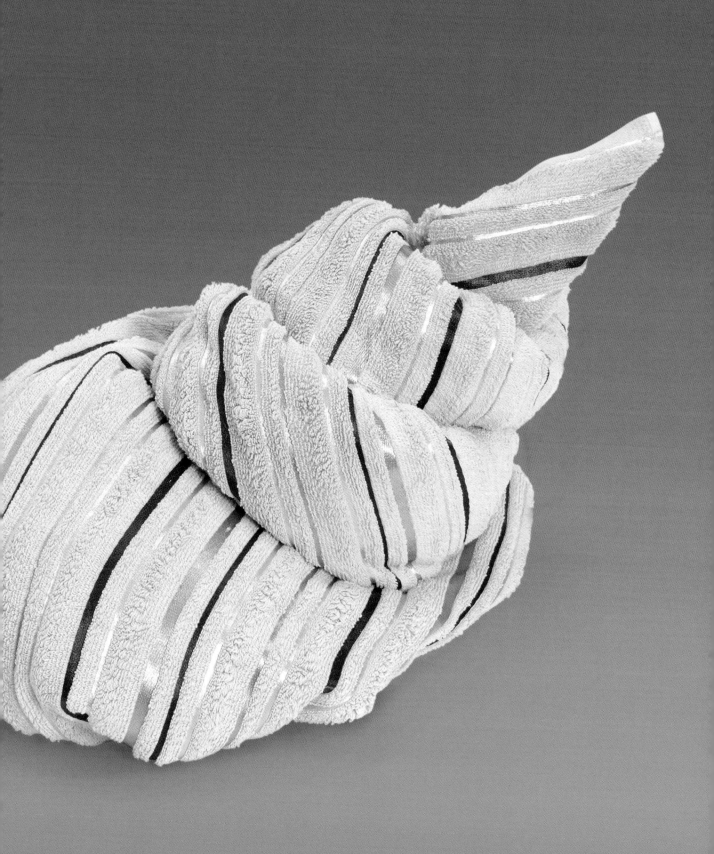

DOG WHELK

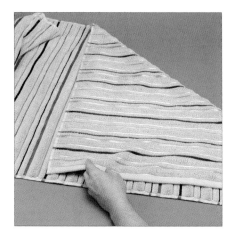

1 Lay both towels out side by side horizontally and overlap the short edges at the center. Secure with several small safety pins. You could use a really big bath sheet as a substitute for two bath towels.

2 Fold the lower right-hand corner at right angles. The diagonal folded edge will form the opening of the shell at the bottom, becoming the blunt end of the pointed shape. Pin the center of the hind leg roll to the underside of the body.

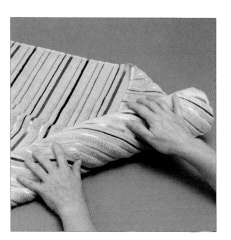

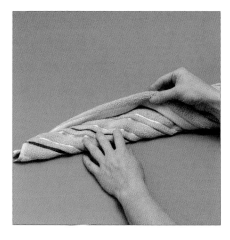

3 Start to roll the towels from the bottom-left, stretching out the towel from the extreme left-hand point as you go, so the roll will be thinner at the left-hand end.

4 As the roll approaches the upper edge of the towels, fold the edge inward to conceal the hemmed edge within the roll. This fold will form a neat overlap when the roll is complete.

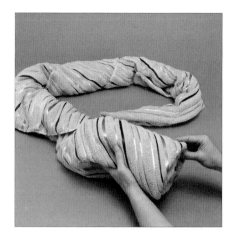

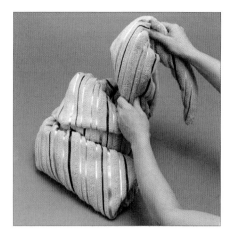

5 Take both ends of the roll and stretch it slightly so it forms a smooth shape. Use a few small safety pins to secure the overlap along the length of the roll.

6 Wind your shell into shape with the blunt end at the base. The finished size of your shell will depend on the size of your towel and you will need to press and squeeze the towel into shape. Use a few safety pins to hold the spirals in place if your towel doesn't do this naturally.

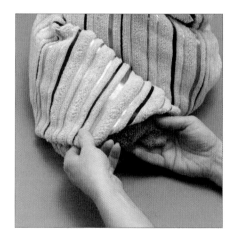

7 Open out the blunt end of the roll a little to form the shell opening. The dog whelk is now complete.

DOG WHELK

 # CRAB

YOU WILL NEED

1 orange beach towel
2 small buttons for eyes
fixing kit (see page 8)

A bright orange crab would look very comfortable sitting on the edge of the bath, ready to jump into the water for a swim. Accessorize your seaside scene with some real shells, starfish and pebbles. Perhaps place some shell-shaped soaps and bathtime goodies inside the crab to surprise your guests. You'll need just one large towel to make this fellow, although the shape translates quite well using smaller sizes, too. Maybe you'd even like to make an entire crab family using hand towels.

TOP TIP

To make the crab look more realistic, slip a rolled-up face cloth under the finished form to give it a little height.

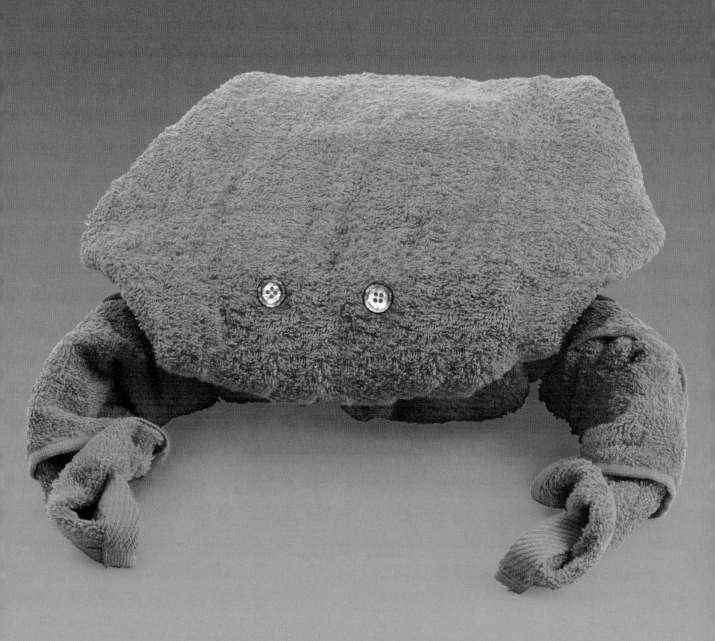

CRAB

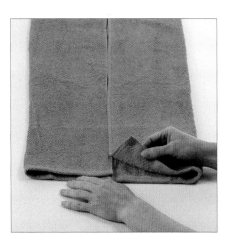

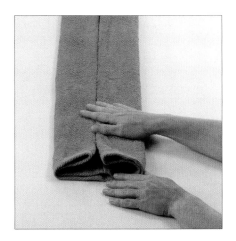

1 Lay the beach towel out vertically, then fold both long side edges to the center. Now press the folds at both sides flat using the palm of your hand.

2 Repeat the first step, bringing the sides to meet at the center of the towel. Then press all the folds flat in order to reduce the bulk of the folded shape.

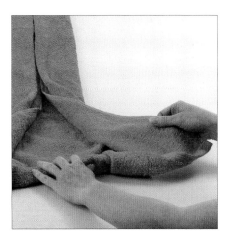

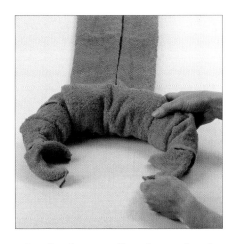

3 Open out the lower edge to form the head and claws, taking care not to disturb the folds that run from around the center of the towel to the top edge. Roll the center of the lower edge upward, causing the two outer edges to splay out.

4 Continue to roll up the towel at the center to form a fat, rounded shape that will represent the crab's head. As you do so, the two lower corners will begin to turn inward. Model the two corners to resemble claws.

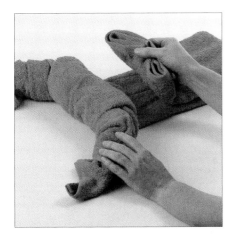

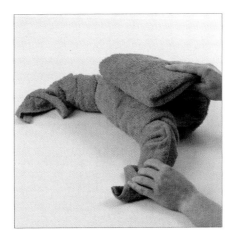

5 When the head and claws are complete, run your hand along the remaining folds to flatten them out again. Bring the top edge downward and tuck it behind the head shape formed in the previous step.

6 Place one hand on top of the folded shape to keep it in place, then put your other hand inside.

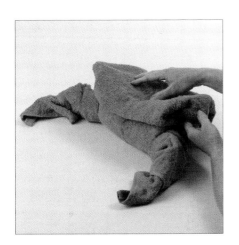

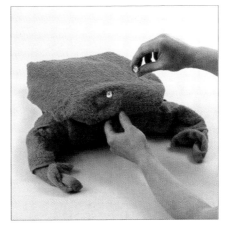

7 Pull out the fold from inside to make an oval-shaped shell, then do the same on the other side to create a symmetrical form.

8 Stick on button eyes using double-sided adhesive tape to complete your crab.

 # LOBSTER

YOU WILL NEED

*1 orange bath towel
for head and legs*

Elastic band

1 orange hand towel for body

2 eyes

Watch out... you'll need to be careful when this little fellow's about. He's got two very fierce-looking claws, ready to give any unsuspecting bather a little nip. Our lobster forms quite a long, but easily manipulated shape. Why not coax the shape to fit around the tap or at the corner of the bath, then place some pretty shell- or starfish-shaped soaps into his claws to complete the theme?

TOP TIP

If you prefer, you can make a
smaller lobster using just one towel.

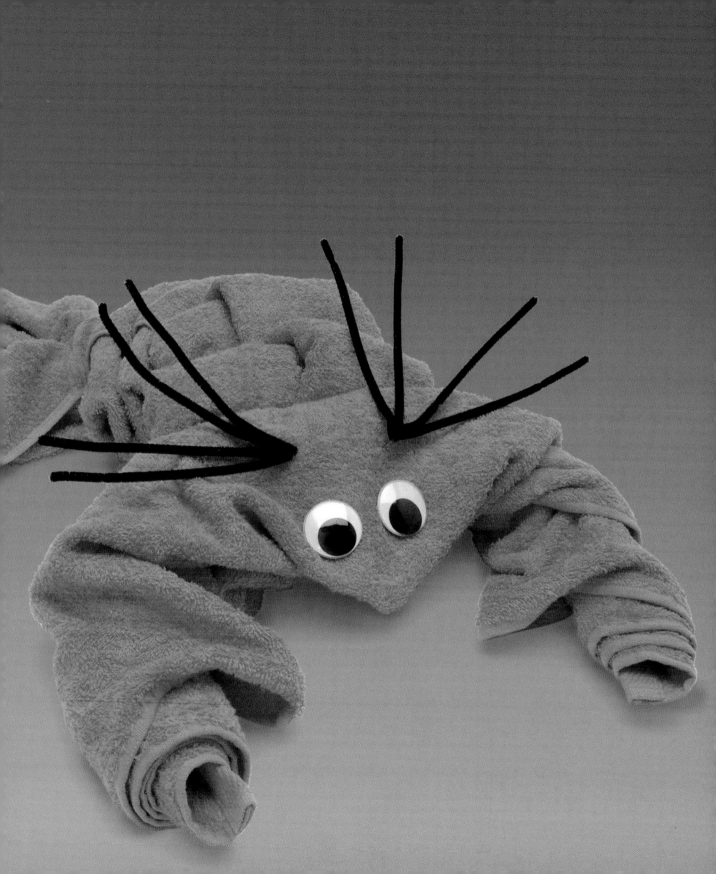

LOBSTER

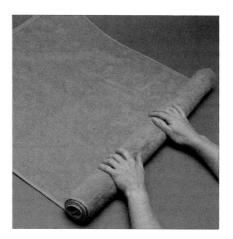

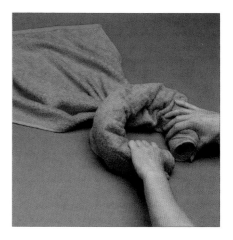

1. Lay one orange bath towel out vertically and roll up one short edge to approximately one-third the length of the towel.

2. Gather in the towel above the roll. Bring the two ends of the roll together to form a shallow crescent shape. These will form the lobster's claws and head. Use an elastic band to hold in place. You can now begin to manipulate the lobster's snippy front claws into shape.

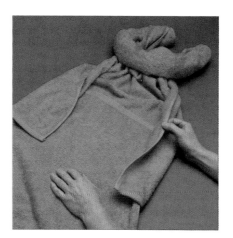

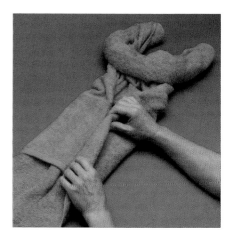

3. Take the orange hand towel and place it on top of the unrolled end of the first.

4. Now fold the long edges of the second towel around the unrolled section of the first. They should overlap at the center.

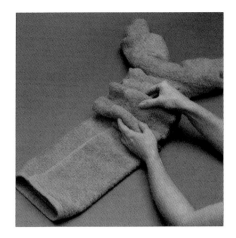

5 For the body, make a series of small pleats along the length of the folded towel that lies behind the head and claws. Leave about 4 inches (10 cm) at the end unpleated.

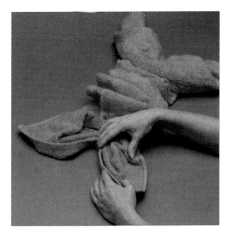

6 Pinch the towel tightly behind the last pleat. Now place your hand inside the folds and spread the towel out to shape the tail.

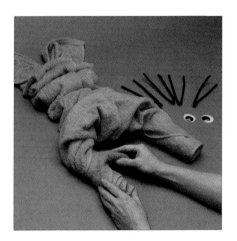

7 Finally, make some adjustments to your lobster's claws and the shape of the head. Fix a pair of eyes to the head with self-adhesive adhesive tape to complete the model.

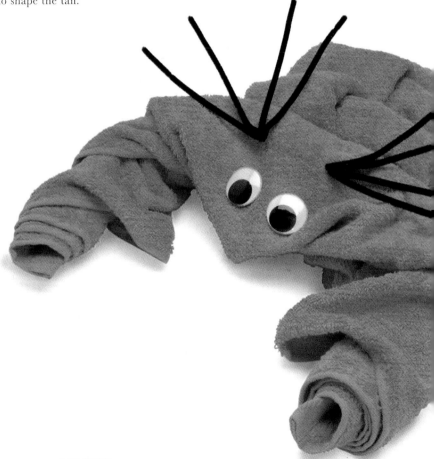

LOBSTER

SEAL

1 grey bath towel for back flippers and body

1 grey hand towel for front flippers and neck support

1 grey hand towel for head and neck

2 plastic eyes

3 white pipe cleaners for whiskers

fixing kit (see page 8)

Having your very own performing seal living in your bathroom can be a lot of fun—especially for the children. Give him a beach ball to play with and a sponge fish as a reward. Seals love the water, but they're really happy when basking on the rocks, safely out of the way of predators. We made our seal grey, which is the usual color of an adult. However, if you have some small white hand towels you could make some very cute seal pups, too.

TOP TIP

To ring the changes, you could give your seal a pair of large tusks and transform him into a walrus.

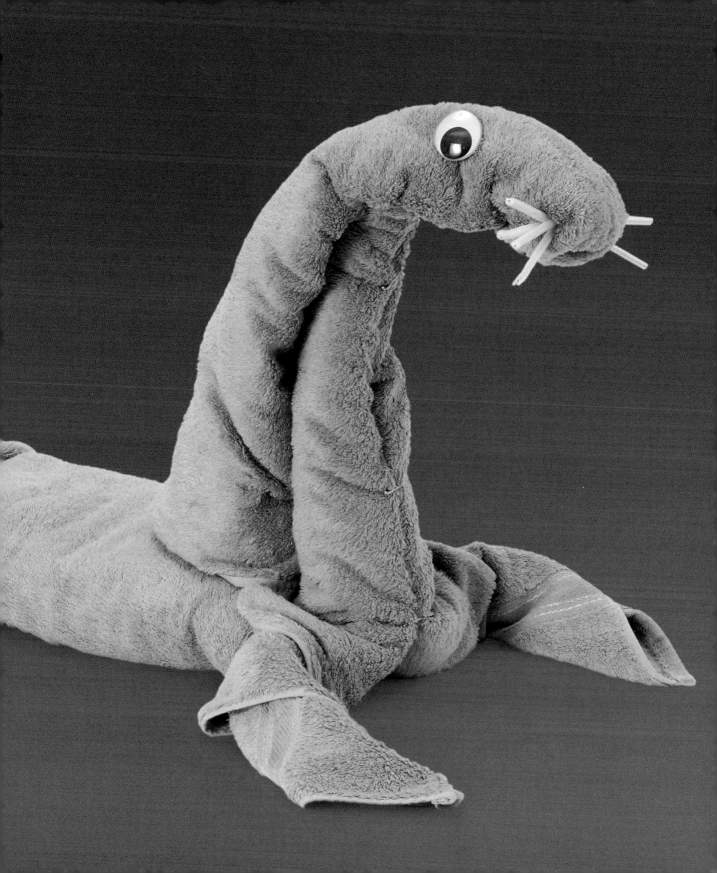

SEAL

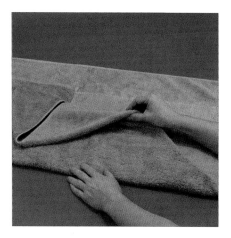

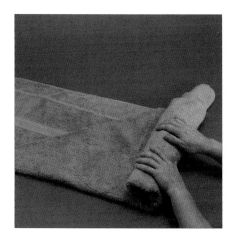

1 For the hind flippers and body, take the grey bath towel and lay it out horizontally. Fold the two lower corners toward the center to form an inverted triangular shape. Now fold the resulting point upward to meet the straight upper edge of the triangle.

2 Now roll one diagonal fold loosely toward the center of the towel, and then do likewise with the other side. Secure the rolls together using two large safety pins.

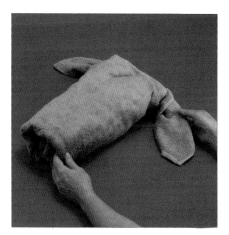

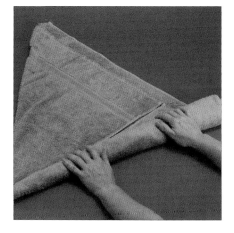

3 Now flip the rolled shape over to the other side, press the folds together from both sides to form a plump shape, and arrange the two pointed ends behind the shape for the hind flippers.

4 For the front flippers and neck support, take one hand towel and lay it out horizontally. Fold the two lower corners to the center, then roll both diagonal folds toward the center to form a slim pointed shape. Pin the rolls together using a safety pin.

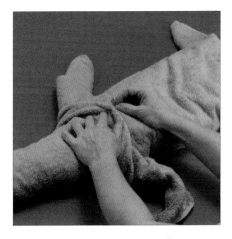

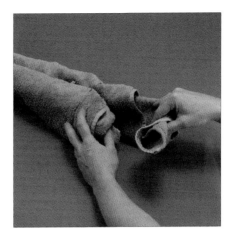

5 Place the rolled shape in front of the body. The long pointed end of the shape will form a neck support whilst the two corners will fold down to form the front flippers.

6 For the head, take the remaining hand towel, then fold and roll in the same way as step 4. Use a few safety pins to hold the rolls together, then tuck the corners into the rolled shape at the base.

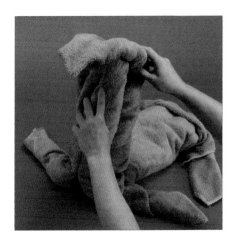

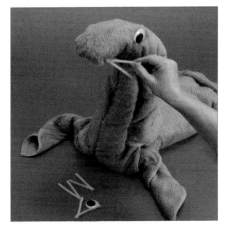

7 Place the head in front of the body and then fold up the neck support and tuck it between the rolls of the head shape. Use some pins to hold all the rolls securely in place then manipulate the head and neck into a pleasing line.

8 Add two eyes to the seal's face and add a few white folded fluffy pipe cleaners each side of his nose for whiskers.

MERMAID

YOU WILL NEED

1 beige bath towel for body

1 beige face cloth for neck

1 blue patterned beach towel for tail

2 blue net body exfoliators

2 scallop shells for upper body

2 eyes

fixing kit (see page 8)

This mythological creature is said to have the body of a woman and the tail of a fish. Folklore tells of mermaids singing songs to enchant unsuspecting sailors, luring them to their deaths on dangerous rocks. But there are also tales of mermaids rescuing drowning men from certain death in treacherous seas. Our mermaid is perfectly harmless… she may do a bit of singing in the bath, though.

TOP TIP

If you live near the sea you could accessorize your mermaid with real dried seaweed or other finds from beachcombing trips.

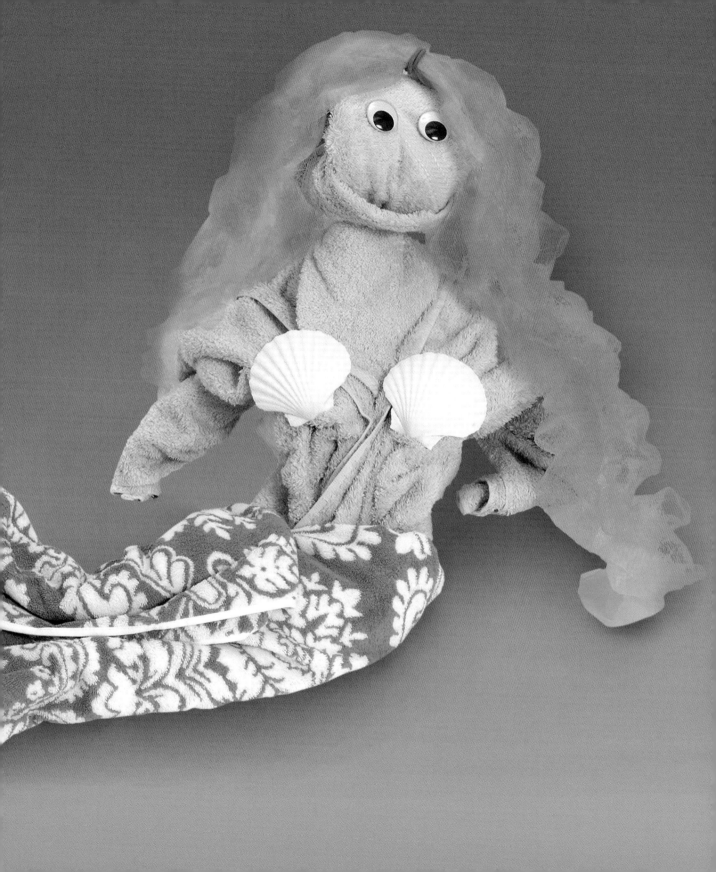

MERMAID

1 Take the beige bath sheet and roll it into the basic four-limbed body shape 1 (see page 10). Use a few large safety pins to hold the central fold together across the chest. This will hold the shape together to allow later manipulation of the body features.

2 Mermaids don't have legs, so twist the lower two limbs of the body shape together and secure with a few large safety pins. Now fold a beige face cloth diagonally into a triangle then roll loosely to form a neck.

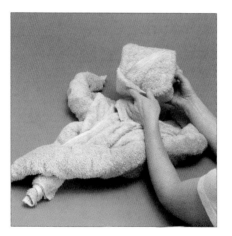

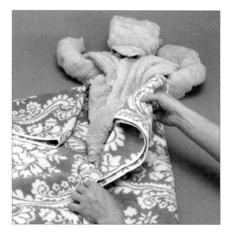

3 Use the beige bath towel to form head shape 2 (see page 11). Pin the overlap securely at the back then manipulate the mouth into an enchanting smile. Place the head onto the neck—you may need to use a support under the head such as a toilet roll or rolled-up hand towel.

4 For the tail, fold the blue towel in half then lay out vertically. Sit the mermaid body close to the top edge. Wrap the top edge around the mermaid's body then secure in place with safety pins.

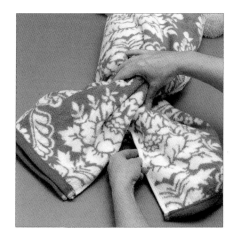

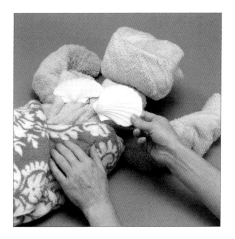

5 Pinch the towel to gather the fabric together, then splay out the lower edge. Roll the edge over once or twice then arrange to form the characteristic fish-tail shape.

6 Place two carefully positioned scallop shells on the mermaid's chest. These can be held in place with double-sided adhesive tape.

7 Place two eyes on the face and secure with double-sided adhesive tape.

8 To complete the mermaid model, unravel two blue nylon net body exfoliators and add to the top of the head for the mermaid's wild hair and position her arms and tail. You may need to use a few safety pins to secure her body or hair.

BUILDINGS

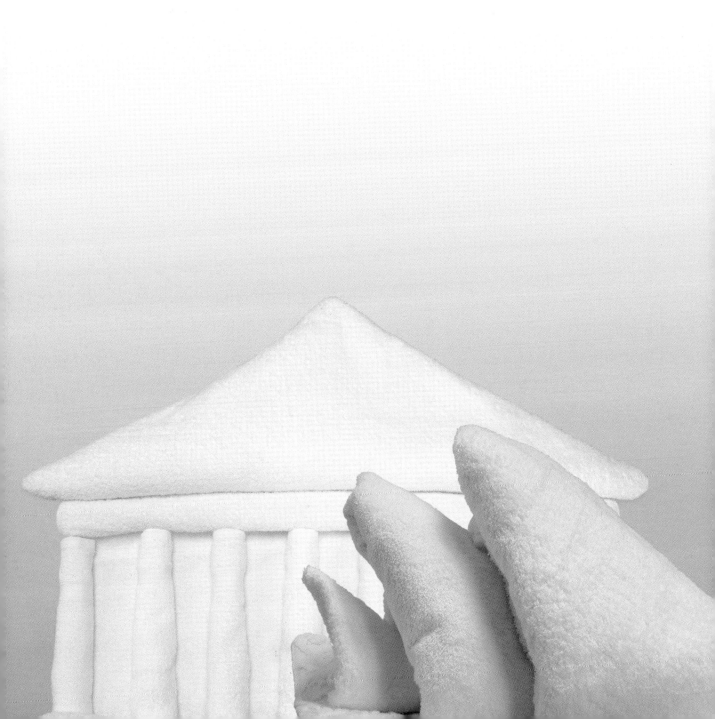

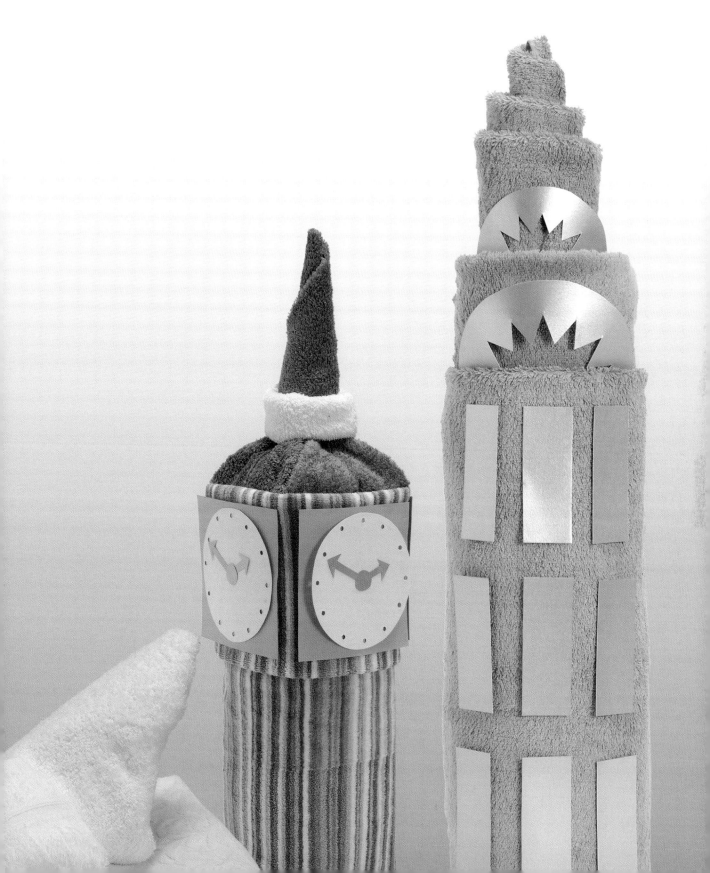

CHRYSLER BUILDING

YOU WILL NEED

2 gray bath towels for tower

1 gray bath sheet for tower

silver-colored paper for windows and details

fixing kit (see page 8)

All you city slickers will love this one—imagine a miniature Chrysler Building in your bathroom. OK, so it's not quite the same as New York City's famous landmark, but it does give a good impression and it is, after all, made from bath towels. This model is extremely useful when bathroom space is at a premium because it stands up by itself. Try balancing the building's shape on the corner of the bath.

TOP TIP

We made our skyscraper using gray towels but the model would work just as well using white or stone-colored ones.

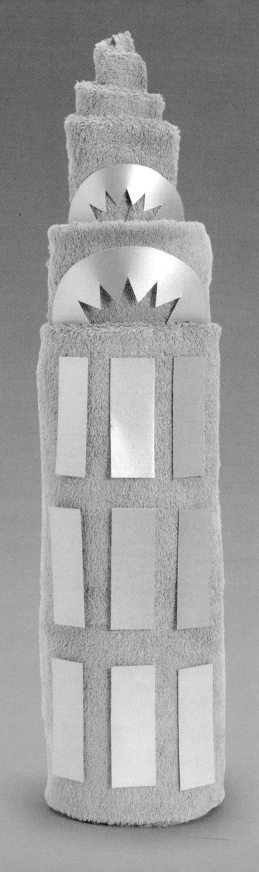

CHRYSLER
BUILDING

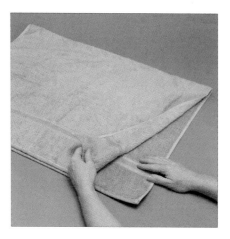

1 Lay one gray bath towel flat vertically, then fold in half, bringing the top edge down to meet the lower edge of the towel.

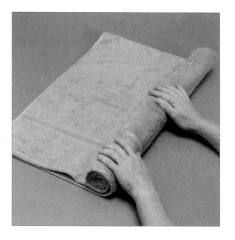

2 Roll up the towel tightly and evenly from the right-hand side toward the left, with the folded edge at the top.

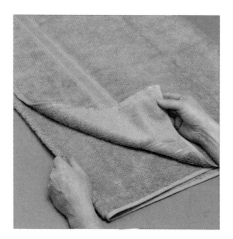

3 Take the large gray bath sheet and lay it out flat horizontally. Fold the towel roughly into thirds. Fold the left-hand edge first so there will be a fold, not an edge, lying at the right-hand side.

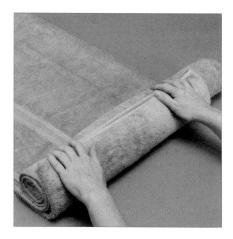

4 Lay the first rolled-up bath towel along the lower edge of the folded bath sheet. Then roll up both of them together, beginning at the lower edge.

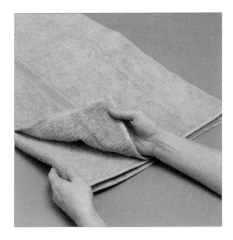

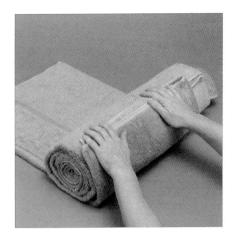

5 Lay the second gray bath towel out flat vertically, then fold into thirds. Press the folds flat with the palm of your hand.

6 Place the rolled towel and bath sheet onto the folded bath towel, then roll together. Secure the edges of the towels at the back of the shape with a safety pin so they do not come undone.

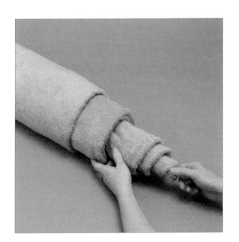

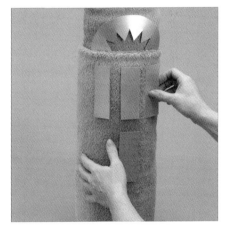

7 Locate the towel edge at the center of the longest roll and pull gently outward to form a slim tapered point for the top of the building.

8 Stand the tower up on end. Cut out the silver-colored card shapes and windows, then attach to the skyscraper. Use double-sided adhesive tape to hold the card shapes in position.

SYDNEY OPERA HOUSE

YOU WILL NEED

1 white bath mat for base

1 white face cloth for small shell

1 white face cloth for join

1 white bath sheet for large shell

*2 white bath towels
for medium shells*

This building can be described as an example of modern expressionist design. It is made up of a series of huge, interlocking shell-like structures. Situated on Australia's Bennelong Point, in Sydney Harbour, it is a close neighbour of the equally famous Sydney Harbour Bridge. The opera house model is surprisingly simple to make and you will find you can easily turn your hand to modern bathroom expressionism in no time at all.

TOP TIP

If any of your shell structures are unstable, support them on the inside using tall, slim bottles of bath foam or shampoo.

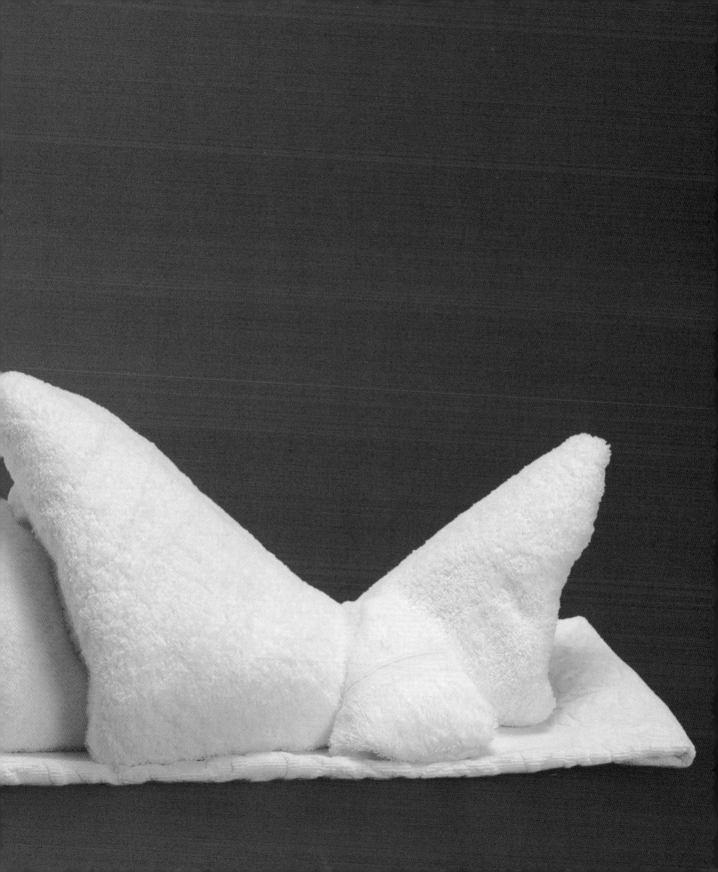

SYDNEY OPERA HOUSE

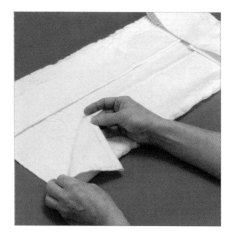

1 For the base, take the bath mat and fold both long and short edges under to form a slim rectangular shape. You can adjust the size later to fit your model.

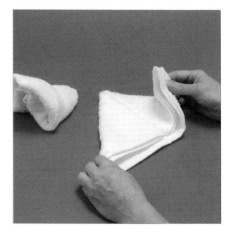

2 For the smallest shell, fold one white face cloth in half then bring both top corners to the center to form a triangle. Repeat using the second white face cloth.

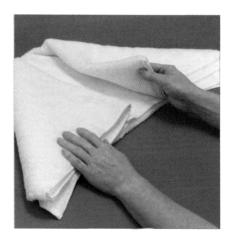

3 For the medium-sized shell, take one bath towel and fold it in half by bringing the short edges together, then fold in half again to form a rectangular band. Fold the upper left and right-hand corners toward the center of the rectangle, to form a triangular shape.

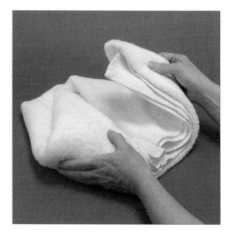

4 Take both left- and right-hand corners at the base of the triangle and fold each in turn toward the center, forming a diamond shape.

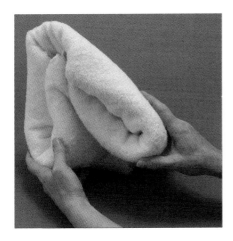

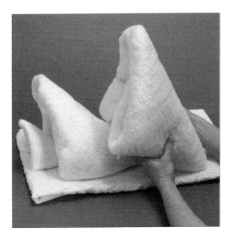

5 Fold in half by bringing the short edges together. Repeat steps 2–4 using the remaining bath towel and bath sheet to create a medium and large shell.

6 Take one folded face cloth and bend it to form a small rounded, pointed triangular shell. Place this on the base at the left-hand side. Now curve and place a medium-sized shell next to the smallest on the left-hand side of the base. Add the largest shell and place centrally on the base. Overlap the shells.

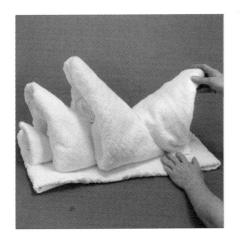

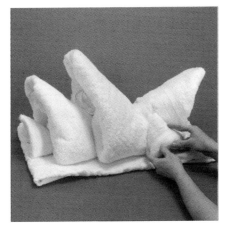

7 Add one medium bath towel and face the point in the opposite direction. Make sure that all the shapes are capable of standing steadily by themselves.

8 Take the remaining face cloth and add this curved triangular shape to cover the join between the largest and the right-hand medium-sized shell. You may need to tuck the edges in neatly.

 # BIG BEN

The name "Big Ben" actually refers to the bell inside the clock tower, not the tower itself. However, the tower is known as Big Ben the world over and is one of London's most famous attractions. It rises over 315 feet (96 m) and the architectural style is described as Gothic Revival. We used a gray-and-beige striped towel to emulate the texture of the stonework tower. However, you could use a plain gray or beige towel instead. Make a towel tower that its designer Augustus Pugin would have been proud of.

TOP TIP

You could also use an enlarged photocopy of a clock face instead of making one from paper.

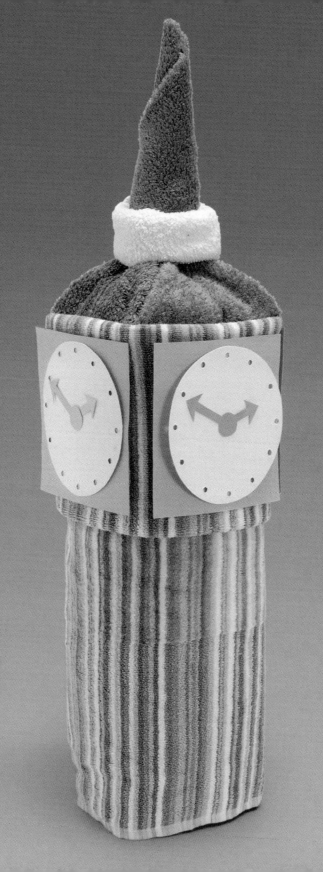

BIG BEN

1 Fold both white bath sheets into a tight cylinder. Fold the striped bath towel in half by bringing the short edges together, then make an 8-inch (20-cm) fold along one short edge. This will form the clock housing at the top of the tower. Wrap the striped towel around the cylinder and pin the overlap securely.

2 For the sloping roof at the base of the spire, take the brown hand towel and fold it into a square by overlapping the short edges at the center.

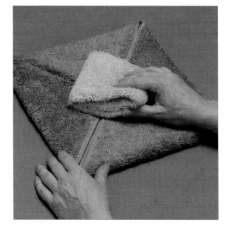

3 Take each corner of the square in turn and fold toward the center, forming a smaller square. Press the shape flat using the palm of your hand.

4 Fold one of the beige face cloths in half, then fold into a small rectangular pad and place it in the center of the square as padding.

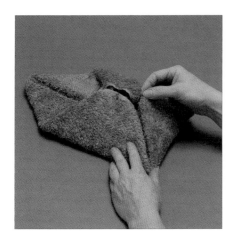

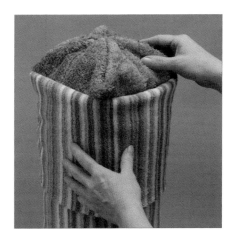

5 To form the sloping shape, pick up each corner of the roof in turn and bring it toward the center. Hold the four corners together using a large safety pin.

6 Place the roof section on top of the tower and tuck the corners inside the top fold. Pinch the striped towel down its length at each corner to form more of a square shape.

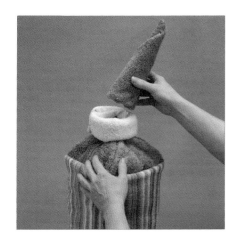

7 Fold a cream face cloth into a loose sausage shape then bend into a circle, using a safety pin to secure the overlap. Squash to a squat square shape and position. Fold the remaining brown face cloth in half. Roll it diagonally from one corner to form the pointed spire, then tuck inside the square.

8 Cut out three beige paper circles to fit the clock housing at the top of the tower and six hands from gray or black paper. Fix the clock faces into position on three sides of the tower using double-sided adhesive tape.

THE PARTHENON

YOU WILL NEED

1 white bath towel
to hold columns

1 white bath towel for pediment

8 white face cloths for columns

fixing kit (see page 8)

Now the ancient Greeks knew a thing or two about building. They developed a specialized mathematical principle called the "golden section" in order to create structures with proportions that were extremely pleasing to the eye. The Parthenon was begun in 447BCE and completed in 432BCE. Hopefully the east facade of your towel Parthenon will take considerably less time to build than that.

TOP TIP

If you want to make the columns look more authentic, add a small, round guest soap to the top of each one to emulate the Doric-style capital.

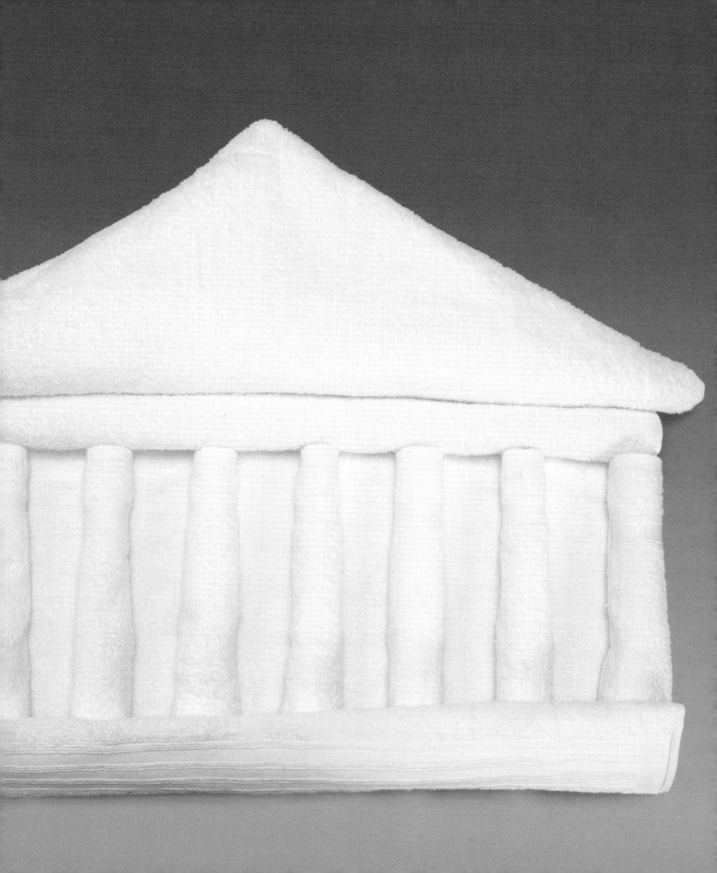

THE
PARTHENON

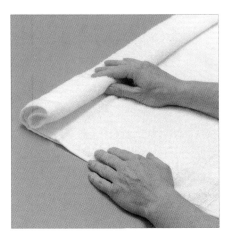

1 Lay one white bath towel out vertically, then fold in half by bringing the short edges together. The width needs to accommodate eight rolled-up columns, each with a small gap in between.

2 Now fold over the top edge. The fold should be about 2 inches (5 cm) deep. This will form the frieze that runs along the top of the colonnade.

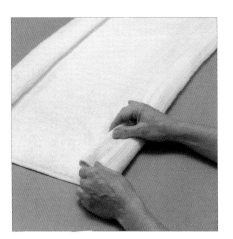

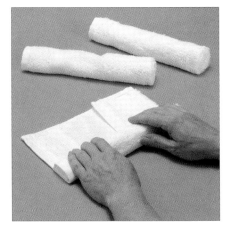

3 Make a fold in the same way across the lower edge. This will form the steps at the base of the Parthenon.

4 Take the eight face cloths and begin to roll the columns. Make a 2-in (5-cm) fold along one edge of each face cloth then roll each up tightly. Secure the overlaps with safety pins. The slightly thicker end will form the base of the column.

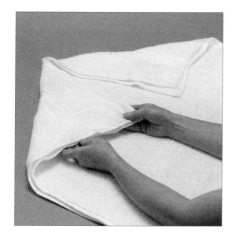

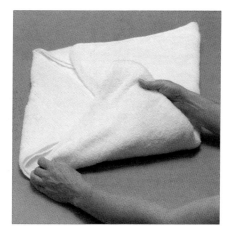

5 For the pediment, take up the remaining bath towel and lay it out vertically. Fold in half to make a square. Fold both top corners toward the center, overlapping to form a shallow triangle along the top edge.

6 Fold the lower corners of the towel upward and toward the center to mirror the triangular shape along the top.

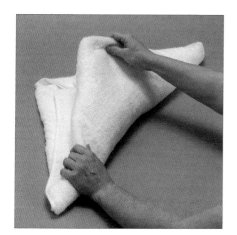

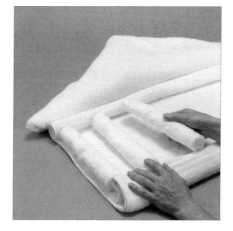

7 Fold the shape in half now to form the shallow triangular pediment.

8 Position the pediment on top of the frieze. The corners at each side should protrude slightly. Place the eight columns upright between the frieze and the steps, allowing an equal distance between each column. Adjust the folds that form the frieze and the base, to make a smooth line.

INDEX

ACKNOWLEDGMENTS

The author would like to thank Christy Towels
for providing many of the props used in this book.
www.christy-towels.com